*Bracket*
Wrought iron, formerly guilded
France; 18th century

Valentine Prinsep, made by Salviat
*Glyph from 'Giorgione'*
*Kensington Valhalla Mosaic Portraits*
1862–1871

CW00801372

*Tile-top Table*
Turkey, Iznik and Istanbul
About 1560

*Capital in the form of a Winged Lion*
Sandstone
Mathura, Uttar Pradesh, North India
Late 1st century / early 2nd century

*Marble Basin from Ablutions Fountain*
Carved marble
Syria, Hama, 1277

Shiro Kuramata (1934–1991)
*Chest: Drawers in Irregular Form*
1970
Capellini, Milan, 1989

*Woman's Chemise*
1851
Linen, marked in ink
'M.J. Sanderson 3'

Matteo Thun
*Fruit Bowl: Kariba*
Porcelain, printed
Memphis, Milan, 1982

The Victoria and Albert Museum

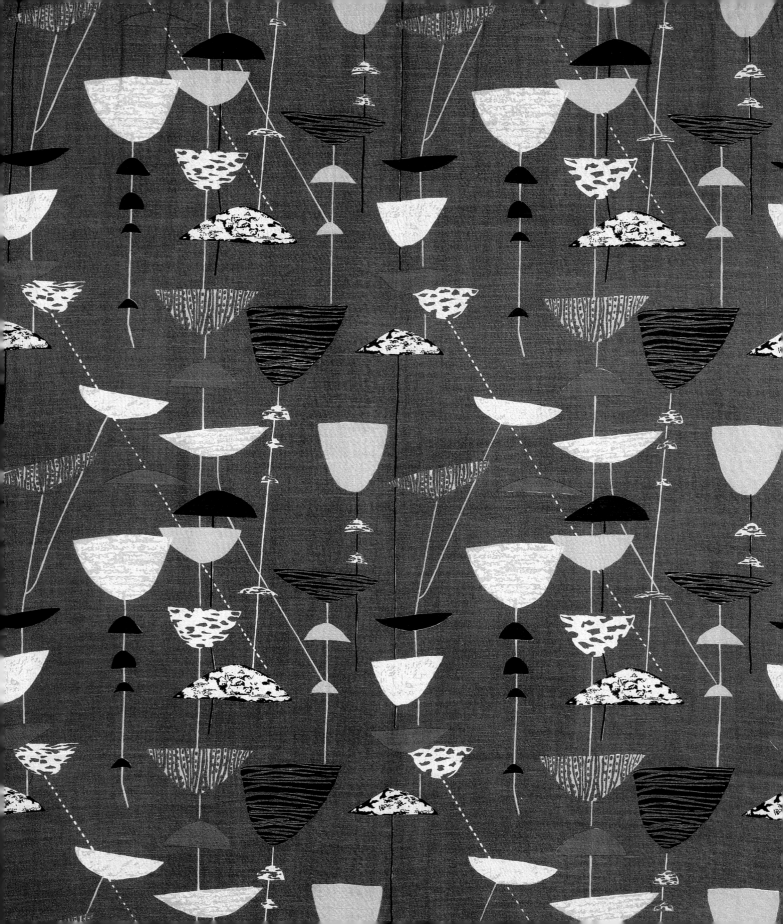

# The Victoria and Albert Museum

## Lucy Trench

With an introduction by Mark Jones

V&A PUBLISHING

First published by V&A Publishing, 2010

V&A Publishing

Victoria and Albert Museum

South Kensington

London SW7 2RL

© The Board of Trustees of the Victoria and Albert Museum, 2010

The moral right of the authors has been asserted.

Hardback edition

ISBN 978 1 85177 508 8

Library of Congress Control Number 2010923039

10 9 8 7 6 5 4 3

2014

A catalogue record for this book is available from the British Library.

All rights reserved. No part of this publication may be reproduced, stored in a retrieval system, or transmitted in any form or by any means electronic, mechanical, photocopying, recording or otherwise, without written permission of the publishers.

Every effort has been made to seek permission to reproduce those images whose copyright does not reside with the V&A, and we are grateful to the individuals and institutions who have assisted in this task. Any omissions are entirely unintentional, and the details should be addressed to V&A Publishing.

Designer: Will Webb

Copy-editor: Johanna Stephenson

Index: Vicki Robinson

V&A Photography by V&A Photographic Studio

pp.22-6 by Alan Williams

Front jacket illustration: *The Three Graces*, by Antonio Canova, 1814-17. V&A: A.4-1994

Back jacket illustration: Fashion in Motion show at the V&A, Gareth Pugh, 2007

Frontispiece: 'Calyx' furnishing fabric, designed by Lucienne Day, manufactured by Heal & Son, 1951

V&A: Circ.190–1954

Case blocking and endpapers: James Goggin for the V&A's Anniversary Album, 2007

Printed in China

**V&A Publishing**

Supporting the world's leading museum of art and design, the Victoria and Albert Museum, London

# Contents

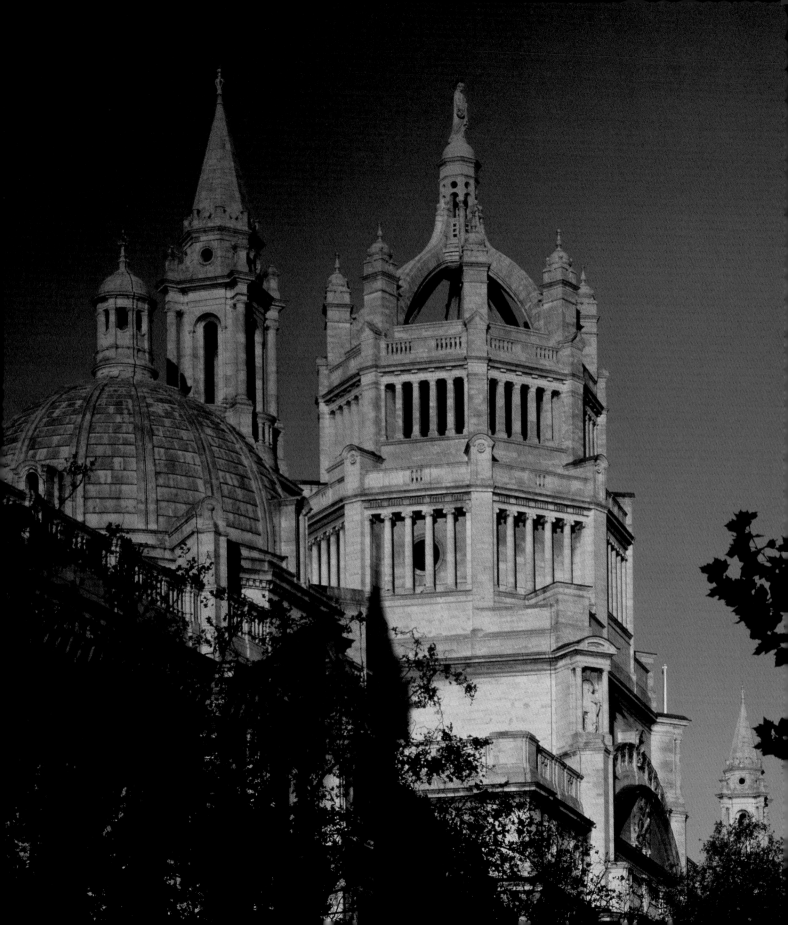

1 Aston Webb's building of 1899–1909 celebrates the whole history of art and design in its elaborate pantheon, and reflects the magic and diversity of its contents in a fantastic roofscape of domes and minarets.

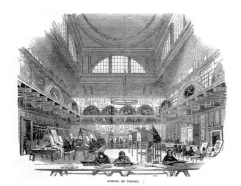

2 The V&A started as the teaching collection of the Schools of Design. This image from the *Illustrated London News* shows the school as it was in 1843, in what had been the Exhibition Room of the Royal Academy in Somerset House. Copies of Raphael's decorative scheme for the Vatican *Loggie* are shown around the gallery and on the right-hand wall. Above the bookcases there are plaster casts. Students are seated in rows, diligently copying what is in front of them.

# A People's Palace

*If ever there was a people's palace, it is here: a Palace of Art devoted to the free culture of the million*

Founded in 1837, the Victoria and Albert Museum was a new kind of museum, created not to house a collection but to achieve a purpose: the improvement of British design. The British Museum came into being to house Sir Hans Sloane's collections; the Louvre to show what had been the royal collection in what had been a royal palace. The V&A began not with a collection, nor with a building, but with practical action to relieve an anxiety: that Britain, though pre-eminent in manufacturing, was losing ground to competitors in design. A select committee of the House of Commons, set up in 1836, heard evidence of the inadequacy of art education in England, and of the superiority of design elsewhere, particularly in France and Germany. In response the government decided, for the first time, to take an educational initiative: they would found a government school of design.

Set up in what had been the fine rooms occupied by the Royal Academy of Arts in Somerset House, it had from the beginning a museum [2]. This was built up as a teaching collection, containing plaster casts of ancient sculpture, copies of Raphael's decoration of the Vatican *Loggie*, and a wide range of contemporary decorative art acquired in Paris by the head of the school, the painter William Dyce. By 1844 there were casts of 'Moresque ornaments from the Alhambra' and architectural fragments from buildings in England and the Continent, while £1,400 (a greater sum in real terms than today's acquisition fund) was spent on purchases from the Triennial Exposition in Paris [3, 4]. The school and museum were open to the public, but lack of space and information made visiting it a confusing and unsatisfactory experience.

3, 4 Two of the objects purchased for the museum of the Schools of Design at the Paris Exhibition of Industrial Art in 1844. The vase was designed and made by Edouard-D. Honoré. It was described on acquisition as 'French modern' in the 'Moorish Alhambra' pattern. The painted glass panel was designed and painted by Antoine Béranger at the Sèvres manufactory. Both companies were known for their technically innovative work.

V&A: 3101-1846 (vase), 58-1844 (glass panel)

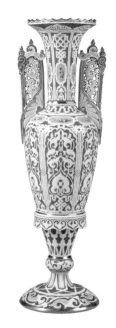

In January 1852 Henry Cole was appointed to run the school. As one of the organizers of the Great Exhibition [5] Cole knew very well that a large public could be interested in the latest goods from around the world. He also understood that there was no point in training excellent designers, and some of the school's early pupils such as Christopher Dresser had proved to be designers of outstanding ability (see page 72), if there was no market for their designs. So Henry Cole [7], friend in his youth of John Stuart Mill and a Utilitarian through and through, conceived of a triply useful institution that would at once educate designers, inspire manufacturers and reform the taste of the public at large or, as he put it, 'elevate the Art-Education of the whole people, and not merely … teach the artisans, who are the servants of the manufacturers'. Prince Albert agreed that, if Cole would make the school and its museum part of his scheme to perpetuate the benefits of the Great Exhibition, he could move both to Marlborough House, a royal residence near Buckingham Palace. New displays opened in May 1852, showing why some designs were good while others, in a 'Chamber of Horrors', were not [6]. 'General Principles of Decorative Art' were drawn up, beginning 'The true office of Ornament is the decoration of Utility. Ornament, therefore, ought always to be secondary to Utility' [8].

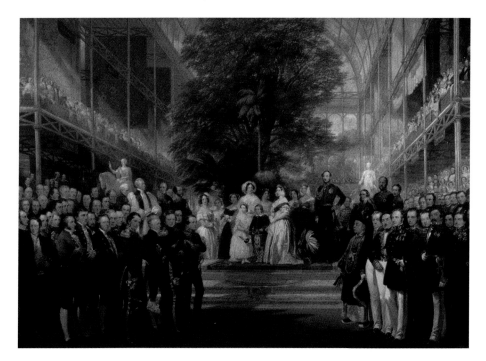

5 Henry Courtney Selous, *The Opening of the Great Exhibition*, 1851. Housed in Joseph Paxton's miraculous Crystal Palace, the Great Exhibition was the first to bring together manufactured goods and products from all over the world. The brainchild of Prince Albert, Queen Victoria's husband and consort, it was a great popular and financial success, proving that there was a mass public for exhibitions of contemporary design and new technology.

V&A: 329-1899

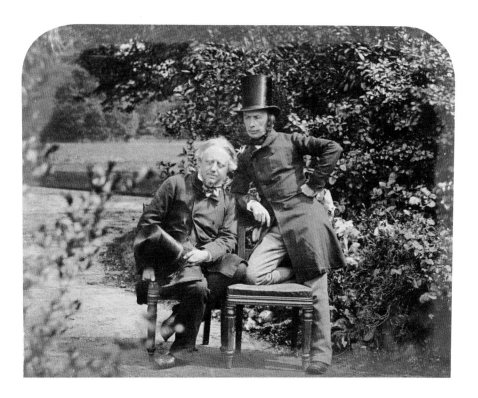

7 Henry Cole (left) and Richard Redgrave, joint secretaries of the Department of Practical Art, in the garden of Gore House in 1854. Gore House and its grounds were acquired in 1852 by the Commissioners of the Great Exhibition as part of their purchase of 86 acres south of Hyde Park to house the museums and educational institutions planned by Prince Albert as its enduring legacy.

8 Henry Cole believed that 'to act upon the principle "every one to his taste" would be as mischievous as "every one to his morals"'. He therefore caused 'General Principles of Decorative Art', stressing the subservience of decoration to form and function, to be circulated to schools of art and design throughout Britain.

6 This convolvulus gas jet made by R.W. Winfield in Birmingham in about 1848, was selected for an exhibition of bad design, the 'Chamber of Horrors', in Marlborough House. It was captioned 'gas flaming from the petal of a convolvulus! – one of a class of ornaments very popular but entirely indefensible in principle'.
V&A: M.20-1974

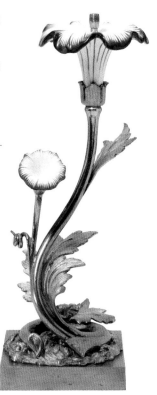

## GENERAL PRINCIPLES OF DECORATIVE ART.

The true office of Ornament is the decoration of Utility. Ornament, therefore, ought always to be secondary to Utility.

Ornament should arise out of, and be subservient to Construction.

Ornament requires a specific adaptation to the Material in which it is to be wrought, or to which it is to be applied; from this cause the ornament of one fabric or material is rarely suitable to another without proper re-adaptation.

True Ornament does not consist in the mere imitation of natural objects; but rather in the adaptation of their peculiar beauties of form or colour to decorative purposes controlled by the nature of the material to be decorated, the laws of art, and the necessities of manufacture.

PUBLISHED BY CHAPMAN AND HALL, 193, PICCADILLY, LONDON.

9 The South Kensington Museum as it appeared when it opened to the public in 1857, drawn by A. Lanchenick. The first new buildings were nicknamed the 'Brompton Boilers' because their rounded form was reminiscent of a ship's boilers.
V&A: 2816

10 A lecture on ironwork, 1870. Objects from the collection are being used as teaching aids.

The new 'Museum of Ornamental Art' was successful, attracting more than 125,000 visits in 1853, but Prince Albert had bigger ideas. He wanted an area, south of the park in which the Great Exhibition had been held, to become home to a great network of institutions devoted to the application of art and science in the improvement of industry, and so of human life in general. In 1857 a temporary, prefabricated iron structure was completed on the new site in Brompton, renamed South Kensington to claim proximity to Kensington Palace by the PR-conscious Cole. This utilitarian structure, nicknamed the 'Brompton Boilers' [9] and later re-erected behind a new façade in the East End of London (now the Museum of Childhood), contained not only the collections of art and design from Marlborough House, but also museums of architecture, building materials and construction, sculpture, domestic economy, education, animal products and machines. The result was, unsurprisingly, incoherent. Prosper Mérimée called it an 'immense bazaar', and even Cole referred to it as a 'refuge for destitute collections', but he was determined that it would make an impact.

In a sideswipe at existing museums Henry Cole declared that, far from being a 'sleepy and useless' repository, the new museum was 'intended to be used and to the utmost extent consistent with the preservation of the articles; and not only to be used physically, but to be talked about and lectured upon' [10]. A lecture theatre was placed symbolically at the heart of the museum, in the centre of the building above the main entrance [11]. Immediately on entering, the visitor found three splendid refreshment rooms serving food and drink at prices intended to appeal to all income levels [12]. The museum was open three evenings a week so that working people were able to enjoy

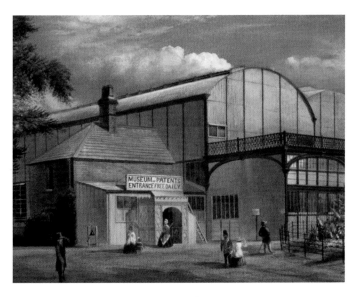

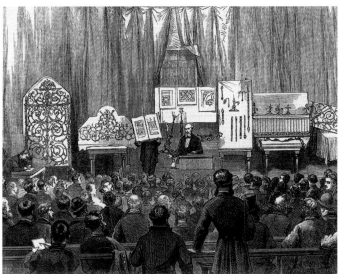

11 Francis Fowke's main entrance façade, begun in 1864, incorporated widespread use of terracotta and mosaic. The mosaic in the pediment was designed by Godfrey Sykes to commemorate the Great Exhibition of 1851, and panels flanking the central block depict the creators of the new museum, including Cole, Fowke and Sykes. In the foreground is *Mirror Mirror*, an installation by the Jason Bruges Studio for the 2009–10 exhibition *Decode: Digital Design Sensations*

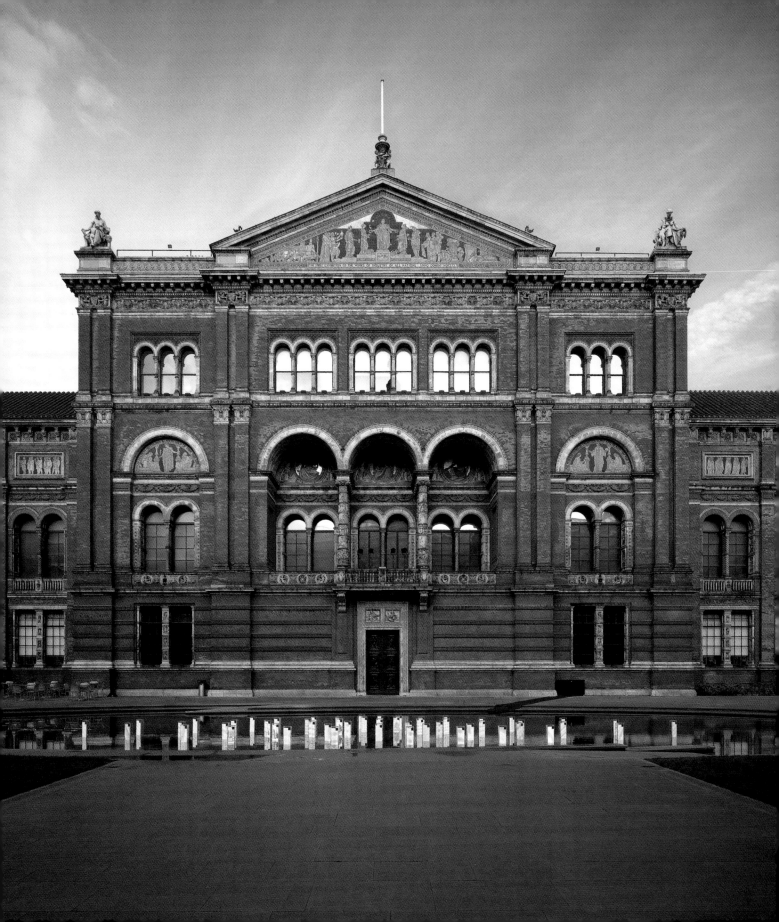

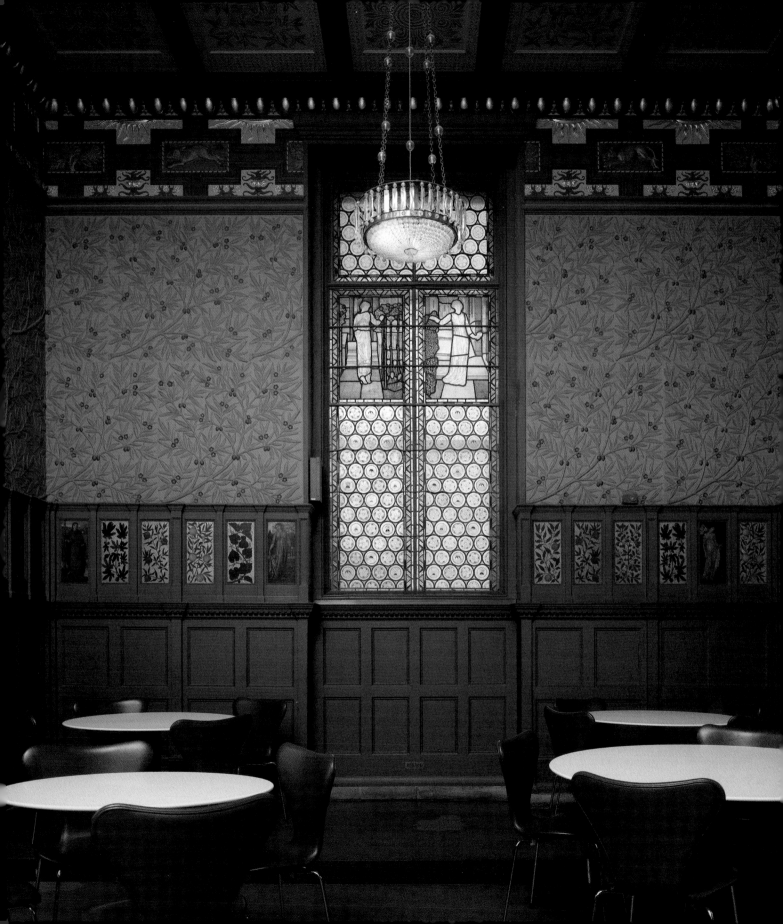

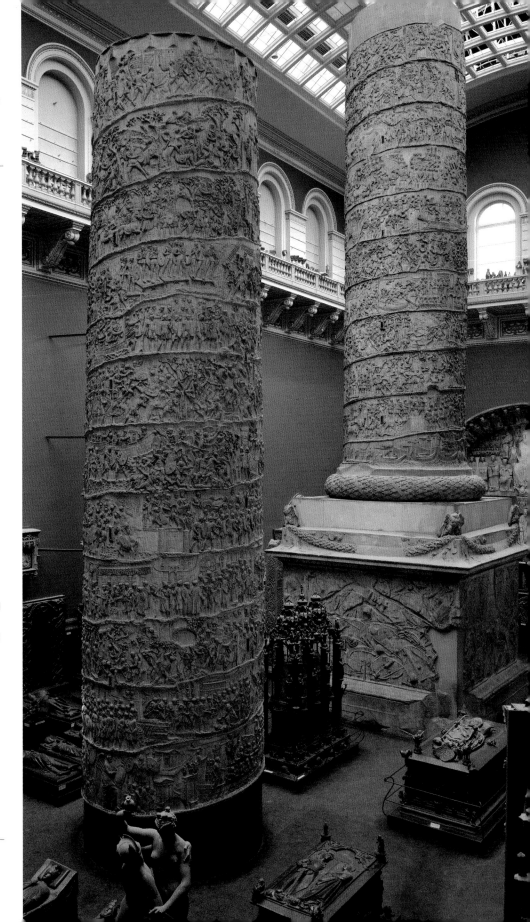

12 The Green Dining Room of 1865–8 was one
of William Morris's earliest commissions. The
decorative scheme, with its olive-pattern walls
and its frieze of hounds and hares, was designed
by the architect Philip Webb; the paintings
were executed by Charles Fairfax Murray after
drawings by Edward Burne-Jones.

13 The Cast Courts, opened in 1873, were
intended to make available a selection of the
finest sculpture and architectural fragments
from around Europe. Henry Cole had engineered
an 'International Convention for promoting
universally reproductions of works of art' signed
by the crown princes of Europe at the Paris
Universal Exhibition in 1867.

The dimensions of the new galleries were
set by the enormous cast of the Pórtico della
Gloria from the Cathedral of Santiago de
Compostela (just visible on the far right). J.C.
Robinson regarded this as 'incomparably the
most important monument of sculptural and
ornamental detail of its epoch' and arranged
for it to be photographed by Charles Thurston
Thompson and cast by Domenico Brucciani
in 1866.

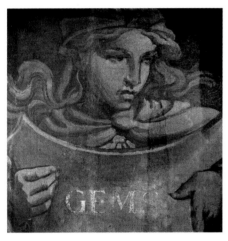

14, 15 The elaborate decorative scheme of the South Courts, designed by Francis Fowke and opened in 1862, included mosaic portraits of great artists and designers, known as the Kensington Valhalla. This personification of Gems, by Godfrey Sykes, remains hidden behind the hardboard that has concealed the original decorative scheme since the late 1940s.

and learn from it, and a great collection of plaster casts of sculpture and architectural decoration was formed [13]. Magnificent galleries were created, demonstrating the innovative use of cast iron and elaborately decorated with reminders of every aspect of the arts [14, 15]. J.C. Robinson, the museum's first professional curator, wrote in 1858 that 'practical utility in an educational point of view is [the museum's] most important function'. And in a lecture intended to answer the questions 'Of what actual use is this Museum viewed as part of the direct instructional system of the Department?' and 'What is its scope and province in the work of elevating the standard of taste and knowledge of ornamental Art in the country generally?' he argued that 'a museum of specimens is as necessary a complement to the studies of the industrial artist, as the laboratory to the chemist, the observatory to the astronomer, or the dissecting-room to the medical student'. Knowledge gained from museums would not inhibit, but inspire, invention for 'he who knows the most will be the most original'.

The V&A was then, in its mid-nineteenth-century incarnation, a museum devoted to access and education. Popular temporary exhibitions were organized to draw in the general public [16]. But the collections were also there to teach and inspire practitioners and students of art and design. The *Art Journal* wrote in 1869, 'No artist of fertile imagination can pay a single visit to such a collection without experiencing a powerful and healthful stimulus to his creative power'. The practice of drawing was considered to be of central importance. As George Wallis, Curator of the Art Collections, wrote in 1859, 'the Art of Drawing involves the power to see objects correctly and to delineate them with accuracy', so cultivating 'the perceptive faculties of the Student' and laying the basis for invention. But the museum was equally intended to educate the public as a whole, directly through its library and lectures and indirectly through the exposure of the public to beautiful things in beautiful surroundings. 'If ever there was a people's palace, it is here', wrote Wallis, 'a Palace of Art, devoted to the free culture of the million' [17]. Public museums in the mid-nineteenth century were intended to extend to the lower middle and respectable working classes a sense that great national treasures and the grand public buildings which housed them were the common property of all, so inoculating them against the revolutionary virus that periodically swept continental Europe. In Cole's mind visiting the museum would have an additional benefit: it would educate visitors as consumers or, as he put it, 'make the public hunger after the objects; … then they will go to the … shops and say, "We do not like this or that; we have seen something prettier at the … Museum"'.

The initial incoherence of the collection found its expression in the incoherence of the South Kensington Museum's buildings. The Brompton Boilers were supplemented by galleries to house John Sheepshanks's gift of paintings, and then the overflow from the National Gallery, the National Art Competitions, loan exhibitions and plaster casts. Development continued piecemeal until the end of the century when a competition to complete the museum was won by the architect Aston Webb. In her last public act Queen Victoria laid the foundation stone of the new building and agreed that it should be named after herself and her late husband, the 'Victoria and Albert Museum'. Coherence of content had also been gradually re-established as the nineteenth century wore on. The original 'Art Museum' ejected the interlopers over time, some to the East End, others across the road to what was to become the Science Museum, and began to assume the character familiar today. But that character is itself the product of divided intentions. Was the museum to continue as a resource for students and practitioners of art and design and an agent for sensitizing a wide public to the causes and consequences of visual choice? Or was it, as became fashionable in the late nineteenth and twentieth centuries, to become a temple for the contemplation of great art? Henry Cole tended to the former, while J.C. Robinson and many of his successors were drawn to the latter.

The exterior of the building is very much as Aston Webb left it on its completion in 1909: monolithic and many-storeyed. Great windows in the façade provide light to the galleries that face on to the street. But in the interior of the museum Aston Webb, like his predecessors Francis Fowke and Henry Scott, needed to provide daylight for the galleries from above, so what appears from the street to be a four-storey building is, for the most part, a series of one-storey top-lit

16 An exhibition of the wedding presents of
the Prince and Princess of Wales in 1863 was
attended by 20,467 people, including 372 babes
in arms, on a single day.

17 'The Sunday Question', *Punch*, 17 April 1869,
contrasts the Public House, in which a working
man is resisting the entreaties of his wife to come
home before he has spent his weekly earnings
on drink, with the newly available House for the
Public (the South Kensington Museum), in which
he and his family can enjoy the free displays
together.

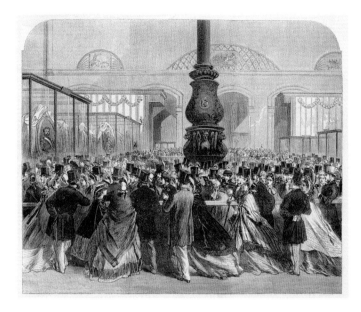

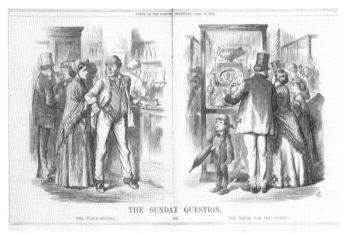

galleries or courts, girt with balconies and lit by great glass roofs. This makes the V&A a spatially confusing experience, providing numerous opportunities to lose oneself in the multifarious riches of the collections and to enjoy expected and unexpected vistas and views, of the immense bulk of Trajan's Column or the Pórtico della Gloria, the marble-clad entrance hall seen from high above, the great processional sweep of sculpture in Britain or the lavish and complex Italianate garden façade glimpsed through panels of stained glass. As the restoration and refurbishment of the building has progressed and original decorative schemes have been restored and revealed, the quality of the original designs has become ever more evident, creating enjoyable harmonies and counterpoints between the objects displayed and their surroundings.

How various these objects seem. Yet they all originate from a single purpose: to bring together the best examples of design and ornamental art. When Henry Cole and his contemporaries gathered to acquire objects from the Great Exhibition of 1851 they asked not whether they came from France or Germany, nor whether they fitted with the existing collection, but whether they provided good examples from which British designers could learn. They admired Indian and Islamic approaches to surface decoration, so Indian and a little later Islamic work was acquired

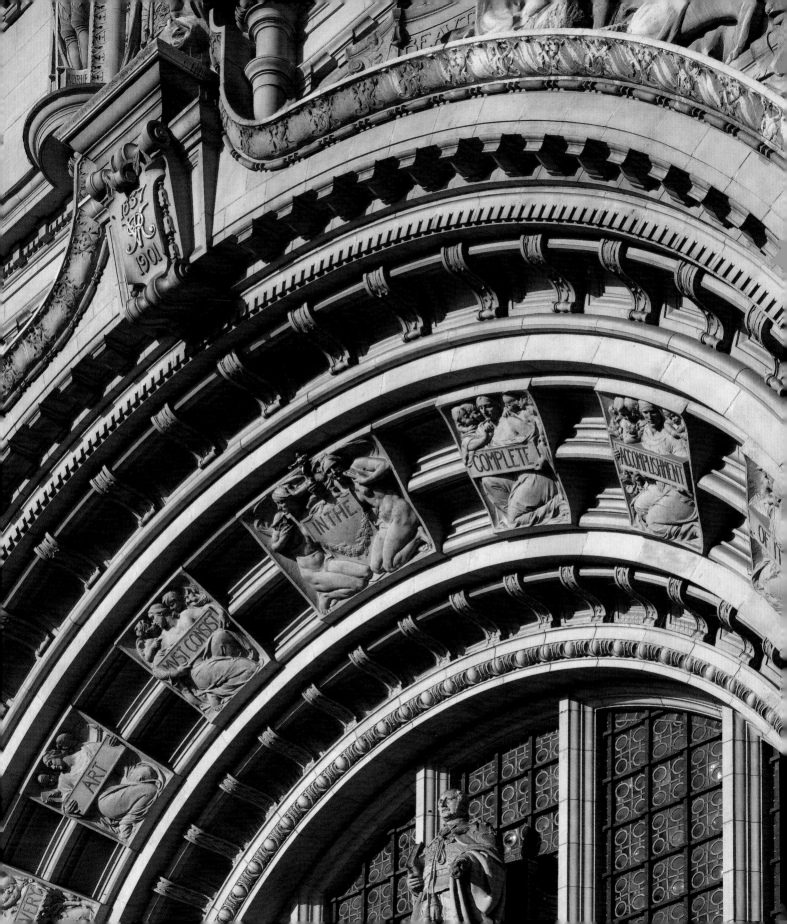

18 This sandalwood jewel-box from Mangalore was admired by J.C. Robinson, who regarded it as a good model for decorative artists to follow. His view was shared by Henry Cole, A.W.N. Pugin, Richard Redgrave and Owen Jones who, as the committee charged with acquisition from the Great Exhibition, spent much more on Indian than on British objects.

V&A: 17-1852

19 The Grand Entrance on Cromwell Road is the focal point of Aston Webb's new building, completed in 1909. In the centre is Prince Albert, who along with Henry Cole had created the museum in the 1850s. The inscription around the arch reads: 'The excellence of every art must consist in the complete accomplishment of its purpose.'

[18]. They appreciated some contemporary European (particularly French) design. They regarded the Italian Renaissance as the *fons et origo* of Western art and culture, and they loved the romance of the Middle Ages [20]. They believed strongly in the virtues of technological innovation: the building itself is a testament to their readiness to experiment with new techniques of construction and decoration. But they also admired and valued the history of technique and craftsmanship, building increasingly encyclopaedic collections of glass and metalwork, ceramics and textiles, furniture and dress, watercolours and drawings, sculpture in all its forms and architectural fragments to help people to understand how things had been done in the past.

It is not my task to describe the collections of the V&A, but I would like to sketch their particular character. The V&A is a museum of art and design, but not all art or every aspect of design. It makes no claim to being a 'universal museum', being predominantly European in attitude and outlook, but it has always admired, collected and valued the arts of China and Japan, of India and the Islamic world. Beginning by collecting for exemplary value only, the V&A soon began also to collect in order to advance understanding of the past and bring objects of exceptional interest and beauty into the public domain. The V&A is not a purely didactic institution, the success of a visit to which is to be measured by the amount learned. Wonder and enjoyment are legitimate – indeed arguably the best – ways of experiencing what the museum has to offer.

There is, though, a unifying thought and purpose behind all the displays at the V&A: to encourage thought about and offer explanations for why things look as they do. On the lower floors, art and design in Europe and Asia are looked at in their cultural and historical context. Objects of all kinds – textiles and dress, ceramics and glass, furniture and paintings, sculpture and graphic art – are shown together. Each informs our view and understanding of the others, building a rounded picture of the visual culture of each period and place and helping us to a greater enjoyment and appreciation of the objects themselves and a better understanding of the societies that created them. We may find that received notions – that medieval Europe was brutish and gloomy, or that Islamic culture shunned images – are challenged by the evidence of our eyes. The notion of style is explored and explained and the role of patronage and the evolution of taste examined. On the upper floors the focus is on understanding the materials from which objects are made and, more particularly, the techniques used to make them. Objects from different times, places and cultures may be brought together to illustrate the development and use of a particular technique.

Each approach is intended to complement the other and both are intended to suggest that there are numerous different and equally legitimate ways in which to enjoy and understand the collections. We can enjoy them for what they show: the model for a pavilion in the Festival of Britain, a young mother with a baby in her arms, the perfection of a Persian garden. The subject may interest or move us: the Crucifixion of Christ, a girl jilted by her lover (Francis Danby's *Disappointed Love*, 1821), the explosion of a mine under Akbar's army. It may be the inventiveness of a designer – Leonardo in his notebooks or Joseph Paxton sketching his ideas for the Crystal Palace (see pages 66–7) – that captivates us. Or it may be the skill of manufacture, the carving of ivory, the setting of gems, the engraving of silver, embroidery or drawing, testimony to years of patient practice, devotion and concentration, and a culture that valued and rewarded such skill. We can enjoy makers' feelings towards their subjects, or the taste (good or bad) of those who commissioned them. And we can interrogate them for the evidence they provide about the attitudes and beliefs of the societies within which they were created.

Objects can acquire mythic status from the accretion of stories and beliefs around them. The Great Bed of Ware, Tipu's Tiger and the Luck of Edenhall (see pages 50–51, 63) have acquired a power through the centuries that would have baffled their first creators. Objects are not, in themselves, good or bad. But they can reflect and embody the virtues and the sins of those for whom they were made: what could show more national and personal pride than Lord Castlereagh's inkstand [21]? They can mislead us: one of the deceptive things about many objects in the V&A is that they appear to have a straightforward function but were made for reasons quite other than use. The Melville Bed in the British Galleries is a state bed, a great ceremonial object, fit to be the centre of court ritual that focused on the *lever* and *coucher* (getting up and going to bed) of the king,

but probably never to be slept in (see page 58). The V&A is full of swords and armour that were never to be used in a fight, porcelain to be shown rather than eaten off and clothes to be worn only on rare occasions. What you see are often the relics of conspicuous consumption and conspicuous display: demonstrations of power, wealth and status. The V&A itself could be seen as a great machine for asserting Britain's power and magnificence through display of rare, valuable and exotic objects in a setting itself constructed from luxurious materials and lavish in its consumption of space. But change of perspective from patron or maker to viewer and the very inutility of such objects makes them, like a sonnet or a sunset, a bird's plumage or an elegant theorem, things of beauty in and for themselves, not means to an end but free-standing affirmations that we can value a work of art, like a moment of time, not for its causes and consequences but for itself alone.

20 The Gloucester Candlestick. This early medieval candlestick, commissioned by Peter, Abbot of Gloucester (1104–13), evokes an unceasing struggle between man and demonic beasts, representing sin. The inscription reassures us that 'this upholder of light [the candlestick] is the work of virtue. Shining doctrine [represented by the candle's light] teaches that mankind be not overcome by the darkness of vice'. It is a masterpiece of skilful modelling and a triumph of lost-wax casting, but its acquisition from the collection of Prince Soltykoff in 1861 was more a contribution to the V&A's development as an art museum than to the candlestick's role as exemplar of good design.

V&A: 7649–1861

21 The Castlereagh Inkstand is made from 21 gold boxes given to Lord Castlereagh by the crowned heads of Europe in recognition of his central role as British Foreign Secretary in the negotiations leading to the treaties of Paris and Vienna at the end of the Napoleonic Wars. These gold and jewel-encrusted boxes contained portraits of the donors and were intended as a mark of honour and a personal bond between the sovereign in question and the recipient. Melting them down to create a utilitarian, if impressive, inkstand, while incorporating the jewels in the hilt of Castlereagh's Garter sword, was an act of insolent pride.

V&A: M8:1 to 6–2003

22 The V&A maintains close links with the creative industries. Its sensational Fashion in Motion programme creates live catwalk events in the midst of the museum. Participants have included Ma Ke Yuwong from China, Jean-Paul Gaultier from Paris, and Alexander McQueen and Gareth Pugh from Britain. This futuristic apparition is from the Gareth Pugh show of 2007.

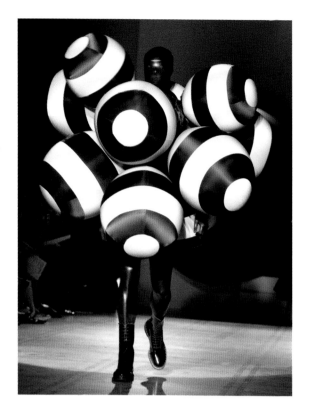

# The V&A in the twenty-first century

If Britain is to remain prosperous it must compete through the quality of its creativity and design. So the V&A must continue to be a compendious store of reference and ideas for practitioners and students of art and design. It needs to engage a wide public, drawn from a population that has links to and interests in every part of the globe, and to make everyone think about design, about its impact on every aspect of our surroundings and about the choices that we make ourselves. To do so it needs to show and explain art and design from past and present and from many parts of the world. It has to be deeply informed about the cultures and context, the skills and traditions, that gave rise to the art of the past so that the present can learn from as well as enjoy what has been done before. It needs lively connections with traditional and radical design elsewhere to expand understanding of what is possible here. Its programme of exhibitions, courses and events must and does aim to gain and spread new understanding of the continually changing world of art and design. And so, increasingly, the V&A can be encountered not only in London, but also elsewhere, in exhibitions that travel from San Francisco to Hong Kong, from Melbourne to Bilbao, from Mumbai to Moscow. On-line, through its publications and conferences it hopes to be, as Prince Albert intended, both a distinctively British institution and part of a world-wide community of those who believe that the things with which we surround ourselves – our clothes, our homes, our tools and our towns – reflect us only too accurately, embodying our feelings for each other and for the world we inhabit and capturing the purity or imperfections of the intentions that brought them into being. In short, they are a mirror. We need to be able to look into that mirror and be proud of what we see.

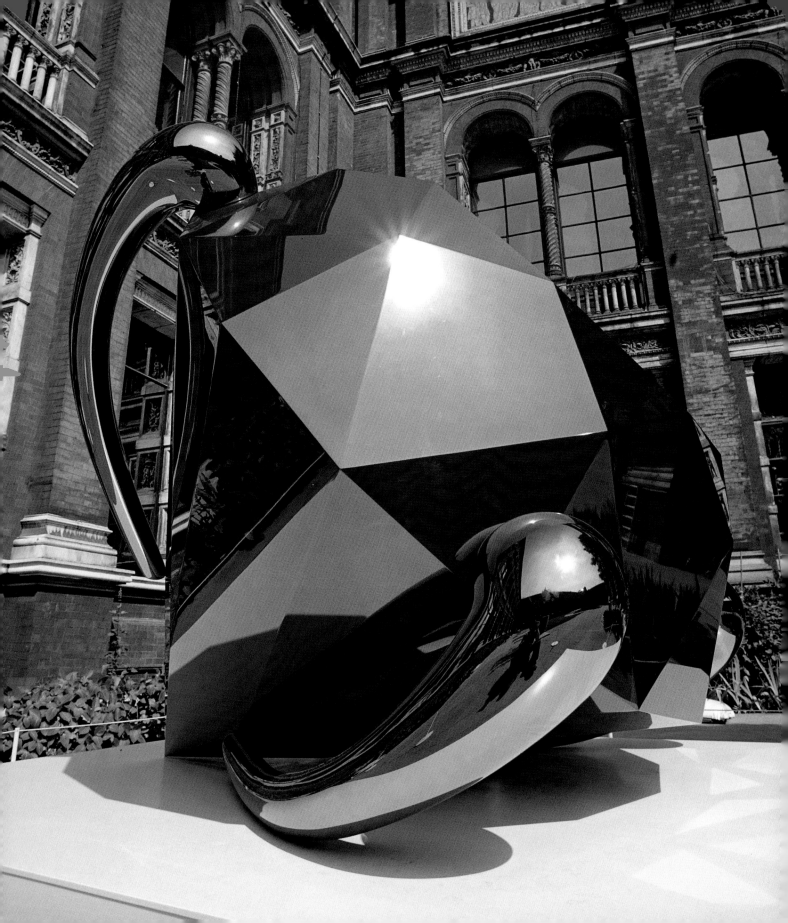

# The V&A Today

23 The V&A encourages debate between
contemporary design and that of the past.
*Diamond (Pink)* by Jeff Koons was temporarily
placed in the garden in 2006. Two metres high
and made of stainless steel, it both celebrates
and critiques our consumer-driven culture.
The John Madejski Garden, designed by Kim Wilkie Associates,
completed July 2005

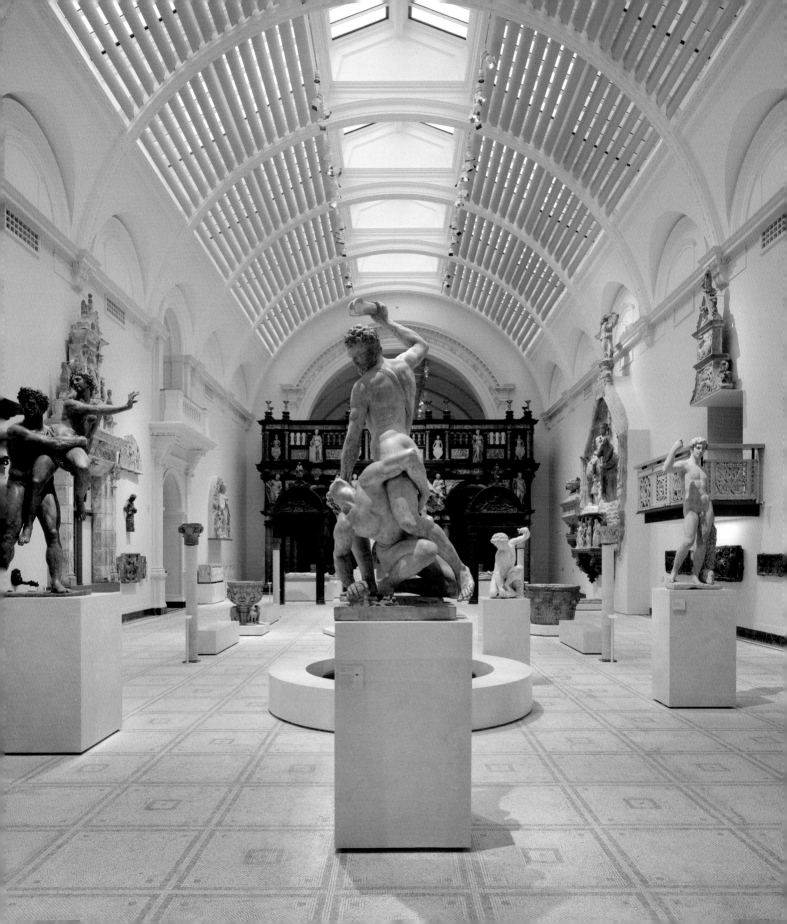

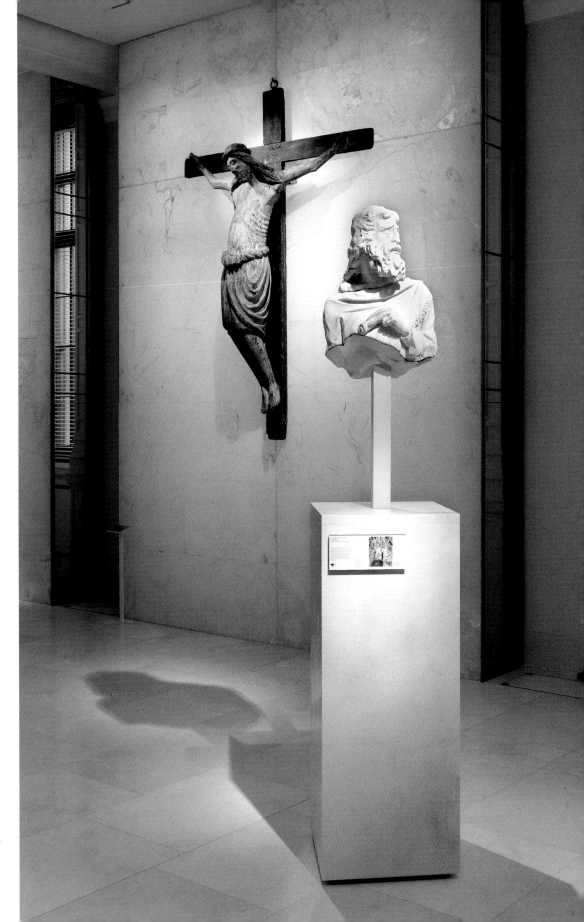

24 The Medieval & Renaissance sculpture gallery (left) is situated in the heart of the museum, in an airy, top-lit space designed by Aston Webb in 1899–1909. Running across the gallery is the 17th-century choir screen from 's-Hertogenbosch in the Netherlands. In the foreground is Giambologna's marble group *Samson Slaying a Philistine*, which was commissioned by Ferdinand de' Medici and later belonged to Charles I.

Room 50a, The Paul and Jill Ruddock Gallery, designed by McInnes Usher McKnight Architects, completed 2010

25 The Medieval & Renaissance galleries tell the story of European art and culture from AD 300 to 1600, from the decline of the Roman Empire to the end of the Renaissance. Room 10 (right) explores public worship as well as the more private world of personal religious devotion. Natural light filters into the gallery through onyx window screens.

Room 10 designed by McInnes Usher McKnight Architects, completed 2010.

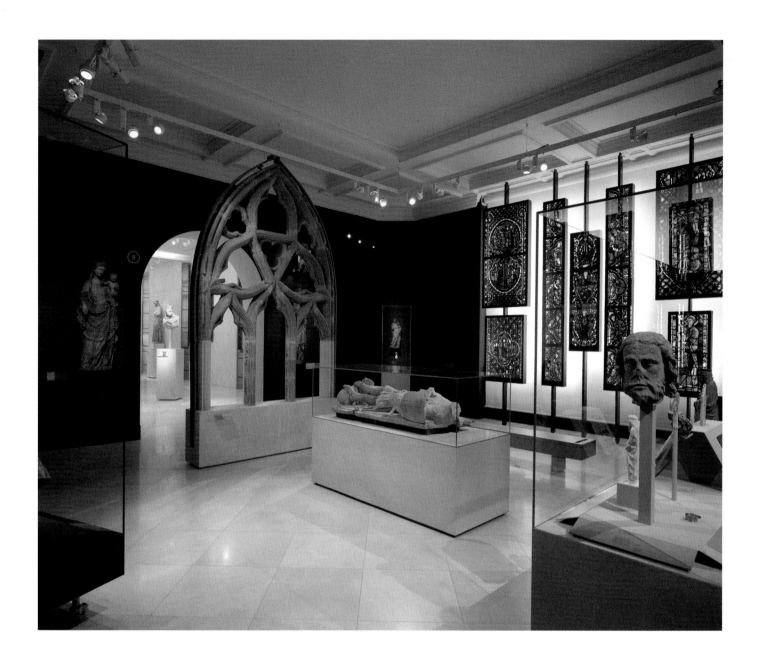

26 The Medieval & Renaissance galleries are witness to the colour and sophistication of medieval art.
Room 9, The Dorothy and Michael Hintze Gallery designed by McInnes Usher McKnight Architects, completed 2010.

27 This gallery in Medieval & Renaissance was created out of an interior light well. It includes large architectural installations, such as the 16th-century façade of Sir Paul Pindar's house in Bishopsgate, London.
The Simon Sainsbury Gallery designed by McInnes Usher McKnight Architects, completed 2010.

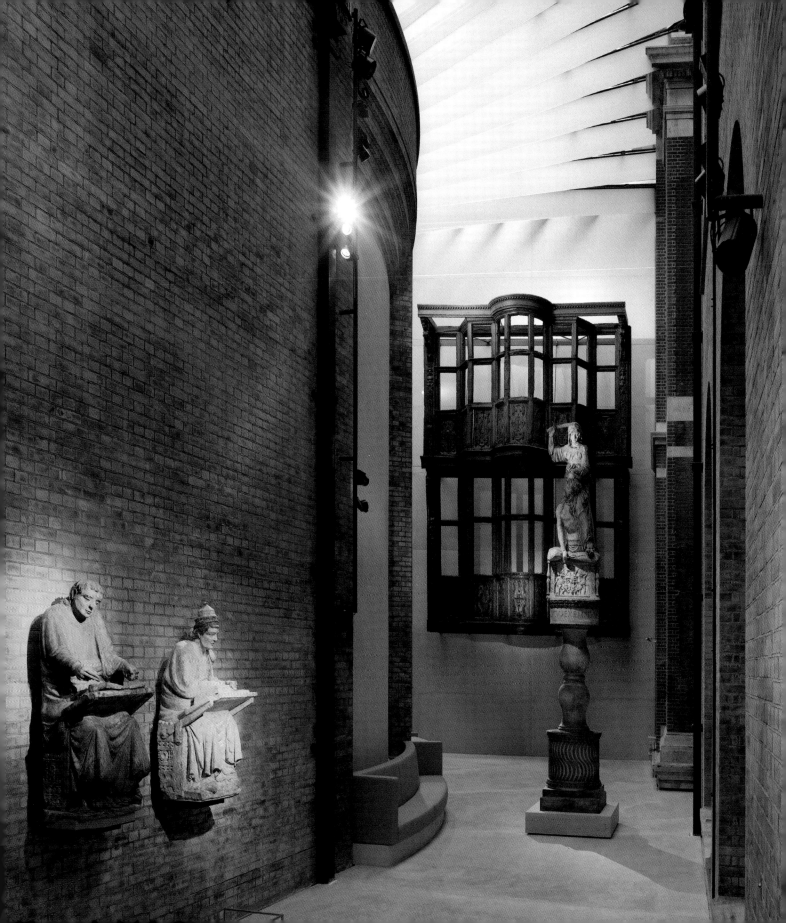

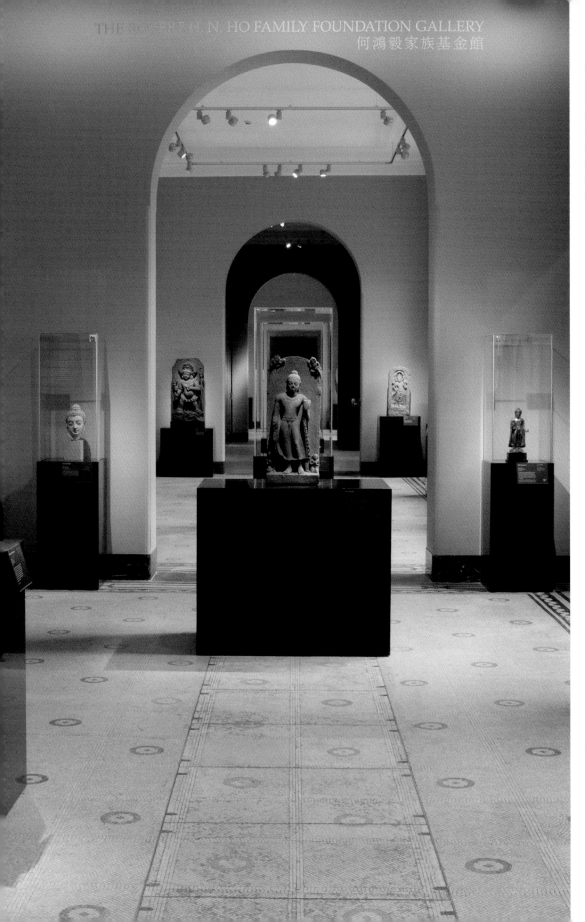

THE ROBERT H. N. HO FAMILY FOUNDATION GALLERY
何鴻毅家族基金館

**28** In creating new galleries, the V&A seeks to reveal the original architecture of the building and where possible to use natural light. This gallery is a calm and beautiful space in which to contemplate masterpieces of Buddhist sculpture.
Room 20, The Robert H.N. Ho Family Foundation Gallery, designed by V&A Design, completed 2009.

**29** The British Galleries show British art and design from 1500 to 1900. The V&A's largest gallery project for fifty years, they were the first of a whole series of new galleries that have transformed the architecture and displays of the museum.
Room 121, The Wolfson Galleries, designed by Casson Mann, completed 2001

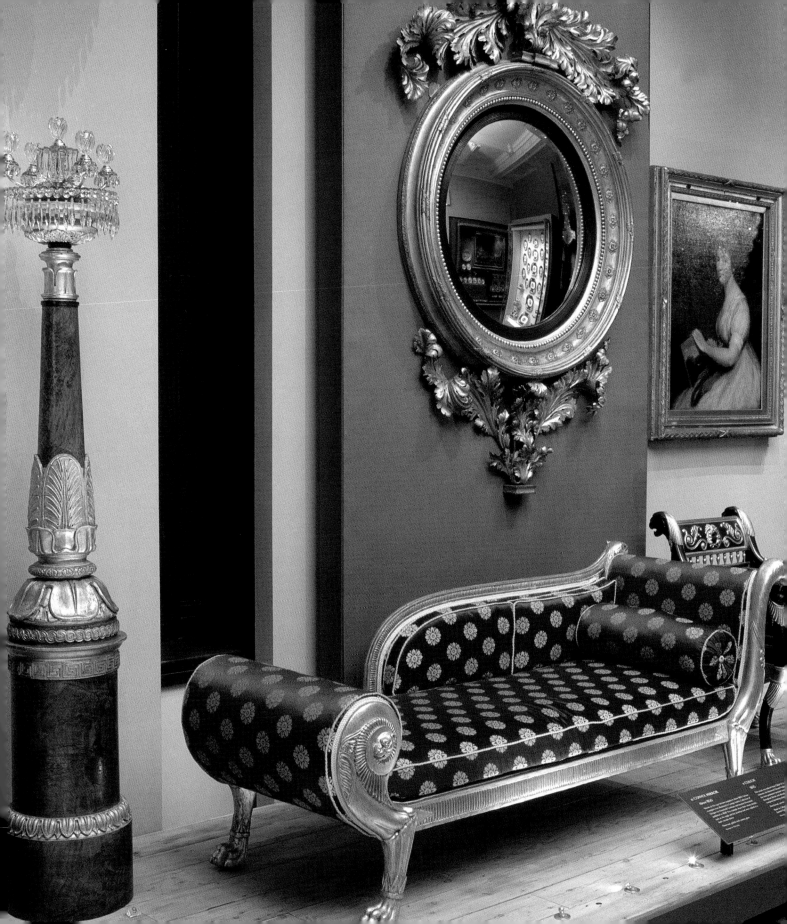

30 The Islamic Middle East Gallery is designed around the Ardabil Carpet, one of the largest and finest carpets in the world. Completed in 1539/40, it was commissioned as one of a pair by the ruler of Iran, Shah Tahmasp, for the shrine of his ancestor, Shaykh Safi al-Din, founder of the Safavid dynasty. At one end there is a dated inscription, 'Except for thy haven, there is no refuge for me in this world.  Other than here, there is no place for my head.  The work of a servant of the Court, Maqsud of Kashan, 946'.

Room 42, The Jameel Gallery, designed by Softroom, completed 2006

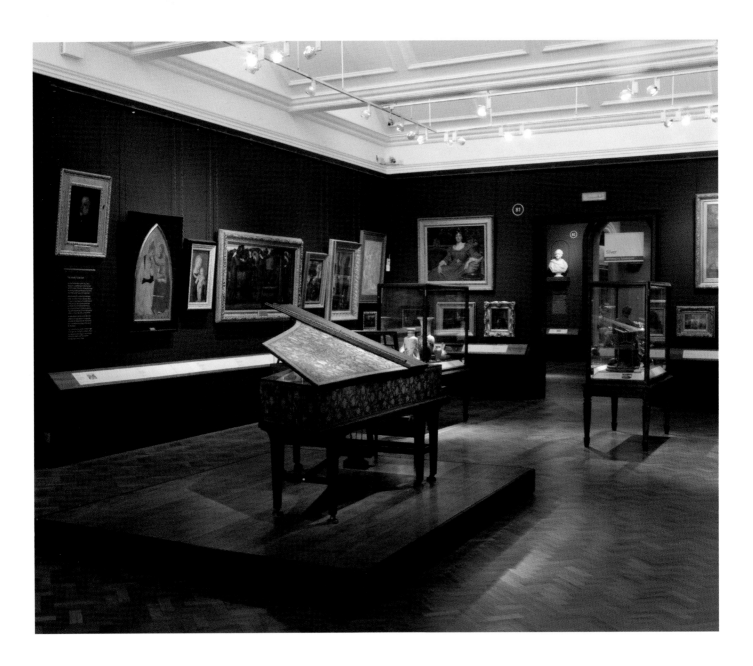

31 The Paintings Galleries are the earliest
galleries in the V&A. First built in the 1850s
as a 'National Gallery of British Art', they now
house the important collections of paintings
given and bequeathed to the museum by John
Sheepshanks and Constantine Ionides. The piano
was designed by the painter Edward Burne-
Jones for another member of the Ionides family.

Room 81, The Edwin and Susan Davies Galleries, designed by
V&A Design, completed 2003

32 At the centre of the Ceramics Galleries is the
dome above the Grand Entrance, and high on its
internal rim is an installation by the British ceramist
Edmund de Waal. Called *Signs and Wonders*,
it consists of 425 monochrome pots carefully
grouped along a brilliant red lacquer shelf.

Room 141, The McAulay Gallery, designed by Stanton Williams,
completed 2009. *Signs and Wonders* supported by The Art Fund,
Nicholas and Judith Goodison, Gerard and Sarah Griffin, Black-
burn Associates Limited and Mr and Mrs Charles Booth Clibborn

**33** Possibly the most spectacular gallery in the V&A is Jewellery. Housing 3,500 jewels from ancient Egypt to the present day, it is a dazzling showcase of virtuosity and design.

Room 91, The William and Judith Bollinger Gallery, designed by Eva Jiricna Architects Ltd, completed 2008

# The Great Exhibition

The Great Exhibition of 1851 was a pivotal moment in the history of the V&A. Until then the museum had been a small teaching collection in the Schools of Design in Somerset House, but the success of the exhibition led to a radical new scheme that would turn this modest assemblage into a far more ambitious enterprise.

The presiding genius behind the exhibition was Prince Albert, the cultured German husband of Queen Victoria. The force that drove it on was Henry Cole, a civil servant known for his administrative abilities and his commitment to design reform. With the resounding title of 'The Great Exhibition of the Works of Industry of all Nations', the exhibition set out to promote domestic consumption and foreign trade.

It also became a triumphant demonstration of Britain's modernity and social stability. The displays were housed in a revolutionary glass building (the Crystal Palace [34]) and were open to anyone who could afford the one-shilling day ticket. In the 23 weeks that the exhibition was open there were six million visitors – one third of the population of Britain. The queen was pleased to find the crowds 'all so civil and well behaved'. With the rest of Europe torn by revolution, this was reassuring.

Britain was then the world's leading manufacturer, responsible for half the goods that were traded around the globe. Much of the display space in the exhibition was dedicated to Britain and her imperial domains. But unfortunately it was all too clear to the experts – though probably not to the general public – that British design was inferior to that of her continental rivals. When the exhibition closed, an official report admitted that 'the great truth has been impressed upon us that art and taste are hence forth to be considered as elements of industry and trade of scarcely less importance than the most powerful machinery'. To address this, the report recommended the establishment of a permanent industrial museum.

The idea materialized in the form of the Museum of Manufactures, with Henry Cole as director. It used the collection belonging to the Schools of Art as a nucleus and Marlborough House in Pall Mall as its premises. To develop the museum, Cole won a parliamentary grant of £5,000 to purchase works from the exhibition: 'Elkington electrotypes, china from Minton and Sèvres, oriental arms and armour, Belgian gold and silver, and other striking objects', each

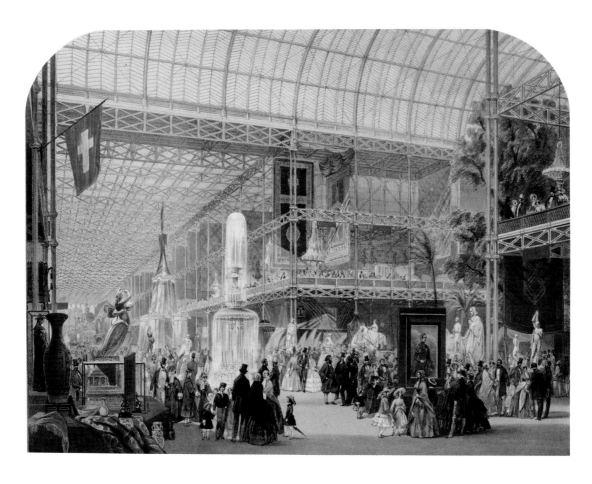

one selected 'for its merits in exemplifying some right principle of construction or of ornament'.

Less than £1,000 was allocated to British purchases, and of this much went on works by A.W.N. Pugin. Like other design reformers in Victorian Britain, Pugin sought an aesthetic response to the challenges of modernity; his solution – as a Catholic convert – was to return to the Gothic style, a truly Christian style that pre-dated the Reformation and reflected a more moral society. Yet, he did not eschew modern commercial production. This chalice [36] is based on a fifteenth-century Italian example but was made by John Hardman & Co., the Birmingham firm that supplied furniture and fittings to churches throughout Britain.

A generous £1,500 went towards Indian material, mainly textiles. Owen Jones, who sat on the purchasing committee and had also devised the colour scheme and banners for the Great Exhibition, picked out Indian textiles for their restraint and good design [35]. In them, he wrote, 'There are no carpets worked with flowers whereon feet would fear to tread, no furniture the hand would fear to grasp'.

The exhibition generated a profit of £186,000. Prince Albert decided that this should be spent on an educational complex dedicated to 'the application of Science and Art to Industrial Pursuits'. The money was used to buy land south of Hyde Park and in time the V&A, the Science Museum, the Natural History Museum and Imperial College came to occupy the site.

The Museum of Manufactures (as the V&A was then called) moved to South Kensington in 1857, still under the direction of Henry Cole. Its guiding principle – that a museum could be an instrument of progress and social cohesion, that it could appeal to the humble artisan and to ladies from Kensington – was one that Cole had learned from the Great Exhibition.

34 INTERIOR OF THE CRYSTAL PALACE **1851.**
Its displays included steam engines, consumer goods, the largest pearl ever found, the Koh-i nur diamond and a knife with 350 blades. Owen Jones arranged the displays and devised the colour scheme.
V&A: 19538:2

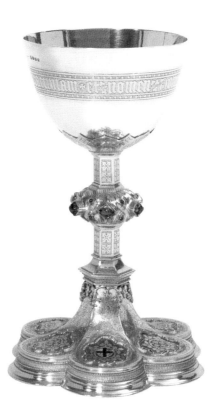

35 GOLD AND SILK SARI **(detail), woven in Benares (now Varanasi), about 1850. The museum bought Indian textiles from the Great Exhibition as examples of good design.**
V&A: 769-1852

36 CHALICE **by A.W.N. Pugin, 1849–50. Pugin designed a Medieval Court for the Great Exhibition, though he was also busy on the Houses of Parliament.**
V&A: 1328-1851

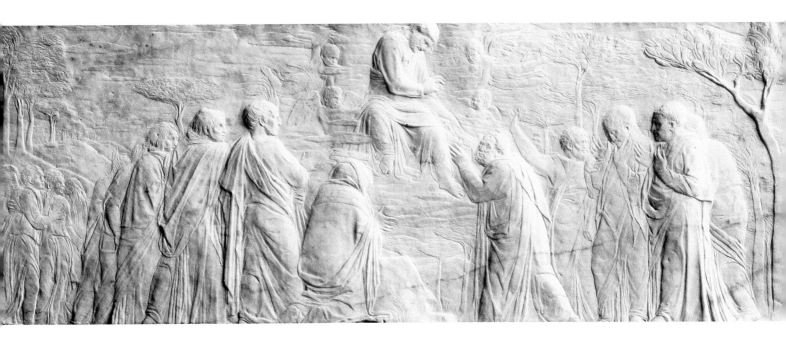

# The Rare, the Old and the Beautiful

Many talented curators and generous donors have contributed to the V&A's superb collections, but no single individual has made a greater impact than John Charles Robinson. Trained as an architect and painter, he taught at a school of design in Staffordshire before moving to London and becoming curator of the museum in 1853. In his ten years as curator he hunted out 'the rare, the old and the beautiful', while others focused on the more utilitarian aspects of the collection. An extraordinary number of the museum's treasures date from his tenure. They include the world's greatest collection of Italian Renaissance sculpture outside Italy, as well as ivories, ceramics and 'many things of little intrinsic value', which Robinson bought for their design and histori-

cal interest but now have a place in the history of art.

Buying without the apparatus of modern scholarship, Robinson relied entirely on a good eye and a good memory. With excellent visual judgement himself, he believed that taste was something that could, and should, be taught; it came readily to 'certain continental people … familiar from childhood with the most refined works of art', but not to the British, who needed a museum to provide that training.

Robinson's main interest lay in the medieval and Renaissance periods. This was a new field of collecting in the nineteenth century, and an exceptionally fertile one. Revolutions throughout Europe had led to the impoverishment of many aristocratic families

and the disestablishment of most religious institutions, with the result that art works were flooding onto the market. Robinson made yearly forays to France, Italy and Spain to rummage through dealers' stock and seek out orphaned collections. These 'yielded up an infinity of treasures' but also exposed him to a degree of personal risk – illness, discomfort and attack by brigands – that few curators would experience today.

The *Ascension* relief [37] was part of the Campana collection, which became available when its owner, the Marchese Campana, was imprisoned for embezzlement. It is not clear where the relief originated; it was recorded in the Medici Palace in Florence in 1492, but might have been commissioned for the

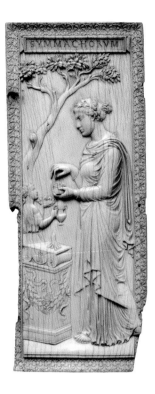

altar of the Brancacci Chapel. The low-relief technique, known as *rilievo schiacciato* (literally 'squashed relief'), was Donatello's own invention. Within a thickness of only 10–20mm he was able to create a sense of depth and spatial continuity that normally was possible only in painting.

Robinson found that in Italy (unlike Spain), 'all classes are willing to barter their artistic possessions'. The Martelli family parted with this exquisite mirror [39], probably once an expensive and intimate wedding gift. Its relief shows an aged satyr entertaining a bacchante who expresses milk from her breast into a ceremonial drinking horn. Presiding over the scene is a small herm in the form of Priapus, the Ancient Greek fertility god. Originally thought to be by Donatello, the mirror is more likely to be the work of the Mantuan goldsmith Caradosso.

The Symmachi Panel [38] is a rare and precious survival from the world of Late Antiquity, the moment when paganism died and Christianity became the established religion. It shows a priestess standing before an altar,

her hair bound with ivy, the plant of Bacchus. Above is the word 'Symmachorum'. This links it to the Symmachi, a wealthy patrician family who remained faithful to the ancient rites. The other half of the diptych, now in Paris, bears the name of the Nicomachi family.

Many ivory panels with pagan subject matter were destroyed or reworked, but these two were incorporated into an early medieval reliquary in the French abbey of Montier-en-Der. The reliquary was broken up after the French Revolution and this panel found its way into a private collection in Montier.

Robinson, for all his brilliance, made difficulties for the museum. The press carped at his purchases, saying that enamels and bronzes were a 'reckless and useless expenditure' in a museum that was intended for the working student; Cole saw him as a rival and thought that he was trying to divert the museum from its original purpose. In 1863 Cole demoted Robinson from curator to art referee and two years later he abolished the new post, effectively sacking him.

37 THE ASCENSION WITH CHRIST GIVING THE KEYS TO ST PETER by Donatello, about 1428–30. With its sturdy realism, psychological intensity and supremely delicate execution, this is one of Donatello's most important works.
V&A: 7629-1861

38 THE SYMMACHI PANEL Rome, about AD 400. This and a companion panel made up a diptych, perhaps to celebrate a marriage or to show devotion to Dionysus.
V&A: 212-1865

39 THE MARTELLI MIRROR possibly by Caradosso, about 1495–1500. Inscribed 'Nature encourages what necessity demands', the mirror was probably a wedding gift.
V&A: 8717:1, 2-1863

# William Morris

William Morris – poet, socialist and designer – was a towering influence on art and design, both in Britain and abroad, even as far away as Japan. He also had a long association with the museum, advising on its purchases of Iznik pottery, Persian carpets and medieval tapestries, and using its collections as a source of inspiration for his own work; having persuaded the museum to pay £1,250 for the Troy tapestry, he wrote in his diary on 26 January 1887, 'it was bought for me since scarcely anyone will care a damn for it'.

In 1861, the year of the sketch [40], he set up an interior design firm with Edward Burne-Jones and other close friends. It was called Morris, Marshall, Faulkner & Co. At one level, the firm was a response to Morris's despair at finding good-quality furnishings for his own house, but it was also a call to arms. Declaring the minor arts in Britain to be in a state of 'complete degradation', Morris said that 'with the conceited courage of a young man I set myself to reforming all that'.

The firm's first public commission was the Green Dining Room at the South Kensington Museum (see page 12). This wallpaper pattern [42], designed around 1862 and first produced in 1866, is very close to the wall treatment of the dining room. It shows Morris's interest in garden plants, his mastery of design and his belief that a gentle, flowing pattern could soothe and civilize. But as a poet he also invested the design with more personal meaning: the apples were the fruit of temptation and the pomegranates a symbol of passion and loss.

With Morris's famous exhortation, 'have nothing in your houses that you do not know to be useful, or believe to be beautiful', the firm flourished, its textiles, embroideries and wallpapers becoming a byword for unostentatious good taste. Eventually, however, the relationship between the various partners began to break down, and in 1875 Morris decided to reform the company under his sole control and under a new name, Morris & Co.

Six years later he relocated the workshops from central London to Merton Abbey, a former silk-weaving factory on a tributary of the Thames. These more spacious premises enabled him to bring all his production under one roof: the dye works, the print works, the stained glass studio and the weaving shed, all employing traditional materials and methods in Morris's determination to revive the craft practices of the Middle Ages.

Morris believed passionately in the value of craft as the crux of the relationship between

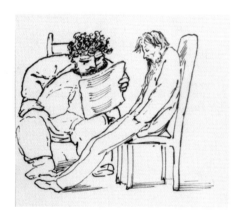

40 WILLIAM MORRIS READING POETRY TO BURNE-JONES **by Edward Burne-Jones, 1861. At the age of 27, Morris was already the pot-bellied dynamo who exhausted contemporaries with his boundless energy.**

V&A: E.450-1976

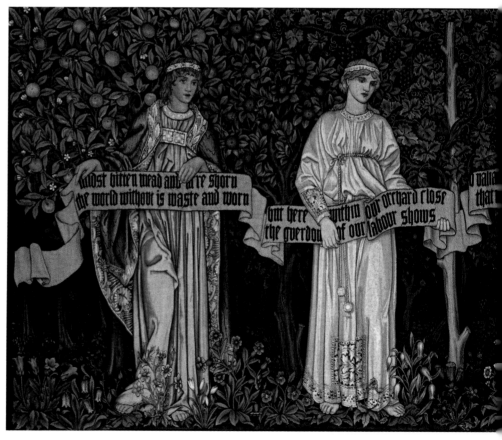

maker and user: the maker would gain pleasure from the act of making, the user from daily contact with beautiful handmade objects. He himself could make virtually anything, but his 'bright dream' was tapestry weaving; he loved it as an art that was both tactile and narrative, for its 'crispness and abundance of beautiful detail'. Beginning with verdure and foliage designs, he taught himself how to weave in the true medieval fashion, and by the time he moved to Merton Abbey he was ready for full-scale commercial production.

*The Orchard* or *The Seasons* [41] was Morris's first attempt at a figurative design. As with many of his tapestries and carpets, it was a collaborative effort, with Burne-Jones drawing the figures and Henry John Dearle the foliage; Morris wrote the poem, displayed in a scroll like those found in medieval German tapestries. Every aspect of the tapestry, from the trees laden with fruit, to the maidens holding the scroll, to the flowers at their feet,

celebrates the bounty of the orchard and the rhythm of the seasons.

The tapestry is unusual in that it came to the museum only two years after Morris's death. At that stage there was virtually none of his work in the collection – an extraordinary omission, considering the importance of Morris and the Arts and Crafts movement, but one that has since been rectified, for the V&A now has the largest collection of William Morris material in the world.

41 THE ORCHARD OR THE SEASONS by William Morris, about 1890. Morris taught himself to weave tapestries, describing the art as his 'bright dream'.
V&A: 154-1898

42 DESIGN FOR A WALLPAPER named 'Fruit' or 'Pomegranate', by William Morris, about 1862. The pattern is very similar to that on the walls of the Green Dining Room in the V&A, designed in 1866–8.
V&A: E.299-2009. Purchased with the assistance of The Art Fund

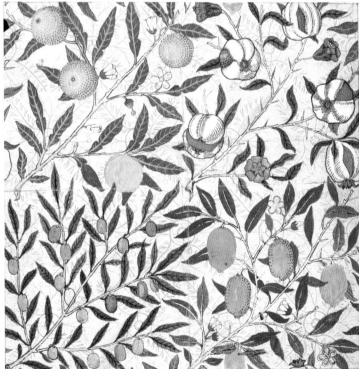

# Islamic Pattern and Design Reform

This book, fully entitled *Plans, Elevations, Sections and Details from The Alhambra* [43], was a landmark publication, for its use of the new technique of chromolithography and for its meticulous depiction of Islamic decoration. It was the first published work of the architect, critic and designer Owen Jones, who would have a profound effect on nineteenth-century design, both through his study of historic pattern and through his work with the Department of Science and Art.

The Alhambra as we see it today was built in the mid-fourteenth century by the Nasrid rulers of Granada. Jones's interest in it was triggered by his 'grand tour' of the Mediterranean and Levant, which revealed the splendours of Islamic architecture, and also by the books of Richard Ford and Washington Irving, which presented a romantic, exotic image of Moorish Spain. Jones's own view, however, was more practical: he believed that the flat geometrical patterning of Islamic

art, allied to new materials such as cast iron, could provide a new direction for European architecture and design.

The publication of *The Alhambra* was long, arduous and expensive. The initial drawings were made in Granada over a six-month period in 1834, but were interrupted when Jones's French colleague Jules Goury died of cholera. Publication began in 1842 but was never completed. Nevertheless, it established Jones as a major force in the design reform movement and eventually won him a commission to decorate the interior of the Crystal Palace for the 1851 Great Exhibition (see page 35).

The following year Jones was invited to lecture at the newly formed Department of Science and Art, the organization headed by Henry Cole that combined practical

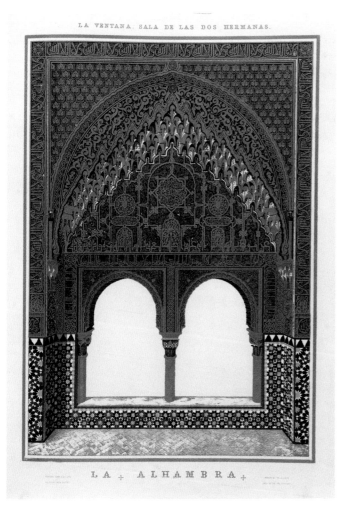

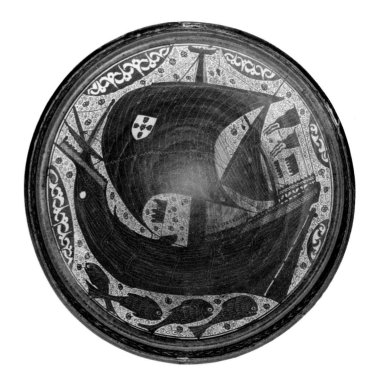

art education with a small museum. The philosophy that Jones proposed in these lectures was eventually codified into 37 axioms of sound design. These were then set out in greater detail in his next major publication, *The Grammar of Ornament*, which appeared in 1856. One of the aims of *The Grammar* was to reach out to students of art and design across the country, in particular to those who did not have an opportunity to visit the South Kensington Museum (as the V&A was then called).

The museum, meanwhile, was collecting Islamic art as practical examples for students. There was always a danger in this age of historicism that designers would copy the forms of the past, but Owen Jones insisted that they simply study them so as to understand the fundamental principles of their design. The English potter William De Morgan understood what was meant by this. In his own practice he reused the ship motifs found in bowls from Islamic Spain [44] and studied the lustre effects seen in early Iranian wares.

The interest in Islamic art continued through to the end of the century. The museum commissioned Sir Robert Murdoch Smith, director of the Indo-European Telegraph in Iran, to buy widely, and later it invested a good deal of money in the purchase of the famous Ardabil Carpet (see pages 28–9). It bought this kaftan [45] in 1880 as part of a group that may well have come from the graves of the 19 younger sons of Sultan Murad III. (The boys were executed in 1595 to ensure the succession of their half-brother Mehmet III, a gory practice that was fortunately never repeated.) Its design of paired wavy lines is based on a tiger-skin coat traditionally worn by the Iranian hero Rustam, whose exploits were popular at the sixteenth-century Ottoman court.

By the time the kaftan entered the museum, Owen Jones's design principles had fallen out of fashion and instead the Arts and Crafts movement had become a powerful force in design. This tiger-stripe pattern, however, has been a continual inspiration to textile designers and can still be seen furnishing fabrics today.

43 PLATE FROM THE ALHAMBRA **by Owen Jones, 1845. Jones believed that the study of Islamic pattern would improve contemporary design.**

NAL: 110.P.36

---

44 BOWL **Malaga, 1425–50. Many designers used the museum's collection as inspiration for their own work. This ship motif reappeared in a dish by the English potter William De Morgan.**

V&A: 486–1864

---

45 KAFTAN **Bursa, Turkey, about 1590. The tiger stripes, also seen in Islamic carpets and tilework, have often been copied by European designers.**

V&A: 753–1884

---

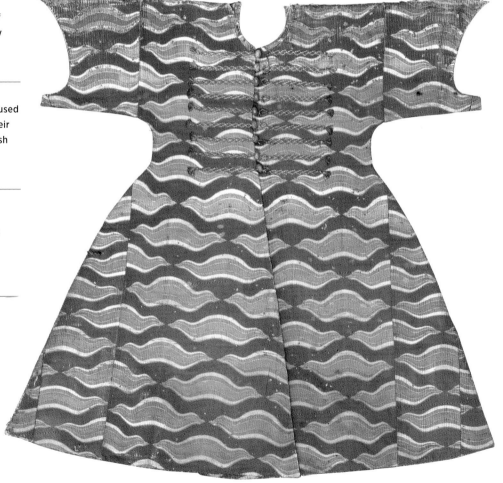

# Marie Antoinette and the Military Tailor

An extraordinary bequest arrived in the museum in 1882. It consisted of 1,034 objects from the estate of John Jones, a military tailor who ended his days at 95 Piccadilly surrounded by choice examples of eighteenth-century French painting and decorative art. Very little is known about Jones, except that he set up his business near the gentlemen's clubs of Pall Mall and made a fortune from the Crimean War. He was unmarried, had no relatives, and never owned a carriage.

Jones began to collect in 1850 and, like many others at this period, he was obsessed with the *ancien régime*, particularly the ill-fated queen Marie Antoinette. This snuffbox [46] shows the queen with her children: the Dauphin, who died in 1789, on the left; Louis-Charles, who died in prison in 1795, in the centre; Marie Thérèse Charlotte, who survived, on the right. The queen's husband, Louis XVI, is portrayed as a profile bust. Jones clearly bought the snuffbox for its link with Marie Antoinette, but he might have been misled as to its authenticity: the miniature may indeed be eighteenth-century, or it may date from after 1814, when Napoleon was defeated and the Bourbon monarchy restored.

The Sèvres vase [47] has similar associations. Made in the royal porcelain manufactory, it was commissioned by Louis XVI as a gift to Tipu Sultan, ruler of Mysore and an important ally of France against the English in southern India. (Tipu is, of course, immortalized in the V&A by the mechanical tiger on page 50.) With decoration after a painting by Boucher and the enamelled *bleu de roi* ground, this vase was an outstanding example of the finest porcelain in Europe. It cost Jones the astonishing sum of £1,078 10s.

At the time when Jones was collecting, the museum had neither the will nor the means to acquire French art of this kind. Design reformers derided it as 'frivolous and false…, the true indications of the likings of a society in which all was show and glitter, luxury and selfishness'. The aristocracy, however, did not share their qualms. As well as the Rothschilds, who were buying widely at this time, there were other collectors such as Lord

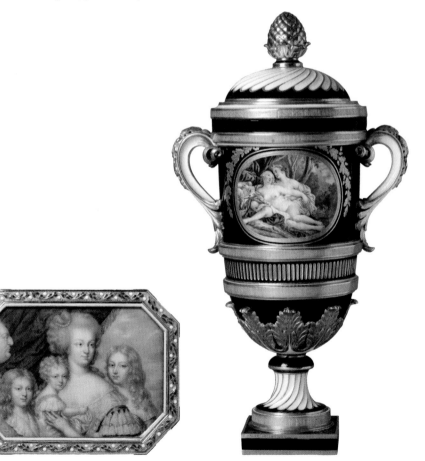

**46 SNUFFBOX** by Pierre-François Drais, 1776–89 and possibly later. Jones was obsessed with the French monarchy: this box is decorated on the lid with portraits of Queen Marie Antoinette and three of her children.
V&A: 905–1882. John Jones Bequest

**47 PORCELAIN VASE AND COVER** Sèvres, about 1770. Commissioned by Louis XVI, the vase shows Jupiter in the guise of Diana seducing the nymph Callisto.
V&A: 747&A–1882. John Jones Bequest

**48 COMMODE** by Bernard II Vanrisamburgh, 1737–45. This once belonged to John Jones, a military tailor and one of the V&A's greatest benefactors.
V&A: 1094–1882. John Jones Bequest

Hertford, founder of the Wallace Collection, with deep pockets and long shopping lists. The price of eighteenth-century French art soared, leaving the museum unable to enter the market.

Mindful of this, Philip Cunliffe Owen, who succeeded Henry Cole as director in 1873, took to visiting John Jones to 'advise him how best to dispose of his collection'. His initiative was rewarded in 1879 when Jones made his will. When the collection reached the museum there was a chorus of disapproval from design purists, but since then it has become one of the glories of the V&A.

There remains a mystery about Jones. We do not know why or how he collected, yet he seems to have had a sure eye. Like the snuffbox, some of the furniture may be wholly or partly nineteenth-century, but that still leaves the V&A with many outstanding pieces. The commode [48], for example, represents the most luxurious French furniture of the period. Signed 'BVRB', it was made by Bernard II Vanrisamburgh, a cabinet-maker of German descent who worked in Paris and supplied work to the court.

Vanrisamburgh specialized in the use and reuse of earlier Japanese lacquer, a practice that was perfectly acceptable in an age that valued novelty and craftsmanship above authenticity. He obtained the lacquer in the form of panels taken from imported cabinets or screens, and then re-veneered it to pieces of furniture made to his own design – not easy when the surface swelled and curved as it does in this *bombé* commode. To frame and enhance the costly lacquer panels he used the finest gilt-bronze mounts. Those on the V&A's commode are identical to mounts on a commode supplied in 1737 to the French queen, Marie Lezcynska.

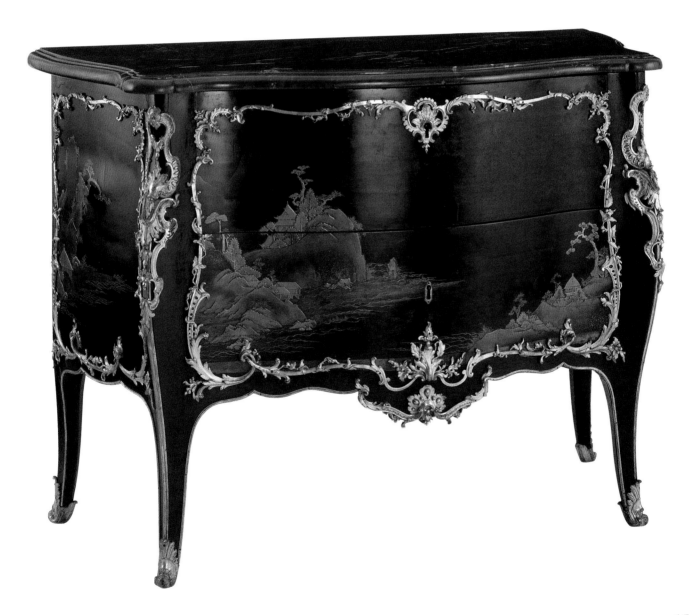

# The Salting Bequest

In 1893 there was an important sale in Paris, that of the collector and dealer Baron Frédéric Spitzer. To the irritation of the dealers present, there was one individual who bid without an agent, spent £40,000 and walked off with the *Shouting Horseman*, probably the most coveted Renaissance bronze in existence (see page 115). This was George Salting, who dedicated his life to collecting and was now sending his purchases directly to the V&A as loans.

Salting was an odd character, a 'pale, lean, tall, eccentric person' even as a schoolboy. The son of an Australian sheep magnate, he found himself at the age of 30 with an income of £30,000 a year and a vague interest in art. With no desire to marry and no philanthropic interests, he decided to become a collector. Although miserly in his domestic arrangements, he was a deadly opponent in the saleroom. Unlike the V&A's other great benefactor, John Jones, he sought advice from the experts and had a close relationship with the museum world. He visited the V&A two or three afternoons a week and when his collection began to burst out of his two-room flat, he installed it in the museum. At his death in 1909, his will – a succinct 400 words – announced his wish to give 'unto the Nation my Art Collections'.

The National Gallery had the pick of the paintings, and the British Museum the prints and drawings, but the rest came to the V&A: one whole case of Palissy ware, three of Limoges enamels, ten of Italian maiolica, ten of Italian bronzes and 29 of oriental ceramics. There were over three thousand works in total, all displaying Salting's eye for quality, finish and detail.

His first love was Chinese ceramics, not the more robust stonewares later admired by Bernard Leach and the British studio potters, but the refined products of the imperial workshops. This celadon vase [49] is a superb piece, made for the highest echelons of the home market, perhaps even for the court. It is decorated with an auspicious theme: four landscapes representing the four seasons, each with a short poem.

In 1891, however, there came a turning point in Salting's collecting when he traded a Chinese *famille noire* vase for a Renaissance bronze. From now on his focus lay in medieval and Renaissance art. This ivory diptych [50], bought in the Spitzer sale, is a rare example of a Gothic ivory of English origin. Its provenance is unknown, other than the fact that it once belonged to Francis Douce, a curator at the British Museum, but the size of the figures and their deep relief suggest that it was made

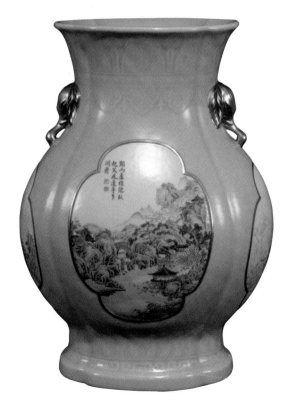

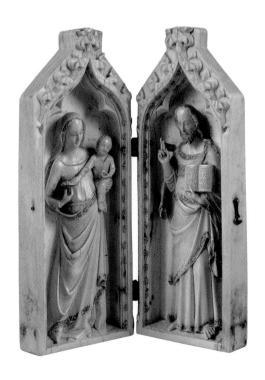

in the court workshop at Westminster. The gilding and the thickness of the ivory indicate a prestigious commission, perhaps for a patron close to the king. Made for personal devotion, it would have folded into a compact, solid object that could be put in a protective case to travel with its owner. The book that Christ holds is inscribed, 'I am the Lord thy God, who made, redeemed and will save you'.

Another of Salting's interests was Islamic art. This carpet [51], woven in silk and wool and metal thread, has inscriptions in Persian in the border. Taken from the great fourteenth-century poet Hafiz, they link the main field, filled with flowers and birds, with a royal garden:

> *Every bird brings a melody to the garden of the King: the nightingale with songs of love, Hafiz with prayers of blessing*

The carpet has given its name to the 'Salting Carpets', a large group that has been the subject of vigorous debate. Salting bought his carpet from a dealer in Istanbul, on the assumption that it was Iranian and sixteenth-century. Later experts disputed this, saying that it was Turkish and nineteenth-century. Recent technical analysis and examination of the inscriptions show that the whole group is indeed Iranian, and may have been given to the Ottoman sultan. Many of the carpets include Shi'ite religious texts which made them unusable in Sunni Turkey, hence their good state of preservation.

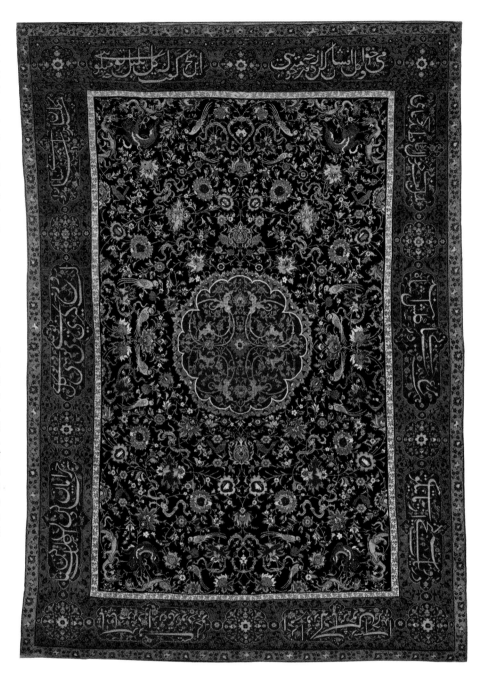

49 PORCELAIN VASE Jingdezhen, 1736–95. Many of the finest ceramics in the V&A were given by George Salting, son of an Australian sheep magnate.
V&A: C.1466–1910. Salting Bequest

50 THE SALTING DIPTYCH probably Westminster, about 1310–20. Salting bought this rare English ivory at the famous Spitzer sale of 1893.
V&A: A.545–1910. Salting Bequest

51 THE SALTING CARPET probably Iran, 1550–1700. The good condition of this carpet has led to disputes about its age and origin.
V&A: T.402–1910. Salting Bequest

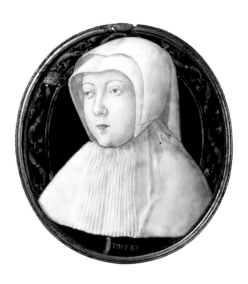

52 A LADY OF THE FRENCH COURT by Léonard
Limosin, about 1530–40. Horace Walpole,
a previous owner, believed the sitter to be
Margaret of Austria, Governor of the Southern
Netherlands.

V&A: 7912–1862

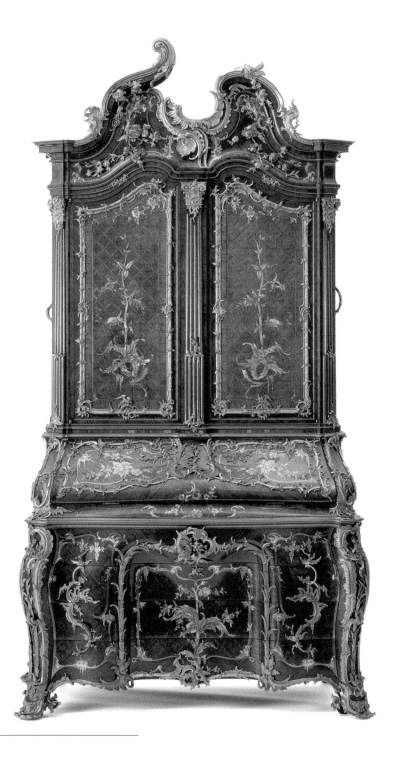

# Pedigree and Provenance

Horace Walpole, collector, connoisseur and creator of Strawberry Hill, was fascinated by the stories that objects tell and their connections with great patrons or collectors of the past. He believed that a 'well attested descent is the genealogy of objects of virtu, not so noble as those of the peerage, but on par with those of race horses'. This interest in pedigree was partly an exercise in name-dropping, but more seriously it was a cornerstone of connoisseurship. A secure, well-documented provenance ensured authenticity and placed Walpole among the pantheon of great collectors. His taste was their taste, and it was excellent.

Although Walpole was truly a great collector, the pedigrees that he attached to objects were sometimes optimistic or even fanciful.

53 CABINET possibly by Michael Kimmel, 1750–55. The cabinet was made for Frederick Augustus, Elector of Saxony and King of Poland. It later belonged to the Rothschilds.

V&A: W.63–1977. Purchased by HM Government from the estate of the 6th Earl of Rosebery and allocated to the Victoria and Albert Museum

54 TABERNACLE OR RELIQUARY Cologne, about 1180. A note written in 1855 says this was once in a Benedictine monastery in Cologne.

V&A: 7650–1861

In his published catalogue, he described this portrait medallion [52] as being 'Margaret of Austria, daughter of Charles V … a present … to Mr. Walpole from Miss Rachael Loyd [*sic*], and belonged to the Princess Sophia, mother of King George I'.

Miss Lloyd was housekeeper at Kensington Palace in 1764 and part of Horace Walpole's social circle, so the connection with Princess Sophia is very likely. The Margaret of Austria claim is more problematic. Daughter of the Hapsburg emperor Maximilian I (not Charles V), Margaret was Governor of the Southern Netherlands and a distinguished patron – so a good catch in Walpole's eyes. On the other hand, authenticated portraits show her to have the pronounced Hapsburg jaw, not evident here.

What is certain, however, is that the sitter is a noblewoman and dressed in mourning. The artist, Léonard Limosin, worked for four successive French kings, starting at the court of Francis I in Fontainebleau. The technique, too, marks this portrait as destined for the court. Painted enamel was a painstakingly slow and difficult medium, and consequently very expensive.

The cabinet [53] has the kind of provenance that would have impressed Walpole. An exuberant example of Rococo design, it bears the cipher of Frederick Augustus, who became Elector of Saxony in 1733 and King of Poland the following year. Frederick was an enthusiastic collector and patron. He supported the Meissen porcelain factory, founded by his father Augustus the Strong, and closely followed the taste of the French court.

This taste – rich, elegant, sometimes frothy – was one that the Rothschilds also admired in the following century. Baron Mayer de Rothschild bought the cabinet in 1835, when he was only 17 years old, for £1,000. It ended up in Mentmore Towers, the Rothschild mansion in Buckinghamshire, which was sold in the 1970s. The Mentmore collection, one of the finest dispersed in recent times, was put up for auction and raised £6 million.

Part of the character of the Rothschild collections was their provenance. Many of the objects had once belonged to royal, noble or famous figures from the past, and the Rothschilds – as canny as they were wealthy – paid great attention to this provenance. Baron Ferdinand wrote of his collections, 'Their pedigrees are of an unimpeachable authenticity. I have only acquired works of art the genuineness of which has been well established'.

Sometimes this authenticity is hard to pin down. The tabernacle or reliquary [54] belonged to Prince Soltykoff, one of the greatest nineteenth-century collectors, and was said to have come from a Benedictine nunnery in Eltenberg. Despite this, its history was shrouded in mystery and its physical state raised many questions. However, when German and British experts investigated the object in preparation for its installation in the new Medieval & Renaissance galleries, they came to the happy conclusion that it was largely original. A hidden fragment of parchment, written in 1855, indicated that it had come from a Benedictine monastery in Cologne, and dendrochronology confirmed the date of the wooden core to be 1148–58. This makes it one of the earliest liturgical objects in the form of a cross-shaped domed church and a masterpiece of early medieval goldsmithing.

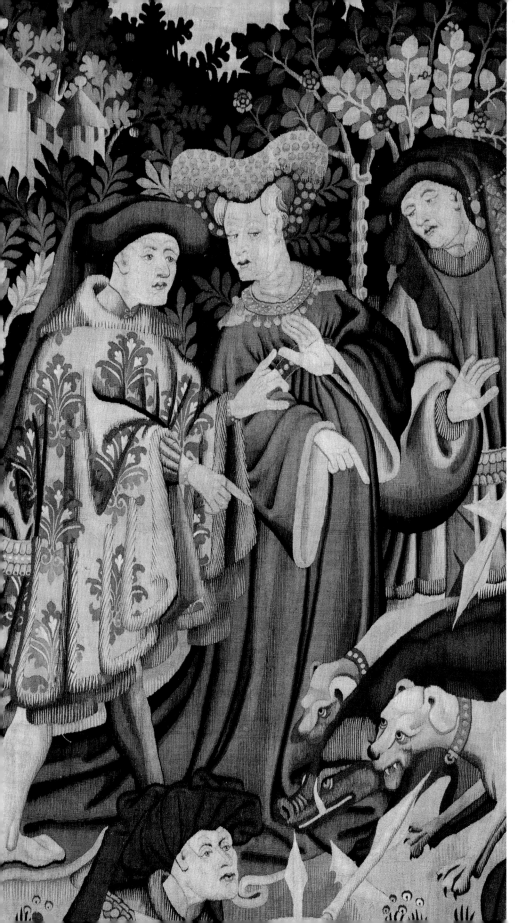

# Saved!

One of the V&A's roles, never envisaged by its creators, is to save for the nation objects that might otherwise be sold abroad. Given the museum's limited acquisition budget, this requires help from many sources, most notably The Art Fund, Friends of the V&A and the National Heritage Memorial fund who have contributed to many important V&A acquisitions.

The problem became particularly acute after the Second World War, when death duties threatened the integrity of the great estates and collections. No estate in Britain is greater than that of the Dukes of Devonshire, owners of two palatial country houses – Chatsworth and Hardwick – and of the most important art collections still in private hands. But when the 10th Duke died in 1950, the family faced an 80 per cent tax bill. In lieu of tax Hardwick Hall was transferred to the National Trust, and the famous Devonshire Hunting Tapestries [55] came to the V&A.

The tapestries are battle-scarred veterans from the late Middle Ages. Now restored and venerated, they were once in a poor state. In the late nineteenth century they hung as curtains over the huge windows in the Long Gallery at Hardwick, patched and cobbled together, often many layers deep, to keep out the biting cold. Insulation was indeed one of the original functions of tapestries, but in the past they were also the most prestigious of art forms. Taking many months to make, and often incorporating costly materials such as silk and metal thread, tapestries were fantastically expensive but they brought colour and narrative into medieval palaces.

Although the tapestries were recorded in a 1601 inventory as 'forest work', their theme is hunting and court etiquette. Hunting was an obsession in the Middle Ages: a source of meat, a display of courage and martial skill, a mark of nobility. The hunting of bears normally took place in winter, but in the tapestry it is eternal spring: the trees are in leaf and flowers sprinkle the turf. While huntsmen pursue and kill, the courtiers flirt and dally. They wear the latest fashions of the Burgundian court – exotic

furs, silks and velvets, made into exaggerated gowns, tunics and headdresses quite unsuited to any physical activity.

Another major purchase on behalf of the nation was the bronze roundel by Donatello [56]. It is an object that embodies two extraordinary stories, the first of its early life in Renaissance Florence, the second of its adventures in England. A document found in 1962 states: 'I record that on 27th of August, 1456, while I was treating Donato called Donatello … in consideration of the medical treatment which I had given and was giving for his illness gave me a roundel the size of a trencher in which was sculpted the Virgin Mary with the Child at her neck and two angels on each side.'

The author of these words was Giovanni Chellini, an eminent Florentine doctor. In his testimony he also mentions that the reverse of the roundel was hollowed out and could be used to cast glass replicas. These replicas might have been linked to rituals surrounding childbirth. In the Renaissance the Virgin was seen as a paragon of motherhood and a shield against the dangers of childbirth. Once a baby had been safely delivered, the mother would be brought nourishing broths in special dishes, or trenchers, similar to that borne by the angels on the right of the roundel.

The roundel passed down through Chellini's family until about 1750 when it was sold to Lord Malton, a young English aristocrat enjoying the Grand Tour. It remained in the hands of his descendants, but lost its identity until brought to the museum for an opinion in 1966. Aware of the Chellini document, the museum curators quickly identified the roundel but then lost sight of it for ten years. When it eventually came on the market in 1975, the roundel was likely to be exported but the then director, Roy Strong, launched an appeal to raise the £175,000 purchase price. With help from the public, as well as the Pilgrim Trust and the National Art-Collections Fund (now The Art Fund), it was saved and is now displayed alongside a bust of Chellini in the Medieval & Renaissance galleries.

55 THE BOAR AND BEAR HUNT (detail) Southern Netherlands, 1425–30. This and three more enormous hunting tapestries belonged to the Dukes of Devonshire and came to the V&A in lieu of tax.

V&A: T.204-1957. Accepted by HM Government in lieu of tax payable on the estate of the 10th Duke of Devonshire and allocated to the Victoria and Albert Museum

56 THE VIRGIN AND CHILD WITH FOUR ANGELS (THE CHELLINI MADONNA) by Donatello, before 1456. A gift from Donatello to his doctor, the roundel was saved for the nation with the help of many generous donors.

V&A: A.1-1976. Purchased with the aid of public subscription, with donations from The Art Fund and the Pilgrim Trust, in memory of David, Earl of Crawford and Balcarres

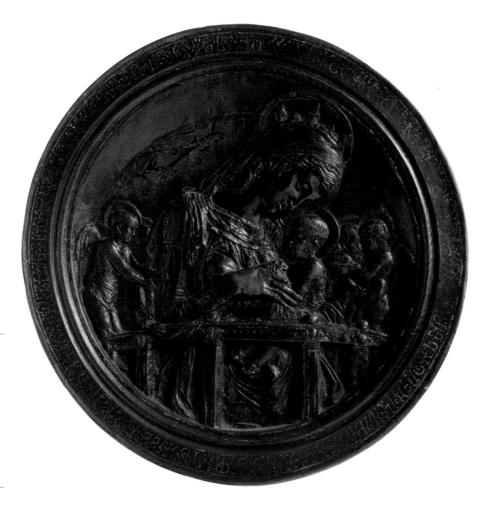

# Family Favourites

Out of the two million objects in the V&A, a couple have a special status, not because they are great works of art but because they have been loved and visited by generations of children. No book on the museum would be complete without them; like a classic fairytale, they appeal to the vivid imagination of a child and to the mature understanding of an adult.

The first is Tipu's Tiger [57], which came from the palace of Tipu Sultan, ruler of Mysore in southern India and perhaps Britain's most formidable enemy in the subcontinent. Tipu was a devout Muslim and saw himself as God's instrument in driving the infidels out of India. As such, he styled himself the 'Tiger of Mysore' and used tiger imagery as a personal emblem on his throne, weapons and uniforms. A silver mount on one of his guns shows a miniature version of the scene in the V&A, with a tiger sinking his teeth into a young Englishman, or 'hat wearer', as Tipu would have called a Christian. The tiger's face bears the Arabic words for 'Lion of God'.

Despite Tipu's determined resistance, the British eventually managed to overwhelm him in their fourth campaign against Mysore, at the battle of Seringapatam on 4 May 1799. Tipu died at the hands of a soldier who tried to wrench off his jewelled sword belt, and that night the British troops looted the town of all its valuables and jewels. The tiger was discovered in a music room a few days later and would probably have been broken up or sold if it had been made of precious materials. Instead, it was shipped to London, where its arrival was heralded by a newspaper report headed 'MUSICAL TYGER'. 'The machinery', it announced, 'is so contrived that while the organ is playing, the hand of the European is often lifted up to express the agony of his helpless and deplorable condition'.

Installed in the museum of the East India Company, the tiger immediately became a star exhibit. Keats described it in a poem as 'a play-thing of the Emperor's choice'. Visitors played it unceasingly, disturbing scholars in the nearby library with the tiger's 'shrieks and growls' and eventually causing the handle to drop off and get lost. The battle of Seringapatam, too, continued to have a hold on the public imagination. It became the subject of a circus extravaganza (the Victorian equivalent of the modern Hollywood block buster) and appeared in popular fiction well into the twentieth century.

In 1858, however, the East India Company lost all its administrative powers and its museum became part of the India Office. Twenty years later the collections were divided between the V&A and other institutions, the tiger coming to the V&A. Although silenced, it remains one the most popular and eccentric objects in the museum.

The Great Bed of Ware [58] has long been famous for its size: as early as 1601, Sir Toby Belch in Shakespeare's *Twelfth Night* described a sheet as 'big enough for the bed of Ware'. Over 3m wide, it regularly slept four couples but probably not 'twenty-six butchers and their wives' as sometimes claimed.

57 TIPU'S TIGER **Mysore, about 1793–4. With its mechanical organ and gruesome sound effects, the tiger has been a favourite with British children ever since its arrival in London in 1858.** V&A: 2545(IS)

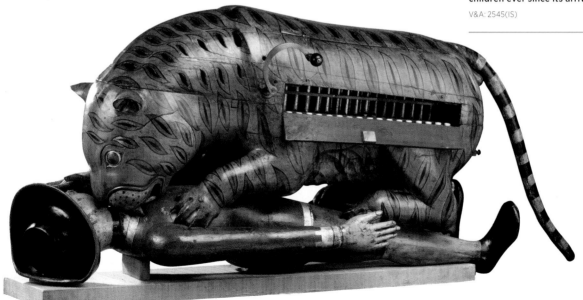

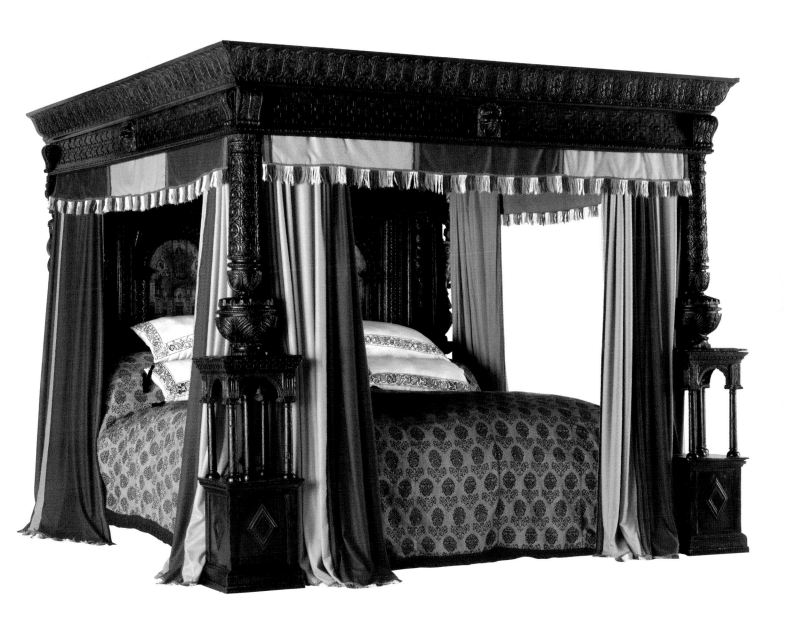

At the time when it was made, a bed of any kind was a modest luxury, for most people would have slept on straw pallets. This outsize version was said to have made for Thomas Fanshawe of Ware Park, Hertfordshire, an official in Queen Elizabeth's exchequer, but it is more likely to have been intended as a curiosity, to attract visitors to an inn. Ware, where the bed has been recorded since 1596, was a day's journey from London and a convenient place to stop for the night.

Apart from its size, the bed is typical of the heavy, ornate furniture of the Elizabethan period. The marquetry panels in the headboard resemble the work of German craftsmen working in Southwark, and the figures on either side of them would have been brightly painted – buildings of the period often have similar wooden figures on their façade. When the bed came to the museum in 1931, via a Bond Street dealer, it was prized as much for its design and craftsmanship as for its history.

58 THE GREAT BED OF WARE England, 1590–1600. Twice the size of a modern double bed, this is mentioned in Shakespeare's *Twelfth Night* and has long been part of local – and museum – folklore.

V&A: W.47–1931. Purchased with the assistance of The Art Fund

# Being British

**59 YOUNG MAN AMONG ROSES** by Nicholas Hilliard, about 1587. This enigmatic image shows a young admirer of Elizabeth I, possibly the Earl of Essex who was executed in 1601.

V&A: P.163–1910. Salting Bequest

Nicholas Hilliard's *Young Man among Roses* [59] has become an iconic image, one that epitomizes a 'golden age' of British history and also the V&A's role as guardian of British art and culture. But this role came late to the museum. In the mid-nineteenth century its founders set out to acquire work from India, the Islamic world and continental Europe as good models for designers to follow; they overlooked British work, thinking it inferior. Towards the end of the Victorian period this policy changed, and thanks partly to the Arts and Crafts movement, there was an increasing interest in English traditions.

Nicholas Hilliard had long been one of England's most celebrated painters, the artist who immortalized the image of Elizabeth I and established miniature painting as a distinctively English medium. The *Young Man among Roses* is probably his most famous work but despite the efforts of many scholars to tease out its subject and meaning it remains an enigma.

The portrait shows a young man, with the soft growth of his first beard, handsomely clad in black and white and holding his hand to his heart. He leans against a tree, entangled in the thorny stems of an eglantine rose. Above is a Latin motto that reads 'Praised faith gives wounds'. Together these visual and verbal images form an *impresa*, a Renaissance device that expressed the ideals and preoccupations of the bearer.

*Imprese* were deliberately enigmatic, to be understood by only an erudite elite. In this image, black and white are the colours of Elizabeth I and the eglantine rose her personal flower; the tree is a sign of steadfastness and the gesture one of undying love. But who is the young man? Some have fancifully claimed that he is the W.H. of Shakespeare's sonnets, but he is more likely to be the queen's favourite, Robert Devereux, the 2nd Earl of Essex. In 1587 Essex was about 21 and newly married; the queen was 30 years older and unaware that he was married – hence his dilemma, and the elliptical inscription.

The handsome chair [61], designed by Robert Adam and made by Thomas Chippendale, represents another high point of national culture. The chair was made for Sir Lawrence Dundas, whose career epitomizes the upward mobility that was possible for someone of talent and ambition in Georgian Britain. The son of a Scottish draper, Dundas made a fortune as an army contractor and obtained a baronetcy in 1762. He bought a palatial country house, Moor Park in Hertfordshire, and a fine town house in Arlington Street, London. To decorate them in the most up-to-date style he employed Robert Adam, who would soon become Britain's leading Neoclassical designer.

Although first thought to be French, the chair was revealed to be English and to the design of Adam in 1922, when the original design drawing was identified. A further discovery in 1967, of a bill for seat furniture for Sir Lawrence Dundas, showed it to be made by Thomas Chippendale, the most famous cabinet-maker of the period. The bill describes the chairs as 'exceedingly Richly Carv'd in the Antick manner' and records that they cost £20 each. This was a very large sum, but Sir Lawrence could well afford it: he was now one of the largest landowners in the United Kingdom and, like many others, the owner of slave estates in the West Indies. This link with slavery was conveniently overlooked in studies of English art and design until the late twentieth century.

In the context of the V&A, the photograph by Maud Sulter [60] provides an apt reflection on the relationship between the wealth and culture of eighteenth-century Britain and the profits from slave ownership and trade. Sulter was of Scottish and Ghanian parentage. She made this photograph as part of a series showing black women posed as Greek muses – in this case performance artist Delta Streete in the role of Terpsichore, the muse of Dance. Streete created the costume as part of a performance that dealt with the relationships between women in a slave/mistress situation.

**60 TERPSICHORE (DELTA STREETE)**
by Maud Sulter, 1989. Sulter made this in response to the 150th anniversary of the invention of photography, in which there was a notable lack of any black presence.

V&A: E.1795-1991. Copyright Estate of Maud Sulter

**61 ARMCHAIR** designed by Robert Adam, made by Thomas Chippendale, 1764–5. Furniture of this date and type is often seen as the highpoint of British design.

V&A: W.1-1937

# Two Queens: Elizabeth and Mary

Objects associated with historical figures, particularly the 'doomed', have always had an allure for collectors and museums. This was especially so in the last decades of the nineteenth century, with its romantic interest in the past and its fascination with British history. The Queen Elizabeth Virginal [62], acquired in 1887, is one of a number of objects that have, or appear to have, personal links to Elizabeth I and her rival, Mary Queen of Scots.

Elizabeth and Mary were united by their cousinship and their role as monarchs, but divided by religion. Mary's claim to the throne of England posed a serious threat to Elizabeth, so when she fled Scotland and sought refuge in England, she was placed under house arrest. During her 15 years of captivity Mary spent many hours in embroidery, often in the company of Bess of Hardwick, wife of her custodian, the 6th Earl of Shrewsbury. This small panel [63] is one of a series worked by Mary, Bess and their ladies, with the intention of making bed and wall hangings. Many of the motifs were taken from books, and they often hold personal or secret messages; but this panel simply shows Mary's dog, Jupiter.

Even in captivity Mary was the focus of Catholic plots, and eventually Elizabeth agreed to her execution. She signed the death warrant – reluctantly – on 1 February 1587, and seven days later Mary was executed at Fotheringhay Castle. Shortly before her death Mary gave a rosary to the Countess of Arundel.

The little triptych [64] is said to have belonged to Mary and may also have been given to one of her supporters at some point. The evidence is circumstantial rather than definite, but it is two-pronged and tantalizingly specific. The first link is a 1617 inventory of the Wittelsbach rulers of Bavaria, which lists the triptych and notes that it had a silver label explaining that it belonged to Mary Queen of Scots; the second is an inscription along the edge of the triptych saying that it was given by Elizabeth Vaux to Claudio Aquaviva, General of the Jesuit Order between 1581 and 1616 – the Vaux family were committed Catholics and featured in secret lists of Mary's supporters.

Whether or not the triptych belonged to Mary, it is an exquisite piece of enamelling. Although only 8.4cm high – small enough to be held in the palm of the hand – it shows a series of English saints on one side and eight scenes from the Life of Christ, plus the Coronation of the Virgin, on the other. The saints were originally on the outside, where they would aid the worshipper in his, or her, prayers. The scenes were then inside, where they would act as a focus of intense contemplation on Christ's death and resurrection.

In contrast to the triptych, the virginal has a secure link to its royal owner. Made in Venice, it bears the royal coat of arms and a raven with a sceptre, the personal emblem of Anne Boleyn, mother of Elizabeth I. A virginal is a spinet, or a small harpsichord, housed in a box instead of being placed on legs or a stand; Elizabeth is reported to have played 'excellently well … when she was solitary, to shun melancholy'.

While the virginal evokes the queen's private moments, the Heneage Jewel [65] shows her in her full glory. Tradition claims that the queen gave it to Sir Thomas Heneage, Privy Councillor and consummate court 'fixer', shortly after the defeat of the Spanish Armada in 1588, but in fact it is likely to have been made some years later. The jewel is a complex object, its symbolism as layered as its construction. On the obverse, or front, under a layer of rock crystal, there is a profile bust of the queen, probably a version of a Garter Badge. On the inside is a miniature by Nicholas Hilliard. On the reverse is the ark of the Church of England on a stormy sea, inscribed 'peaceful through the waves' in reference to her role as head of the Church.

62 THE QUEEN ELIZABETH VIRGINAL
by Giovanni Baffo, about 1594. The case bears
the royal coat of arms and the personal emblem
of Anne Boleyn, mother of Elizabeth I.
V&A: 19-1887

63 PANEL EMBROIDERED BY MARY QUEEN
OF SCOTS 1570–85. While imprisoned by her
cousin Elizabeth, Mary occupied herself with
embroidery.
V&A: T.33P-1955. Presented by The Art Fund

64 DEVOTIONAL TRIPTYCH probably English,
1350–70. This is traditionally said to have
belonged to Mary Queen of Scots.
V&A: Lent anonymously

65 THE HENEAGE JEWEL England, around 1595.
Inside is a miniature by Nicholas Hilliard of a
more youthful Elizabeth. On the back of the lid is
a Latin inscription that translates as 'Alas, that so
much virtue suffused with beauty should not last
for ever inviolate'.
V&A: M.81-1935. Given by the Rt. Hon. Viscount Wakefield CBE,
through The Art Fund

66 DRESS AND BOLERO (detail) made for Princess Diana, by Catherine Walker, 1989. Diana called this her 'Elvis' outfit because the stand-up collar reminded her of Elvis Presley.
V&A: T.1:1, 2-2006. Given by The Franklin Mint

67 'SUPER-ELEVATED GHILLIE' PLATFORM SHOES by Vivienne Westwood, 1993. When wearing these shoes during a catwalk show in Paris, Naomi Campbell famously toppled over.
V&A: T.225:1, 2-1993. Given by Vivienne Westwood

have miraculous powers. Representing the physical presence of the saint, or of Christ himself, they offered protection against disease and ill fortune, or even a route to eternal life. When praying, worshippers could see the relics and kiss the reliquary, but only the privileged and high-ranking could touch the relics themselves.

Celebrity relics have a similar function. They are real; in an age of the virtual and the reproduction, they stand witness to the actual, physical presence of the famous person. By being real, and so close that they can almost be touched, they transfer to the viewer something of the enduring fame attached to that person. In evoking the personal life of the celebrity – the sorrows, triumphs, disasters, inadequacies – they help the viewer to comprehend their own lives.

In recent times, one of the most famous celebrities of all was Princess Diana – fashion icon and tragic heroine. In 1997, just months before she died, she sold 79 items from her wardrobe in a charity auction at Christie's, New York. The 'Elvis' outfit [66] was bought by The Franklin Mint and later donated to the V&A. Its designer was Catherine Walker, a French-born, self-taught couturière who created much of Diana's official wardrobe, and to a large extent defined her sleek, stylish look. Diana commissioned this outfit for an official visit to Hong Kong, hence the profusion of pearls, and first wore it at the 1989 British Fashion Awards, where she was guest of honour.

Another superstar is the model Naomi Campbell. The V&A acquired the 12-inch blue

# Celebrity

Celebrity is not new in the V&A. One of the most successful exhibitions ever held was the display of the Prince and Princess of Wales's wedding presents in 1863. Open for only two weeks, it had 230,000 visitors.

More recently, the *Kylie* exhibition in 2006 was another hit, attracting queues of teenage girls and a total of 270,000 visitors. A star exhibit was the pair of gold hot pants that Kylie wore for the video *I'm Spinning Round*. The actual hot pants, the ones Kylie *wore* – even mounted on a dummy in a museum display, they had the magic of a holy relic.

The museum is full of relics – fragments of the True Cross incorporated into crucifixes, body parts of saints preserved in enamel caskets, fragments of the arrows that killed St Sebastian concealed in a statuette. In the Middle Ages these relics were believed to

68 GOLDTOP LES PAUL DELUXE GUITAR 1960s.
One of the many guitars that Pete Townshend
smashed during his stage career.

V&A: S.12–1978. Given by John Entwistle

mock-croc platforms [67] immediately after the famous incident in which Campbell fell over during Vivienne Westwood's *Anglomania* show in Paris, an episode that made the *Ten O'Clock News*. Westwood, too, is a celebrity. She and Malcolm McLaren first became known for their punk designs and provocative T-shirts; but later Westwood developed a serious interest in historic dress, for which she did much of her research in the V&A. The shoes, inspired by sixteenth-century chopines but for Westwood a sign of female empowerment, would allow her models to pose as if on a pedestal. 'Fashion', she says, 'is like walking a tightrope. You risk falling off into the ridiculous, but if you can stay on that tightrope, you can achieve a triumph.'

Princess Diana might have found Westwood too challenging, but as a rock fan she would have loved the Pete Townshend guitar [68]. The incident in September 1964, when he smashed his guitar in the Railway Hotel, Harrow, was included by the *Rolling Stone* magazine in their list of '50 Moments that Changed the History of Rock & Roll'. This guitar met its end in the late 1960s or early '70s and is now a star exhibit in the V&A's Theatre & Performance Galleries, along with Mick Jagger's jumpsuit and Margot Fonteyn's tutu.

# Court
# Ritual

To our eyes it is obvious that a throne embodies the presence of the monarch but less obvious that a bed should do so. In Versailles, however, where the court ritual was the most elaborate in Europe, the *Chambre du Roi* was more sacred and more potent than any other room in the palace. It was situated at the epicentre of the vast complex, facing the rising sun, with the bed standing on a dais, protected by a balustrade. Princes of the Blood bowed when they entered the room; ladies curtsied.

The king, Louis XIV, never slept in this bed but in a private room next door. Instead, he made the state bedchamber the centre of court life, where the royal person and the royal exercise of power were inextricably linked. Here, he performed the *lever* and *coucher* under the awestruck gaze of senior courtiers and distinguished guests. Here, he issued official orders and received, or admonished, ambassadors. So important was the idea of the royal bed that the king's seat of honour in parliament was called the *lit de justice*.

The V&A's Melville Bed [69] was never used by a king, but it made provision for a royal visit and so underlined the owner's closeness to the monarch. Its owner was George Melville, Secretary of State for Scotland under William III and 1st Earl of Melville from 1690. Six years later, when he became President of the Privy Council, Melville began work on a splendid new house north of Edinburgh to mark his elevated status. The bed stood as the climax of an enfilade or succession of rooms known as the state apartment. This apartment would never have been used by the family: they lived in rooms on the ground floor. The bed is close to designs by Daniel Marot, a Huguenot who had trained in the proximity of the French court and then worked for William III in Holland. It would have been hugely expensive. The hangings are of crimson Genoa velvet, the linings and bedcover of white Chinese silk; the silk passementerie, or trimmings, are the

finest that a London upholsterer could supply. Its headboard is surmounted by three coronets and bears the earl's initials, intertwined with those of his wife, granddaughter of the 1st Earl of Leven.

In India it was the throne that denoted kingship. This golden throne [70] belonged to Ranjit Singh, ruler of the Punjab. Though a Sikh, he adopted many of the practices of Hindu and Muslim kingship. His throne has the polygonal shape of Mughal court furniture but is decorated at the base with two tiers of lotus petals. The lotus, a symbol of purity and creation, was traditionally the throne of the Hindu gods. Made in the palace *toshkana*, which housed the royal treasury and turned out the richly embellished weapons and gifts needed at court, the throne is covered in thick gold sheet, not the leaf used in European furniture.

A contemporary painting shows Ranjit Singh holding court. A small man, blind in one eye, he sits cross-legged on the throne while his relatives and courtiers sit on Western-style chairs. Ranjit Singh wears strings of pearls, bracelets with enormous emeralds and a jewelled ornament in his turban. By inclination he was a man of austere tastes, but in India it was customary for a king to appear festooned with jewellery.

During his fifty-year rule Ranjit Singh welded the many clans of the Punjab into a single state, one that was powerful enough to resist the advance of the British. But when he died in 1839, his kingdom rapidly disintegrated and in 1849 the British were finally able to annex the Punjab. They took over the Crown Property of the Sikh court (including the famous Koh-i nur diamond) and gave the throne to the East India Company Museum. Later, when the museum was disbanded, the throne came to the V&A, where it has since become one of its most famous exhibits.

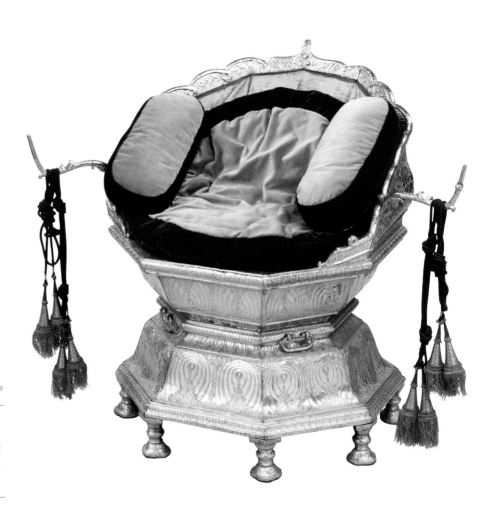

69 THE MELVILLE BED possibly designed by Daniel Marot and probably made by Francis Lapiere, about 1700. In the ritual of the French court, the most important royal events look place in the king's bedchamber. In a grand house such as Melville, the presence of a state bed was a status symbol, suggesting that the owner was important enough to receive a visit from the king.
V&A: W.35.1 to 61–1949. Given by the Rt Hon. the Earl of Melville

70 MAHARAJA RANJIT SINGH'S THRONE by Hafiz Muhammad Multani, 1820–30. In India it was the throne that was the focus of court ritual.
V&A: 2518(IS)

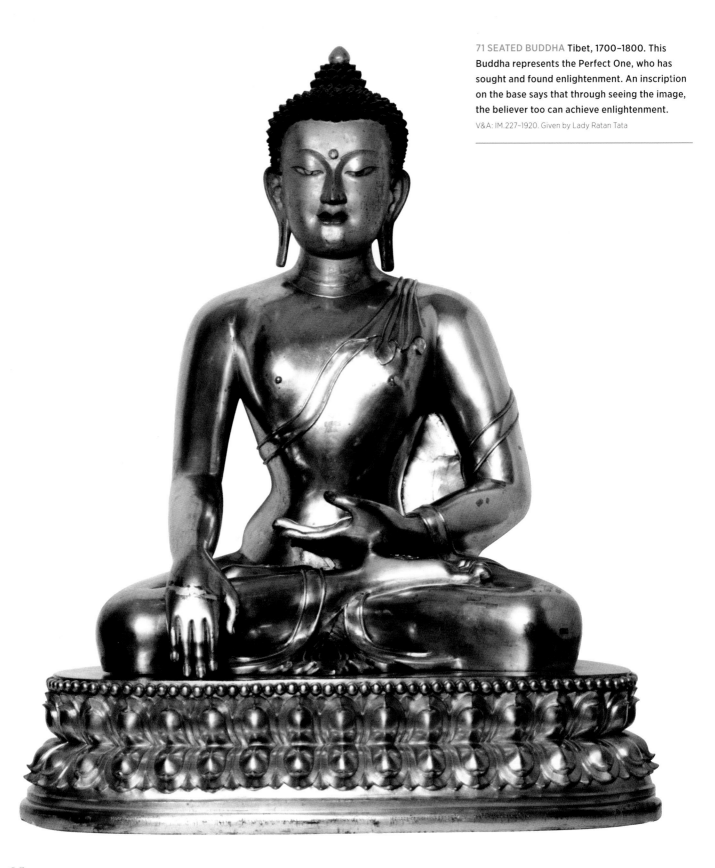

71 SEATED BUDDHA **Tibet, 1700–1800. This Buddha represents the Perfect One, who has sought and found enlightenment. An inscription on the base says that through seeing the image, the believer too can achieve enlightenment.**

V&A: IM.227–1920. Given by Lady Ratan Tata

# Faith Incarnate

A fundamental challenge in all religions is how to give concrete form to abstract concepts; the challenge in museums, in a largely secular age, is for non-believers to fully see and comprehend religious imagery, not simply in a 'socio-cultural' context but for what it should be – transcendent and deeply meaningful. Many objects now in museums were once potent images, with miraculous or redemptive powers, but now they are seen purely as works of art.

In the early years of Christianity, the image of Christ was conveyed through signs and words, not through any human representation. The Jewish tradition forbade the worship of 'graven images', saying that the godhead was so far beyond human understanding that it could only be represented by analogy. However, the Nicene Creed of AD 325, which formed the cornerstone of orthodox Catholic belief, insisted that Christ was 'made of flesh, and became man'. This made it possible to show his dual nature – human and divine.

The first representations of the Crucifixion, dating from the fifth century, show Christ triumphant over death, with his eyes wide open and his body unsullied. In the Middle Ages, however, there was greater emphasis on the suffering of Christ. It was the humanity of Christ the fact that God chose to be born, to suffer and to die in order to redeem the sins of mankind – that so impressed believers. One fourteenth-century monk wrote:

> I know not for sure … how it is that you are sweeter in the heart of one who loves you in the form of flesh than as the word … It is sweeter to view you as dying … than as holding sway over the angels in Heaven, to see you as a man bearing every aspect of human nature to the end, than as God manifesting divine nature.

The crucifix by Giovanni Pisano [72] would have been made for private devotion. Its closed eyes and drooping head indicate that Christ is truly dead, victim not victor;

this is the body of Christ, sacrificed for the redemption of mankind and consumed during the Eucharist for the salvation of believers. The contemplation of such an image would bring the believer closer to God by evoking powerful and conflicting emotions: compassion for Christ's suffering, guilt that he died to expiate human sin, gratitude for his ultimate sacrifice.

In early Buddhism there was also a debate about the nature of images. Some insisted that the Buddha could not be represented in human form because his spirit was now released from the cycle of incarnation. Like Jesus in early Christian art, he was represented by signs and images – footprints, an empty throne, a wheel – but not in bodily form. By the first century AD, however, some five hundred years after the Buddha's death, it was acceptable to portray him as the historical Buddha. Then, some two hundred years later, it became possible to show him as a representative of the transcendent state of Buddhahood with its many incarnations past, present and future.

The various schools of Buddhism differ in their beliefs and attitudes. In the Tibetan tradition, a Buddha image is primarily a focus of meditation. It is through meditation and yoga that the believer is able to obliterate desire and find release from suffering. This poised, remote, ethereal figure [71] represents the historical Buddha at the moment in which he attained enlightenment. It bears the distinguishing marks of Buddhahood – the cranial bump, the mark on the forehead, the 'Wheel of the Law' on the palms of the hands and the soles of the feet. The right hand is lowered in the *mudra* (gesture) by which the Buddha called the Earth Goddess to witness his liberation. The left hand is open in the gesture of gift giving, for a Buddha image has the power of conferring spiritual merit. Around the base is an inscription in Tibetan. Through seeing the image, it says, the believer may attain spiritual advancement and eventual enlightenment.

For a Buddha image to function – today as in the past – it has to be complete, undamaged and consecrated; a damaged image is 'as useless as a

leaking pot' and has to be mended or destroyed. In contrast to Christ, whose broken body reflects the sins of humanity, the Buddha image is one of perfection and release.

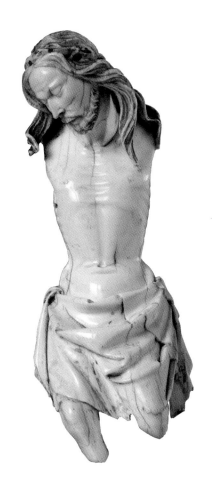

72 THE CRUCIFIED CHRIST by Giovanni Pisano, 1285–1300. An image like this would help Christians to comprehend the humanity of Christ and the nature of his sacrifice. Now fragmentary, it originally had arms and legs and was mounted on a small cross.

V&A: 212:1 to 3-1867

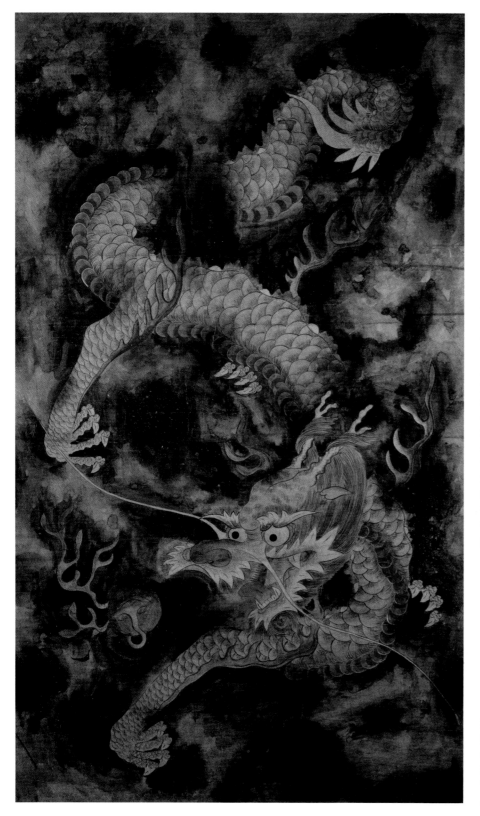

# Magic Powers

Certain objects have their own magic – a power derived from their material, their imagery or their history. This magic may once have glowed brightly, but in a museum it dims and fades unless we, the viewers, remember the enchantments and rekindle the flame. Even if we cannot experience the same feelings of comfort or fear that our ancestors found in these objects, we can at least try to understand them – and remember that we too have our own talismans and prophylactics, that we wear jewellery that connects us to our forebears and spend fortunes on medicine that has no proven value.

In the past, with poor food hygiene and sudden death lurking around every corner, people had a great fear of poison. All kinds of substances were believed to offer protection against its swift or insidious effects. Some were natural but weirdly exotic: coconuts, cowries and bezoars (found in the stomach of a goat), or the horns of unicorn, narwhal [74] and rhinoceros. Some, such as porcelain and ruby glass, were manufactured but with such difficulty as to seem almost miraculous. Others, like serpentine and jade, derived their powers from their colour, hardness or rarity.

**73 SCROLL WITH A DRAGON CHASING A FLAMING PEARL Korea, 1800–1900. In Korea the dragon was a bringer of rain and Guardian of the East.**
V&A: FE.48:1-1995

These magic substances were used for drinking vessels, cutlery and dishes, and also for amulets that could be worn close to the body for 24-hour protection.

In the Korean scroll painting [73] it is the dragon, not the object itself, that has magic powers. There are many protective animals in Korean art – tigers, dragons, birds and tortoises – but the dragon is pre-eminent. It writhes over ceramic jars, mirrors and amulets, houses, shrines and temples. It is a symbol of heaven and royal authority, a repeller of evil spirits and a bringer of rain; in a country that has faced invasion from every quarter, it is also the Guardian of the East. Images painted for rain rituals show the dragon as an inhabitant of the watery depths.

There it hibernates as a turtle, fish or serpent until the moment comes for it to assume its dragon form and take to the sky, accompanied by heavy rain and crashes of thunder.

The Luck of Edenhall [75] was not made with any special power, but acquired it in the course of a long and eventful life. It was made in Syria or Egypt as a luxury drinking glass and probably brought to Europe by an Italian merchant; the colourful enamelling, known in the Middle East but beyond the abilities of European glassworkers, would have made it a rare treasure. In the fourteenth century it was given a leather case emblazoned with the sacred monogram IHS, which suggests that it was then used as a communion cup.

At some point, perhaps very early on, the glass became the property of the Musgrave family of Edenhall. Its true origins were forgotten and instead it acquired its own myth: that fairies were picnicking by a well and when disturbed they fled, leaving the glass behind and shrieking 'If this cup should break or fall/ Farewell the Luck of Edenhall'. Fortunately the Luck survived, in the careful hands of the Musgraves, and in 1926 it came to the V&A for safe keeping. But its message still rings loud and clear. A ballad about the Luck written in 1834 by Johan Ludwig Uhland and translated by Henry Wadsworth Longfellow imagines the terrible consequences of its breaking during a banquet; in doing so, it reminds us of the fragility of our culture and of the need to preserve the material links with our past:

*As the goblet ringing flies apart*
*Suddenly cracks the vaulted hall;*
*And through the rift the wild flames start;*
*The guests in dust are scattered all,*
*With the breaking Luck of Edenhall!*

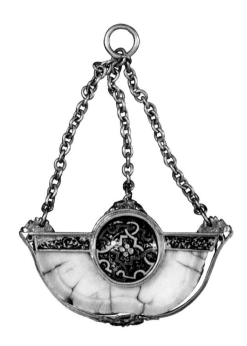

74 THE DANNY JEWEL **England, about 1550. This protective amulet incorporates a piece of narwhal tusk. The long, pointed tusk of the narwhal was often identified as the horn of a unicorn, believed to be one of the most effective detectors of poison.**

V&A: M.97-1917. Bryan Bequest

75 THE LUCK OF EDENHALL **Egypt or Syria, 1200–1300. It was believed that if the Luck broke, the Musgrave family who owned it would be destroyed.**

V&A: C.1 to B–1959. Purchased with the assistance of the Pilgrim Trust, The Art Fund, the Goldsmiths' Company, the Salters' Company, the Drapers' Company and the Merchant Taylors' Company

# Cradle to Grave

On 27 January 1658 John Evelyn recorded in his diary his 'unexpressable griefe & affliction' at the death of his 5-year old son, Dick, 'the prettiest, and dearest Child, that ever parents had'; eighteen days later he wrote bleakly of the death of his baby, George. Of his eight children, only one survived her parents.

It is often said that the high mortality rate hardened parents to the loss of their children. John Evelyn's diary, as well as other harrowing accounts, shows this to be untrue, as does the figure of Lydia Dwight [76] commissioned by her grieving father. She lies on a lace-trimmed pillow, her mouth grimly set in death and her little hands grasping a posy of flowers, symbol of her fleeting life. A companion figure shows her resurrected, with a skull (vanquished death) at her feet.

These two figures, a unique and affecting memorial to a long-dead child, are also significant in the history of English ceramics. They came to the museum in 1871 as part of the 'Dwight heirlooms' belonging to the last descendant of John Dwight, a scientist and innovator who almost discovered the secret of porcelain a good thirty years before Johann Böttger's breakthrough in Dresden. Dwight was a strange, secretive man, a brilliant chemist who rose from humble origins to mix with the leading scientists of his day, and he probably ordered the figures of Lydia from his own modellers as a private memento.

In childbirth and infancy, sorcery was an ever-present anxiety. To protect against the 'evil eye', a child might wear a coral amulet – like those seen in Renaissance paintings – or the mother might be given a spoon with a coral handle. Coral was efficacious on account of its colour: red was widely regarded as protective, and there were frequent claims that drapes or wrappings of scarlet cloth could cure smallpox. This spoon [77], made in Germany, has an image of Diana on the silver-gilt part of the handle. In her incarnation as Lucina she was patroness of childbirth; her presence suggests

76 LYDIA DWIGHT **London, 1674. The figure, only 25.5cm high, is inscribed, 'Lydia Dwight dyed March 3 1673'.**

V&A: 1055–1871

77 SPOON Germany, about 1550–75. Children wore coral amulets or had coral spoons as protection against sorcery and illness.
V&A: 2268-1855

78 TRENCHER AND BOWL by Nicola da Urbino, 1533–8. In Renaissance Italy a mother would be given broth in a special bowl after a successful delivery.
V&A: C.2258&A-1910. Salting Bequest

79 THE TORRE ABBEY JEWEL England, 1540–50. An inscription affirms the Christian belief in resurrection.
V&A: 3581-1856

that the spoon was a gift to a pregnant woman, not part of the sets recorded in inventories.

Child mortality was endemic in all societies until the early twentieth century. With the general apprehension surrounding childbirth and infancy, elaborate rituals were developed to safeguard mother and child, and to celebrate a successful birth. In Renaissance Italy, for example, a new mother would be given a nourishing broth in a special bowl (even today, Italians are great believers in the restorative value of broth). Here the accompanying trencher [78] shows a childbirth scene, with a curtained bed in the background and an old man bearing a horoscope, while in the bottom of the bowl are the new baby with two nurses, one warming a napkin at the hearth. This vignette would only reveal itself as the mother drank the broth.

But eventually death would strike, and with it came judgement and perhaps damnation. Mindful of this, people would wear a *memento mori* – so-called from the Latin phrase 'Remember you must die' – to remind them to lead a virtuous life. This pendant [79], with its typically unflinching portrayal of bodily corruption, is inscribed 'THRONGH [*sic*].THE.RESVRRECTION.OF CHRISTE. WE.BE.ALL.SANCTIFIED'. It was this faith, that through Christ's sacrifice on the cross and his rising from the dead we would find redemption for our sins and attain eternal life, which sustained John Evelyn in his loss.

65

# Thinking on Paper

When he died in 1519 Leonardo left around five thousand pages of notes and drawings. About half are now loose pages, and the rest take the form of notebooks. The V&A is fortunate in having five of these notebooks, bound at a later date into three volumes and named the 'Codex Forster' after their previous owner, John Forster, who bequeathed them to the museum in 1879.

For Leonardo, as for many creative people, drawing was a means of thinking, a way of investigating and understanding a problem or phenomenon that was more useful than any verbal exposition. And sight, on which drawing depends, was believed to be the noblest and most certain sense. Together, seeing and drawing acted as a primary tool of analysis and showed the essential unity of all things designed by nature.

Many of Leonardo's drawings are investigations – of the human body, of the movement of water, of the action of light, of the composition of geometrical solids. Others are designs – for buildings, ideal cities, paintings, masque costumes, mechanical devices and, most famously, flying machines. In the ferment of his mind, he often jumbled all sorts of subjects on the same sheet. In this example from Codex Forster I [80] he describes, and draws, the action of an archer and works out a device for drawing water. As in many other sheets, the drawings are interspersed with notes, written right to left, in mirror writing – probably not for secrecy, as has been claimed, but because Leonardo was left-handed and would otherwise smudge the ink.

The range of Leonardo's invention and the limitations of Renaissance technology meant that few of his schemes reached fruition. Paxton's design for the Great Exhibition building, on the other hand, was conceived, commissioned and executed with astonishing speed.

Paxton made the sketches [81] on 11 June 1850 during a Midland Railway board meeting in Derby. Within a week he had them converted into engineering drawings and presented them to the Royal Commissioners for the Great Exhibition for their consideration. When they confirmed their acceptance on 6 July, Paxton telegrammed his wife with the news, and that telegram is now mounted with the same piece of pink blotting paper as the sketches.

This great haste, untypical of a committee, was forced on the commissioners by the fact that the exhibition was due to open in 11 months and would cover 18 acres. Paxton's design, based on his lily conservatory at Chatsworth House, would be cheap and quick to build. It was for a modular construction – the first of its kind – that could be built using standardized and prefabricated components. Contrary to popular belief, it was not just made of iron and glass. The ribs were laminated wood, and it was only when the building was re-erected at Sydenham as the Crystal Palace that they were replaced with metal.

Another drawing which records the very moment that an idea is born is Henry Beck's sketch for a map of London Underground [82]. The extent of the underground system and its complex relationship to the lie of the land above ground had defeated a number of mapmakers, but as Beck realized, 'If you are going underground, why do you need bother about geography? … Connections are the thing.' His map distorts the geography of London by expanding the centre and shrinking the periphery, and it reduces the wandering network of lines to simple verticals, horizontals and diagonals oriented around the Central Line.

Beck was not actually employed by London Underground at the time that he made this sketch. Trained as a graphic artist, he had been an engineering draughtsman for London Underground but had recently been made redundant. It took over a year for his design to be accepted, and the first edition of 750,000 was issued in January 1933. Unsurpassed in its simplicity, economy and utility, the map is now recognized as a classic, revered by graphic designers and imprinted in the mind of the traveller. Almost unaltered, it forms the basis of the present-day Tube map and has been adapted for urban transit maps all over the world,

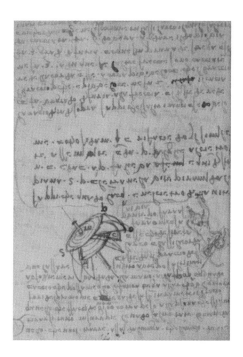

**80 CODEX FORSTER I** by Leonardo da Vinci, 1487–1505. For Leonardo, seeing and drawing were essential means of analysis. The V&A has five of his notebooks – tiny volumes crammed with notes, sketches and diagrams pertaining to geometry, mathematics, the forces of nature and the movement of the human body.

NAL: Forster MS 141/1

**81 SKETCH FOR THE GREAT EXHIBITION BUILDING** by Joseph Paxton, 1850. Paxton sketched out his idea for the Crystal Palace on pink blotting paper during a meeting of the Midland Railway board.

V&A: E.575-1985

**82 SKETCH FOR THE LONDON UNDERGROUND MAP** by Henry C. Beck, 1931. Designed by an unemployed graphic artist, this is the origin of the present London Underground map. Its basic principles have been adopted around the world.

V&A: E.814-1979

# Thinking in 3-D

*Whenever perfect works of art are planned,*
*The craftsman always makes a model to*
*Be the first simple part from which shall grow*
*The finished object underneath his hand.*

*Later, in living stone, more perfect still,*
*A lovelier thing is shaped; beneath the blows*
*Of the fierce hammer, he can feel the thrill*
*Of art emerging from its own birth throes.*

As Michelangelo shows in this poem, the use of models was a fundamental part of the sculptural process. As well as using drawings, sculptors worked out their ideas in three dimensions, exploring form and composition on a small scale using flexible materials, such as wax or clay. Wax, with various additions, was particularly useful, as it softened in the hand but was firm at room temperatures. It could also be built up or carved away, left in a rough state or smoothed to a more shiny finish.

A contemporary Florentine writer recorded an episode in which Michelangelo was given a finely finished wax statuette by the young Giambologna. He crushed it in his hand and remodelled it into a more vibrant composition, making the point that you have to be able to master modelling and composition before creating the finished article.

In contrast to finished sculptures, which have often been worked up by assistants, models reveal the mind and hand of the artist. For this reason they have been especially valued by collectors and connoisseurs. Michelangelo acknowledged this interest by sometimes allowing his models to be sold, though he also destroyed many preparatory works.

The wax *Slave* [84] came to the V&A in 1854, as part of a collection of early models bought in Florence. It relates to the 'tragedy of the tomb', Michelangelo's long and ill-fated attempt to make a magnificent tomb for Pope Julius II. Commissioned in 1505, the tomb was finally built, in a much-reduced form, in 1545. The wax is a sketch for a marble of 1516, now in the Accademia in Florence, which shows the unfinished figure struggling as if to free itself from the block. The marble appears to have been worked from the front. According to Vasari, a friend and contemporary of Michelangelo, the sculptor laid his models horizontally in water so that initially only the front surface was visible. As he worked on the full-size marble, the water level was gradually reduced to reveal more and more of the wax.

In his model for a tensegrity structure [83] Robert Matthew is also thinking in 3-D, but not to the same end as Michelangelo. While the wax *Slave* is undoubtedly a model for a full-size sculpture, the tensegrity structure is made in the spirit of play and experimentation.

The term 'tensegrity' is a contraction of 'tension' and 'integrity'. It was coined by Buckminster Fuller, the American inventor of the geodesic dome, to describe structures in which the forces of tension and compression are clearly articulated. Tensegrity structures exist in nature, even at a molecular level, and can be seen in tents, bicycle wheels and suspension bridges, but they were not considered relevant to architecture until the 1940s.

Robert Matthew was an eminent Scottish architect, founder of Robert Matthew, Johnson-Marshall & Partners (RMJM) and chief architect to the London County Council. His model, the size of a small cardboard box, is made of string, Meccano and the metal tops of file dividers. Matthew has tensioned the strings to brace and locate the struts in a free spatial arrangement; even though no struts meet, he achieves stability. Like the wax *Slave*, this is a structure that could never come to life by use of pencil and paper. It has to be conceived in 3-D, by the physical manipulation of materials.

83 MODEL FOR A TENSEGRITY STRUCTURE by Sir Robert Matthew, about 1960–64. Here the architect is investigating the principles of a tensegrity structure that he learned from Buckminster Fuller.

V&A: LOAN: KITTY DOUGLAS-HAMILTON.1-2003.
Lent by Kitty Douglas Hamilton

84 WAX MODEL FOR A SLAVE by Michelangelo, about 1516–19. When developing a three-dimensional work, artists often make models out of wax, clay or plaster.

V&A: 4117-1854

# Art and Craft

The terms 'art' and 'craft' were once nearly synonymous: both referred to skill. Artistic practice in medieval and Renaissance Europe ranged across the arts, from painting to goldsmithing, from royal entries and performance to fortification. With the assertion of a hierarchy in the arts in the seventeenth and eighteenth centuries artists began to argue that the fine (or useless) were superior to the applied (or useful) arts; just as, a little later, those engaged in pure research came to assert that acquiring knowledge for its own sake was superior to problem-solving or applied research. The Romantic movement, with its idea of the artist as spirit freed from the conventions of society and the trammels of the material, tended to accentuate the distinction: the craftsman was tied to the market, the artist floated above it.

The V&A though has always been committed to seeing the arts as a whole, the fine with the applied, art with craft, concept with realization. It is interested in the art of engraving or tailoring, in the craft of painting, in the casting techniques used to create a bronze, as well as the modelling of the figures and the allegorical significance of the subject. Its interest in craft derives from its commitment to explaining how inert and often refractory materials have been and can be transformed by the application of skill.

85 EVENING ENSEMBLE in gazar silk, by Cristóbal Balenciaga, 1967. 'Balenciaga uses fabric like a sculptor working in marble', said Cecil Beaton, 'He can rip a suit apart with his thumbs and remake or alter his vision in terms of practical, at-hand dressmaking'.
V&A: T.39&A-1974. Given by Mrs Loel Guinness

There is now, after a period in which admiration for concept seemed to have swept respect for making from the scene, a renewed understanding that the hand can lead as well as follow. The creative process is not always orderly, sequential and linear, beginning with an idea, continuing with a design and realized in manufacture. It is also possible to think through doing: ideas can emerge from the exigencies of the material. Craft is not an area of practice distinct from art. It is a way of focusing on the importance of making, on the part played by hand and eye.

In the exclusive world of haute couture the making is usually the work of anonymous teams of tailors, cutters and fitters. Most couturiers sketch out a design and leave the execution to their assistants, but Balenciaga was unusual in being a supreme craftsman. Trained as a tailor, he had a profound understanding of fabric, handling samples for a long time before making a decision, or in the case of gazar silk [85] developing a textile that would enable his austere, sculptural vision to take shape. Many of his designs were determined by the fabric, and he would often cut and fit the garment himself, reworking it again and again to achieve the perfect sleeve or drape.

One of the oldest and most basic craft skills is basketry. Often the work of women, using materials of no monetary value, it is normally associated with the daily tasks of gathering food and transporting goods. Recent basket makers have drawn on this tradition to make basketry with the spatial and tactile qualities of abstract sculpture. Kazue Honma is one of a close circle of Japanese basket makers who have moved away from traditional practices, while retaining an interest in natural forms and manual skill. *Mobius* [86] at first sight appears to be a contorted, inside-out bird's nest. Made of strapping tape dyed with persimmon tannin, it has an intricate pattern, subtle texture and ambiguous structure that invite the viewer to weigh, feel and explore.

A similar appeal to the viewer's intellect and emotions can be seen in the work of Per Sundberg, designer and artist for the acclaimed Swedish glass manufacturer Orrefors. In his 'Fabula' series [87] he takes a cooled gather of glass, applies transfer prints, and then reheats and reworks the glass into a vase-like form. The transfers, in this instance the heads of cats, dogs and horses, are trapped within the glass and distorted by its glittering, reflective, uneven surface. The technique of applying

86 SCULPTURE: MOBIUS by Kazue Honma, 2004. Honma says she becomes so immersed in weaving that she completely forgets about functionality. The abstract form is the spontaneous outcome of her exploration of the materiality of humble strapping tape.
V&A: FE.14-2005

87 FABULA: ANIMAL FACES by Per B. Sundberg, 2000. Sundberg employs traditional glass techniques to disturbing effect.
V&A: C.8-2003. Purchased with funds provided by Paul Bedford

transfers to glass was used in the nineteenth century, but in Sundberg's hands the images are surreal and disturbing, the monsters of a fairy tale or nightmare, not the flowers, butterflies and chinoiserie of a Victorian drawing room. Sundberg says of his vases: 'I am exploring the limits of glass and want the viewer to feel something and get involved.'

# A World of Design

The belief that good design can make for a better world (and generate profits for manufacturers) is one that underpins the very existence of the V&A. Christopher Dresser, often described as the first industrial designer, trained at the Schools of Design in Somerset House and was inspired by Henry Cole's reforming mission.

When the museum opened its 'False Principles' display at Marlborough House in 1852, Dresser describes the contents with a fascinated horror: 'scissors formed as birds, which separated into halves every time the scissors were opened … candlesticks formed as human beings … egg-cups formed as bird's nests'. As a botanist, he understood the principles that underlay natural forms and believed that they could be applied to designed objects, but only when distilled to the point of abstraction. Many of the objects he designed are so starkly abstract and geometric that they proved an inspiration to the early Modernists, and are still impressive today.

Like William Morris – another great British reformer – Dresser believed that the objects we use in our daily lives should be beautiful, but unlike Morris he realized that mass production was the only way to make them affordable. Working freelance, he supplied designs to many different manufacturers for production in a variety of media – silver, iron, glass, ceramics, textiles and wallpaper. Some of the smaller firms, such as Hukin & Heath of Birmingham, gave him control over a range of products, not just one or two items.

The toast rack [88] is one of Dresser's most original and enduring designs: it is still produced by Alessi and looks as striking now as it did in the 1870s. In its rigorous geometry, its clear separation of vertical and horizontal units, and its suggestion of layered planes, the toast rack is indebted to Japan. This was Dresser's other principal design source: he travelled around the country in 1877 at the request of the British government to study its crafts and manufactures, and later wrote a book called *Japan: its Architecture, Art and Manufactures*.

Industrial design came of age in the first half of the twentieth century. Its principle aim was to improve the quality of manufactured goods through a marriage of design and technology. In his 40-year career at Braun, Dieter Rams created a series of classic designs that seem as modern today as they did half a century ago. Declaring that he hated fashion, he gave Braun products a clean, coherent, functional look, in a monochrome palette of grey, white and, later, black; many included interchangeable units. This may sound austere, but actually Rams was very aware of human emotions and the need to enjoy consumer products. The dials and switches in Braun products are often brightly coloured, and the leather handle of the TP1 [89] is an inviting, tactile element in an object that is otherwise coolly technological.

Rams also seeks to anticipate consumers' needs by designing objects for evolving lifestyles. The TP1 was in many ways a precursor of the Walkman and i-Pod: in one small, neat unit it combined a miniature transistor radio and a record player for the 7-inch singles of the Pop era. They can be separated from each other and used independently, or slotted together into an aluminium carrying case.

Jonathan Ive, the British-born designer of the iMac [90] and later of the iPod, is a great admirer of Dieter Rams. He shares many of Rams's values, as well as his obsessive attention to detail and his insistence on devising new products, not just styling existing ones. Of the iMac he said: 'Our objective was to design a computer for the consumer market that would be simple, easy to use, highly integrated, quiet and small.' Also, he said, they 'wanted it to be an unashamedly plastic product' but one that was beautiful and fun, not the dreary grey of most office equipment.

88 TOAST RACK designed by Christopher Dresser in 1878, manufactured by Hukin & Heath about 1880. Christopher Dresser is said to be the first industrial designer. The stark, functional form of his toast rack anticipates Modernist design of the following century.
V&A: M.14–2005

89 TP1 PORTABLE RECORD PLAYER AND TRANSISTOR RADIO designed by Dieter Rams in 1959, manufactured the same year by Braun AG. In his work for Braun, Dieter Rams became an inspiration for many other industrial designers.
V&A: W.28:1 to 3–2008

90 IMAC G3 PERSONAL COMPUTER designed by Jonathan Ive in 1998, manufactured by Apple Inc. in 1998–9. The iMac G3 was quickly recognized to be the best computer for design work. This example belonged to Philip Steadman, a professor of architecture, who bought it in 2003.
V&A: W.29:1 to 4–2008. Given by Philip Steadman

91 'CLUB' CHAIR MODEL B3 designed by Marcel Breuer in 1925/6–7, manufactured by Standard-Möbel in 1927–8. Breuer made the prototype for this chair with the help of a plumber. Its light, intersecting forms subverted the solidity of the traditional armchair.
V&A: W.2-2005

92 'SWING-BACK' ARMCHAIR designed by Le Corbusier, Pierre Jeanneret and Charlotte Perriand in 1929, possibly manufactured by Duflon, Hour & Le Gac or Labadie. Le Corbusier's Modernist houses required a new style of furniture.
V&A: W.31-1987

# Sitting on Air

The challenge of making a chair that is suited to the modern interior, that uses the latest technology and materials, that is mass produced and affordable, and that is practical and stackable or demountable has preoccupied many of the great architects and designers of the twentieth century. Yet Marcel Breuer once memorably distilled the aesthetics of this problem to one simple aim, to make people think they were sitting on a 'resilient column of air'.

The 'Club' chair, the model B3 [91], designed when Breuer was a master at the Bauhaus design school in Weimar, is perhaps the most influential piece of furniture of recent

times. Its importance lies in the use of tubular steel (a decision that was inspired by the frame of Breuer's Adler bicycle) and in the separation of the functional aspects of the chair into a steel frame and canvas supports. This created the transparency and lightness that Modernists craved for in their interiors, while also denoting hygiene and functionality. The 'Club' chair also proclaimed the virtues of technology and mass production – the 'machine aesthetic' – though actually it was made by hand in small batches. Standard-Möbel, the manufacturer, was Breuer's own company, but in 1929 it was taken over by Thonet, who kept the chair in production but only in a limited quantity.

Breuer did not spend a lot of time articulating his approach to design; indeed, he preferred not to 'philosophize before every move'. Le Corbusier, on the other hand, philosophized everything: a house was a 'machine for living in', chairs were divided into different categories that reflected the activity of the user – talking, reading, eating, writing. The 'Swing-back' armchair [92], or *fauteuil à dossier basculant*, was intended for working. Initially it was handmade under the supervision of Charlotte Perriand, a designer who had created unified steel and glass interiors at a time when Le Corbusier was still struggling to find suitable furnishings for his houses: of the furniture that was readily available, only the Thonet chair and the 'Indian' or 'Campaign' chair, with leather strap arms, were acceptable. The 'Swing-back' shows the influence of both,

93 'DIAMOND' CHAIR designed by Harry Bertoia in 1952, manufactured by Knoll International in 1953. Bertoia was a sculptor, more interested in the abstract qualities of design than its practicality.

V&A: Circ.82–1969

94 STACKING CHAIR designed by Verner Panton in 1960, manufactured by Herman Miller Furniture Co. in 1967. This early example is made of fibreglass reinforced polyester, which was strong but brittle and heavy.

V&A: Circ.74–1969

and once the initial prototypes were approved it went into production with Thonet.

For Le Corbusier and Perriand, furniture had to comply with the aesthetic of the architecture. 'Metal', said Perriand, 'plays the same part in furniture as cement has done in architecture'. The chair rests on slender metal legs, just as a modern house stood on pilotis (piers); space flowed above and around it, just as it did in the house; structure – whether that of the chair, or that of the house – was explicit and always visible.

Both these chairs have a distinct sculptural presence and purpose. They articulate and define their own space as well as that of the room in which they are placed. The third chair illustrated here [93], by Harry Bertoia, is resolutely the work of a sculptor rather than an

architect. Claiming, perhaps provocatively, that 'Furniture is nothing to me – it was a means of eating', Bertoia saw his chairs as functional sculptures, as studies in space, form and metal.

The cantilevered red chair [94], by the visionary Danish designer Verner Panton, is the first chair to be conceived as a single piece. For some years the concept was too advanced for the available technology. Serial production only became possible in 1967 and a satisfactory material, offering the right mixture of flexibility, durability and lightness, was not available until the 1990s. Despite these manufacturing problems, the 'Panton' became an icon of the Pop era. In 1970 it featured in a *Nova* magazine shoot in which a model demonstrated 'How to undress in front of your

husband'. In 1995 it reappeared on the cover of British *Vogue*, again with a naked woman, model Kate Moss.

Panton's achievement was not only technological. He introduced fun, fantasy and colour into furniture – qualities that would have appalled the Modernists. Reacting against the ubiquitous white of modern interiors and the sterility of steel furniture, Panton stressed the human aspect of design. 'For me', he said, 'mood is also a function.'

# Radical Britain

E.W. Godwin and, later, Charles Rennie Mackintosh were the two most innovative furniture designers in Victorian and Edwardian Britain. At home neither received the recognition they deserved, but abroad both made a significant contribution to the radical design movements that sprang up in Germany and Vienna. Both were eclectic and wide-ranging in their use of historical sources, but unlike other nineteenth-century practitioners they sublimated these influences within a total re-examination of design, construction and ornament.

In creating this sideboard [95] Godwin was inspired by Japanese furniture and architecture, particularly by the plank construction of Japanese buildings; the result is a disciplined composition of voids and solids, horizontals and verticals that anticipates the work of de Stijl and the Bauhaus. Godwin designed the sideboard for cheap commercial production, though the original softwood proved so unsatisfactory that he changed to mahogany. Seven ebonised sideboards, and one in oak and pine are known to survive. The one in the V&A has Japanese leather-paper panels in the doors, while others have a little surface decoration, gilded, geometric, sparse;

all would have been at home in the Aesthetic interior, along with the sunflowers, peacock feathers and Japanese prints that were so fashionable in artistic circles.

Though rigorous, the sideboard seems almost clumsy in comparison with the subtlety of Mackintosh. This fireplace [96] comes from the Salon de Luxe on the first floor of the Willow Tea Rooms in Glasgow. The tearooms, owned by a Miss Cranston, were a haven of refinement in a city of poverty, disease and heavy industry. Mackintosh took charge of the entire building, remodelling the exterior and designing every detail of the interior with the help of his wife, Margaret Macdonald. The tiled surround of the fireplace alludes to vernacular design: the geometry and the exquisite relationship between line and void are perhaps Japanese in origin; the slender stems and open, bud-like finials recall ancient Egyptian ornament; yet these references are

so understated as to be barely recognizable.

Everything else in the Salon de Luxe – the stained-glass windows, the rows of heavy square tables, the massive throne-like chairs – formed part of a tight geometric grid intermeshed with attenuated organic decoration. The colour scheme was white, purple and silver. The waitresses wore dresses and chokers designed by Mackintosh, and facing the fireplace was a gesso panel, designed by Macdonald, of ethereal females with the words 'O ye, all that walk in Willowwood'.

Mackintosh's interiors, whether private or commercial, were so spare and intensely symbolic that they found little favour in Britain. On the Continent, however, he attracted great interest (though perhaps not so much as other British designers now forgotten). He exhibited in Vienna and Turin, and his design for a 'House for an Art Lover' was widely published in Germany, though never built. But

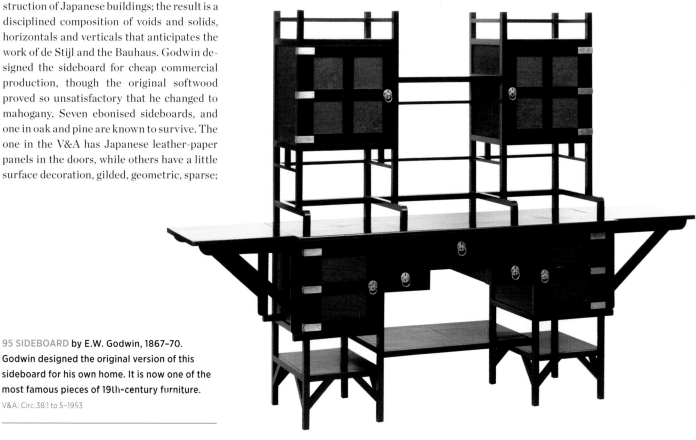

**95 SIDEBOARD** by E.W. Godwin, 1867–70. Godwin designed the original version of this sideboard for his own home. It is now one of the most famous pieces of 19th-century furniture.
V&A: Circ.38:1 to 5-1953

most of all, Mackintosh played a part in the geometrical manifestation of Art Nouveau and was later seen as a pioneering Modernist.

The other British designers who had an impact abroad were, of course, William Morris (see pages 38–9) and his companions in the Arts and Crafts Movement. A vital element in their philosophy was the idea of the designer-maker (an idea that was not important to Godwin and Mackintosh). Particularly in furniture, this evoked all kinds of nostalgic notions about local traditions, medieval craftsmanship and a return to nature. The chair by Ron Arad [97], however, represents a thoroughly modern, urban and international take on this designer-maker position.

Arad was born in Tel Aviv and has lived in Britain since 1973. When designing for batch production he uses plastics and synthetic upholstery, but in the studio he works only in metal. Unlike the designers of the Modern Movement, who emphasized the sleek, machined qualities of metal, Arad enjoys a more rugged, post-industrial aesthetic. One of his most famous chairs was made from the seat of a Rover car. This one, the 'Little Heavy', is made out of stainless steel, beaten with a rubber hammer to create an uneven, imperfect surface.

Arad has become one of the world's most influential designers. In a country that now prides itself on its leading-edge design, he has achieved a fame and success that eluded Godwin and Mackintosh.

96 FIREPLACE FROM THE WILLOW TEA ROOMS by Charles Rennie Mackintosh, about 1904. Mackintosh's austere designs puzzled British observers but were influential in Europe.

V&A: Circ.244–1963. Given by Daly's of Sauchiehall Street, Glasgow

97 'LITTLE HEAVY' CHAIR by Ron Arad, designed 1989. Arad is one of the most innovative and influential designers of his generation.

V&A: W.17–1993

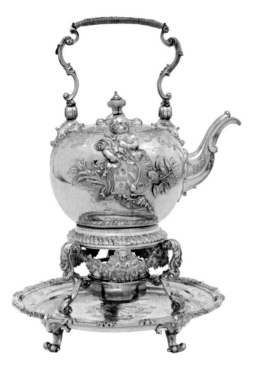

98 TEA KETTLE WITH STAND AND LAMP by Paul de Lamerie, 1736–8. Many of the silversmiths in 18th-century London were Huguenots of French Protestant descent. They introduced new skills and the latest French fashions.
V&A: LOAN:GILBERT675:1 to 4-2008. The Rosalinde and Arthur Gilbert collection on loan to the Victoria and Albert Museum, London

99 DRESS PANEL Spitalfields, London, about 1749–52. The arrival of Huguenot silk weavers meant that Britain was no longer dependent on the import of high-quality silks.
V&A: Circ.243-1959. Given by D.M. Gower

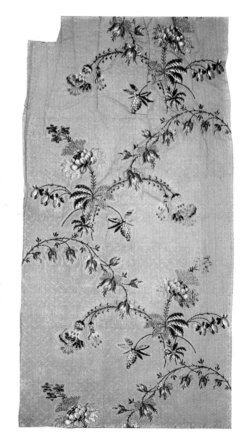

# Refugee Status

Britain, on the margins of Europe and far from the more sophisticated cultures of France and Italy, has sometimes been a provincial backwater. One way of redressing this situation was to attract foreign workers with more advanced skills and a knowledge of the latest continental fashions. When Britain became predominantly Protestant, and as its economic power grew, it acted as a magnet to workers who no longer had a place in the Catholic countries of mainland Europe.

The first influx of Protestant workers took place in the 1540s, with potters and furniture makers from the Netherlands and Germany. In the following century, following the Revocation of the Edict of Nantes in 1685, this trickle turned to a flood. The Edict, introduced by Henry IV in 1598, had allowed Protestants to practise their faith and their trades without interference; but Louis XIV reversed this policy and imposed draconian penalties on Protestants who refused to convert. The Huguenots, as they were called, left France in droves – abandoning their property but taking with them their skills, their business acumen and their reputation for probity and honest workmanship.

As with the Jewish diaspora in later periods, this exodus proved an enormous benefit to the countries that received the *refugiés*. In Britain there was little state sponsorship of the arts, but in France Louis XIV and his chief minister, Colbert, had been promoting and developing the luxury trades since the early 1660s. The arrival of several thousand skilled craftsmen, including silversmiths, clockmakers, sculptors, engravers and painters, enabled Britain for the first time to compete with her long-standing rival and produce top-quality goods within her own shores.

Paul de Lamerie was a second-generation refugee, born in the Netherlands to French parents. He trained under another Huguenot silversmith and worked within the close-knit Huguenot community, using the latest French designs and employing freelance specialists for chasing, engraving and modelling. This tea kettle [98] was made to celebrate the marriage between a Huguenot client, Sir John Le Quesne, and a Miss Knight. Tea was then so expensive that it was kept in a locked box and the lady of the household would often make it herself, using water heated by a spirit lamp.

While many silversmiths lived and worked around St Martin's Lane, the Huguenot silk-weavers settled in the new suburb of Spitalfields, east of the city [99]. One of their churches is still the focal point of the area, and the weaving lofts, with big windows to admit light, can still be seen in the neighbouring streets. With their skill in drawing and their knowledge of the latest technology, the French weavers and entrepreneurs transformed the British textile industry, making Spitalfields one of the great silk-weaving centres of Europe.

In the following century, the Huguenots were replaced by Jewish immigrants fleeing pogroms in Eastern Europe. Many of them worked as furriers or cabinet-makers, sometimes in the very houses that had been built for the silk-weavers. Another influx of refugees came between the two world wars, when avant-garde designers – many of them Jewish – made a well-timed escape from Nazi Germany. One of them was Marcel Breuer, a Hungarian who had trained and worked at the Bauhaus.

Breuer was an architect and furniture designer, responsible for some of the most radical chairs ever made. He only stayed in Britain for a couple of years before moving on to America, but during that time he made contact with Jack Pritchard, one of the few people in Britain who appreciated Modernist design and believed in its potential to transform society. This desk [100], made by Pritchard's Isokon Furniture Company, brings together three key Modernist materials: glass, plywood and tubular steel. It was commissioned by another refugee, Dorothea Ventris, for her flat in Highpoint 1, in Highgate, London, which itself was a seminal Modernist building designed by the Russian-born architect Berthold Lubetkin.

Despite so many talented designers from Eastern Europe, Modernism never really took hold in pre-war Britain. It was seen as foreign, left-wing, ugly and uncomfortable. In the eighteenth century, by contrast, people yearned for foreign goods and welcomed – though not always with open arms – the craftsmen who could emulate the refinement and luxury of neighbouring France.

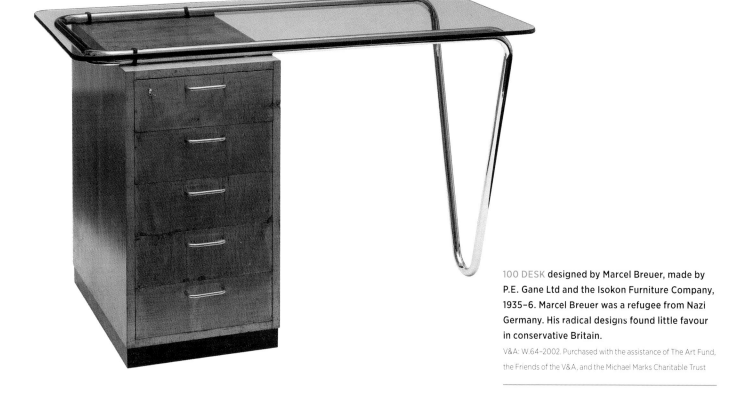

**100 DESK** designed by Marcel Breuer, made by P.E. Gane Ltd and the Isokon Furniture Company, 1935–6. Marcel Breuer was a refugee from Nazi Germany. His radical designs found little favour in conservative Britain.

V&A: W.64-2002. Purchased with the assistance of The Art Fund, the Friends of the V&A, and the Michael Marks Charitable Trust

# Chinese Whispers

This white tankard [101], decorated with just an applied floral sprig, may seem insignificant but in fact it represents a eureka moment in the history of European ceramics: the discovery, in Meissen in 1709, of the recipe for porcelain.

Porcelain is a hard, white, translucent ware, fired at a very high temperature of 1,250–1,400 degrees centigrade: its whiteness, hardness and clear blue decoration made it supremely desirable. The Chinese had been making porcelain from around AD 600 and exporting it since the early fourteenth century. Rulers across the world – from Safavid Iran to Ottoman Turkey and Renaissance Europe – collected it with a passion; potters tried to emulate it, their efforts giving rise to Iranian fritware, Turkish Iznik ware, Dutch delftware and the so-called Medici porcelain.

Many of these wares were beautiful and successful but none was true porcelain. The breakthrough came in Dresden, where the ruler, Augustus the Strong, was fascinated by porcelain, so much so that he once exchanged 600 mounted soldiers for 151 Ming ceramics. Included in his extraordinary collection were vases like this one [102], imported from the imperial porcelain factory in Jingdezhen in south-west China. Its decoration shows a popular love story, the *West Chamber*. This, along with the slender vase shape, suggests that it was made for the Chinese market, not for export, though a few are known to have been acquired for Augustus's 'Japanese Palace'.

To fund his habit, Augustus turned to alchemy, a science both serious and spurious in which practitioners tried to make gold out of base metal. He found a young alchemist called Johann Friedrich Böttger and put him to work alongside a Saxon nobleman called Ehrenfried Walther von Tschirnhausen, who was trying to discover the secret of porcelain or 'white gold'. When Böttger failed in his attempts to make gold, he was put under house arrest and ordered to turn his attention to porcelain. This he clearly viewed as a demotion, for he put above the door of his laboratory the following notice: 'God, our creator, has turned a goldmaker into a potter'.

Success came on 28 March 1709, when Böttger made the first specimens of unglazed white porcelain; two years later the first porcelain factory in Europe opened, in a fortress in Meissen near Dresden. The decoration of the early wares was problematic – hence the sprig on the tankard – and Böttger spent his remaining years trying to develop a satisfactory range of enamel colours. He died in 1719, at 37, still a prisoner so that Augustus could have exclusive use of his precious recipe.

Despite Augustus's efforts, industrial spies quickly managed to penetrate the Meissen factory and take its trade secrets to Vienna and Venice. Eventually the porcelain recipe became common knowledge throughout Europe and rulers everywhere set up their own factories, partly to supply their own tables but also as a display of technical prowess. Many of these factories made a slightly different ware from that produced at Meissen. Known as 'soft-paste' porcelain, it cannot rival the sharpness of detail, the glittering glaze and the brilliant enamels of true 'hard-paste' porcelain but – as can be seen in this Chelsea group [103] – it has a special charm and character of its own.

The Chelsea factory, founded in about 1744 by a goldsmith from Liège called Nicholas Sprimont, was the most prestigious of the English porcelain factories. In common with its lesser rivals, it was a commercial concern run by entrepreneurs, rather than a state-run enterprise sponsored by the local prince or monarch. Joseph Willems, who made the group, was the finest modeller employed at the factory; like Sprimont, he came from the Low Countries.

The Chinese musicians, a variation on a Meissen theme, were probably a table ornament, with some kind of lighting device held in the central opening. Two versions of the group are known, one of them featuring in a 1756 auction catalogue as 'A most magnificent LUSTRE in the Chinese taste, beautifully ornamented with flowers, and a large groupe of Chinese figures playing on music'. The flower-strewn base and animated, wheeling figures are thoroughly European and Rococo, but the subject matter shows the enduring appeal of all things Chinese.

101 PORCELAIN TANKARD **Meissen, about 1715. Augustus the Strong, ruler of Saxony, was determined to find the secret of porcelain. The breakthrough came in 1709, but coloured glazes were only developed a decade or so later.**
V&A: C.136-1945

102 PORCELAIN VASE Jingdezhen, about 1700. Augustus the Strong owned over 24,000 Asian ceramics; there were several vases like this in his 'Japanese Palace'.

V&A: C.859–1910. Salting Bequest

103 GROUP WITH FOUR CHINESE MUSICIANS modelled by Joseph Willems and made in the Chelsea porcelain factory, about 1755. This is made of 'soft-paste' porcelain, an acceptable alternative to the 'hard-paste' of Chinese and Meissen wares.

V&A: C.40–1974. Purchased with the assistance of a special Treasury Grant, The Art Fund and A.W. Tuke

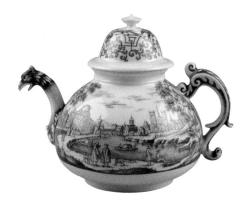
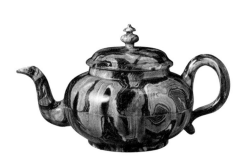
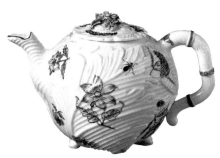
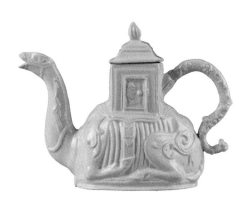

# 1,637 Teapots

The V&A's collection of ceramics is the finest in the world. Among the tens of thousands of pieces are around 1,637 teapots. This small selection shows how the classic teapot form, based on seventeenth-century Chinese imports, has been manipulated with wit, fantasy and a spirit of radical enquiry. Yet, despite the three hundred years of invention, the white Dehua teapot [104] is without peer, its bold geometry a forerunner of Modernism and an inspiration to contemporary ceramists.

**104 PORCELAIN WITH CLEAR GLAZE** Dehua, China, about 1650–1700.

V&A: Circ.62-1931. W.G. Gulland Bequest

**105 RED STONEWARE WITH MOULD-APPLIED DECORATION** Delft, Netherlands, by Ary De Milde, 1670–1700.

V&A: C.75&A-1949. Given by Mrs M. Gross

**106 HARD-PASTE PORCELAIN, MOULDED AND PAINTED IN ENAMELS** Meissen, Germany, enamelled by Ignaz Preissler, about 1720–30.

V&A: C.75&A-1939

**107 SOLID AGATE WARE, WITH LEAD GLAZE** Staffordshire, England, 1740–50.

V&A: 151:1, 2-1874

**108 SOFT-PASTE PORCELAIN, PAINTED IN ENAMEL COLOURS** London, made in the Chelsea porcelain factory, about 1747–9.

V&A: 2877&A-1901. Transferred from the Museum of Practical Geology, Jermyn Street

**109 SALT-GLAZED STONEWARE, MOULDED** Staffordshire, England, about 1750.

V&A· 414:989/&A-1885. Given by Lady Charlotte Schreiber

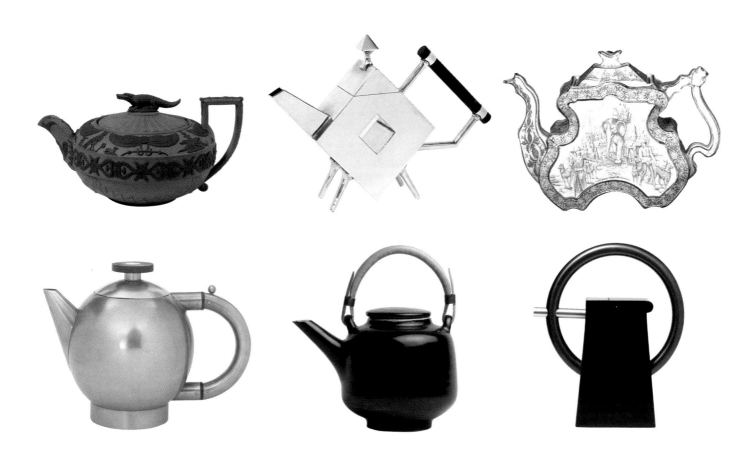

110 RED STONEWARE ('ROSSO ANTICO' WARE)
WITH APPLIED RELIEF DECORATION
**Stoke-on-Trent, England, manufactured by
Josiah Wedgwood & Sons, about 1810.**
V&A: 2375&A-1901. Transferred from the Museum of Practical
Geology, Jermyn Street

111 ELECTROPLATED NICKEL SILVER WITH
EBONY HANDLE **Sheffield, England, designed by
Christopher Dresser, manufactured by
James Dixon & Sons, about 1879.**
V&A: M.4-2006. Purchased with generous support of the
National Heritage Memorial Fund, The Art Fund, the American
Friends of the V&A and an anonymous donor, the Friends of
the V&A, the J. Paul Getty Jr. Charitable Trust and a private
consortium led by John S.M. Scott

112 EARTHENWARE, WITH TRANSFER-PRINTED
DECORATION **Burslem, England, manufactured
by Burgess & Leigh, design registered in 1896.**
V&A: C.278&A-1983. Given by M.J. Franklin

113 CHROMIUM-PLATED BRASS WITH EBONY
KNOP **Hamburg, Germany, designed and made
by Naum Slutzky, 1928.**
V&A: Circ.1232-1967

114 STONEWARE, WITH BLACK GLAZED
EXTERIOR AND WHITE GLAZED INTERIOR
**London, made by Lucie Rie, 1951**
V&A: Circ.20&A-1952

115 ALUMINIUM, DROP FORGED, ANODISED
AND POLISHED, WITH ACRYLIC HANDLE
**Queanbeyan, Australia, 'TP49', made by
Robert Foster, 2004.**
V&A: M.2-2006

116 UNGUENT JAR Egypt, 1400–1336 BC. Made in a workshop close to the court of an Egyptian pharaoh, this is an early example of a glass vessel. Beads had been made from about 2500 BC.

V&A: 1006-1868

# Out of the Sands of Time

Glass is 60 to 70 per cent sand, or properly speaking, silica. With an alkaline flux to lower the melting temperature and a stabilizer to stop it dissolving in the presence of water, it makes for an almost magical material: one that is made of the crudest materials, yet is wonderfully clear, translucent and malleable.

The V&A glass collection, initially formed to instruct designers and manufacturers, is encyclopaedic in its range and presentation. It includes beads made in ancient Mesopotamia right through to abstract work by contemporary glass artists. This tiny blue jar [116], just 3.5cm high, comes from the palace of the Egyptian pharaoh Amenhotep III, at Malqata on the west bank of the Nile opposite the Luxor temple.

Glass was then a luxury product, made in royal workshops close to the court for the exclusive use of the royal family and nobility.

The jar, perhaps used by the pharaoh himself, would have held perfumes, oils or cosmetics. It is 'core-formed', meaning that the molten glass was drawn from a crucible and wrapped around a core of dung and clay. For decoration, the glassmaker trailed different coloured glass threads around the body and combed them into patterns with a pointed stick. He then added handles, made of a translucent glass that forms a subtle contrast with the opaque glass of the body.

The invention of glass-blowing, in Syria or Palestine sometime in the middle of the first

century BC, transformed the nature of glass. Skilled workmen could now create a huge variety of shapes with speed and ease, making glass a utilitarian rather than a luxury product. After Roman times the quality of glass to some extent deteriorated until the Venetians developed *cristallo* in the 1450s. By rigorous control of the raw materials, and by adding manganese to de-colourize the batch, they were able to make a glass that was absolutely clear, as clear as the rock crystal from which it took its name.

The new glass was also exceptionally ductile, which meant that it could be drawn and blown into extraordinary shapes. In an age that valued wit, fantasy and virtuosity,

117 PERFUME SPRINKLER, FLASK AND GOBLET
Venice, 1600–1700. The Venetians developed a form of clear glass known as *cristallo*, which could be worked into astonishingly complex shapes.
V&A: 74-1853; 171-1893; Circ.534-1928

118 ARCUS 1 by Stanislav Libenský and Jaroslava Brychtová, 1991. Pioneers in the creation of sculptural glass, Libenský and Brychtová developed the technique of 'mould-melting'. Chunks of raw glass are laid into a mould taken from an original clay model and fired in a furnace.
V&A: C.4-1993

it became highly desirable. Its fragility, far from lessening the appeal of glass, made it a metaphor for life itself. In a 1540 treatise on glass-making, Vannoccio Biringuccio wrote: 'one cannot and must not give it too much love, and one must use it and understand it as an example of the life of man and of the things of this world which, though beautiful, are transitory and frail.'

Venetian glass was indeed transitory and frail. Much of it also suffers from a condition known as 'crizzling' in which the glass reacts with moisture in the air and eventually disintegrates. In their drive to purify the ingredients, the Venetians had inadvertently removed the stabilizer that rendered the glass water resistant. This, as well as normal breakage, means that very little Venetian *cristallo* has survived from the early years.

The perfume sprinkler [117], flask and goblet are seventeenth century but they give a good idea of what Renaissance glass would have looked like. The sprinkler, on the left, takes the form of a sea serpent swallowing a guitar adorned with cupid's wings; the guitar is moulded, the rest blown, applied and worked into shape with tongs. The mouth of the flask is a trumpet-like flower, while the goblet has supporters in the form of upside-down sea horses with curling tails and spiky snouts. All are made of the clearest *cristallo*, enlivened with touches of bright, light blue.

These vessels, though made for display as much as for use, retain a functional purpose. It was not until the mid-twentieth century that artists began to value glass for its sculptural potential. Pioneers in this new approach were the Czech husband-and-wife team Stanislav Libenský and Jaroslava Brychtová, who became fascinated by what they called the 'inner light space' of glass. With the full resources of the state-run glass industry at their disposal they were able to experiment with materials and technologies that were beyond the reach of other glass artists [118].

# Story and Status

Stained glass, its bright colours undimmed by age, provides a window into the Middle Ages [119]. This scene of Esau giving up his birthright offers a glimpse into the back yard of a prosperous German home. A hunter with cloak and boots stands on the cobbles while another man, in clogs or house shoes, hands him a bowl of pottage. The wall is cut away to reveal a child sitting in a fireplace decorated with a Renaissance frieze. He turns an animal on a spit, basting it with a large ladle, while above him five fish hang in the chimney to smoke.

The story, of course, is biblical. It comes from the book of Genesis and shows the twin sons of the patriarch Isaac: Esau 'the cunning hunter' and Jacob the 'plain man, dwelling in tents'. Esau, the first-born, was his father's favourite, and Jacob his mother's, a situation that was to have momentous consequences. One day, when Esau came in hungry from the fields, Jacob succeeded in tempting him to surrender his birthright in exchange for food. In describing the birth of the twins, the Bible says that Esau was 'red, all over like an hairy garment', and if you look closely at the panel you can see that the backs of his hands are indeed covered with long, coarse hair.

Originally this panel was part of a whole cycle of stained glass in the cloister of the

119 PANEL SHOWING JACOB TEMPTING ESAU
TO SELL HIS BIRTHRIGHT **probably by Gerhard
Remisch and possibly Everhard Rensig, 1521.**
This comes from the cloister of the Cistercian
monastery of Mariawald, near Cologne. As the
monks passed through the cloister, they would
have enjoyed the glowing colours and homely
details of the stained glass, while also recognizing
the religious significance of each story.
V&A: C.120-1945

120 PANEL WITH THE ARMS OF THE COUNTY
OF KYBURG **probably by Lukas Zeiner, 1490.**
Stained glass was also made for secular settings.
It was particularly suited to a display of armorial
bearings.
V&A: C.9:1-1923

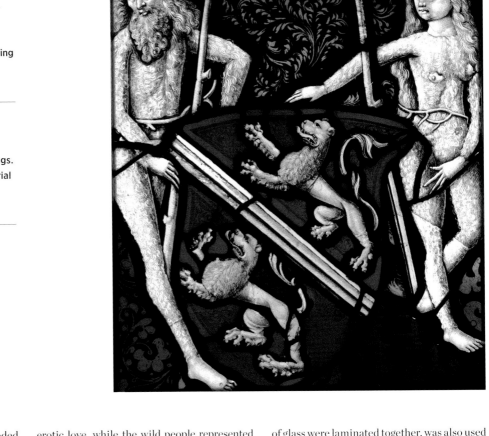

Cistercian abbey of Mariawald in the wooded hills of the Lower Rhine in Germany. As in the Biblia Pauperum (the 'bibles of the poor'), each Old Testament scene was paired with one from the New Testament. The pair to Jacob and Esau was the episode in which Christ is fasting in the desert and the devil tempts him to feed himself by turning stones into bread.

Not all stained glass was narrative, instructional and religious. In Switzerland especially there was a vogue for stained glass with heraldic coats of arms. Displayed in a town hall or other secular setting, these pieces were a declaration of civic status. A specialist in this kind of glass was Lukas Zeiner, who worked in Zurich, and this intriguing panel [120] is one of his finest works. It shows the arms of the County of Kyburg supported by a wild man and wild woman, each covered in fur and wearing a garland of flowered twigs. The garlands were symbols of erotic love, while the wild people represented strength, potency and freedom.

Zeiner's panel has the flat, two-dimensional appearance of medieval glass, while the Mariawald panel uses perspective and framing devices to give a sense of depth. This attempt to emulate painting was a sixteenth-century development that became more pronounced with the increasing use of enamel in stained glass.

Both panels show the extraordinarily rich effects that could be achieved within the constraints of the medium. The glass is either clear or coloured in the batch, but all sorts of tricks could be used to build up an image: silver stain to provide yellow tints in the clear glass, grisaille paint for detail and modelling, and scratching to create bi-colour effects in 'flashed' glass – as in the leafy background to the wild couple. Flashing, in which two colours

of glass were laminated together, was also used to brighten the effect of red glass, which when thick was so dark that it blocked the light.

In 1802 the abbey of Mariawald was closed down, as were many other religious institutions during the sweeping secularization of the period. Its glass was bought by a dealer in Norwich, who sold it to Lord Brownlow for his chapel in Ashridge Park in Hertfordshire. Eventually it came on the market and ended up in the V&A. Other panels came to the museum via a similar route, as huge quantities of glass were removed from their original settings on the Continent and sold to antiquarian collectors in England. With other acquisitions from various sources, including some from English foundations that were dissolved at the time of the Reformation, the V&A now has the largest and most comprehensive collection of stained glass in the world.

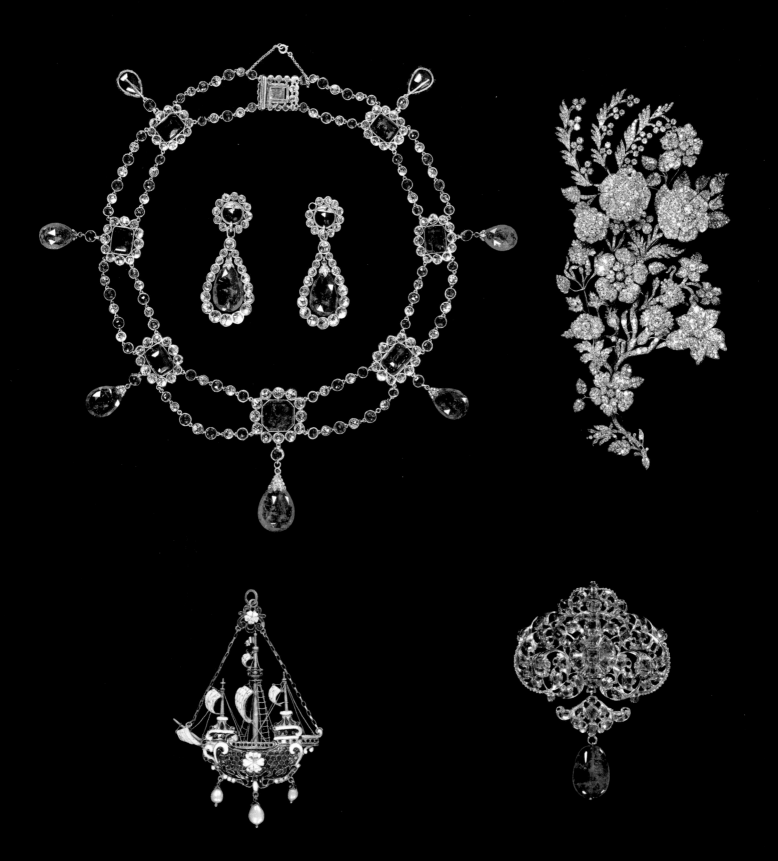

# All that Glisters

The Jewellery gallery in the V&A is a treasure chest of fabulous gemstones and spectacular craftsmanship. Some of the pieces originated as gifts, some were flagrant declarations of wealth, status and power. The emerald necklace and earrings [121] were both. They were a present from Napoleon to Stéphanie de Beauharnais, a distant relative of his wife Joséphine, on her marriage to the hereditary prince of Baden. In forging newly conquered territories into the Confederation of the Rhine, Napoleon needed to build an alliance between his own dynasty and that of Baden. Since he was childless, he adopted Stéphanie, elevated her to the rank of 'Princesse Française' and arranged her marriage with Karl Ludwig Friedrich. For Stéphanie to wear these jewels would be a permanent reminder of her link with Baden's overlord.

According to Mademoiselle Avrillion, maid to the Empress Joséphine, Napoleon gave the 16-year-old Stéphanie 'a fine diamond parure with many other jewels of exquisite taste'. The emerald necklace was probably made by the imperial jewellers, Nitot & Fils. A portrait of Stéphanie – painted in 1806, the year of her marriage – shows that it formed part of a parure, or set, along with a tiara, earrings and bracelets. The great glistening emeralds and double strands of diamonds are carefully arranged over her bosom, framed by the puffed sleeves and low bodice of her empire gown.

When the emeralds left Baden is unknown. By the 1920s they were in the hands of a leading London jeweller, and much later they were acquired by Count Tagliavia, a Sicilian shipping magnate, whose widow gave them to the V&A.

Many of the objects in the jewellery collection have come as gifts or bequests. The bodice ornament [123], encrusted with diamonds, is part of the Cory Bequest of 1951. Lady Cory's husband made a fortune from coal mining and 'Cory's Motor Spirit' (a brand of petrol), enabling her to indulge her passion for jewellery.

The emerald pendant [124] was a gift from Dame Joan Evans, a distinguished medieval scholar who also built up fine collection of jewels. The design, with its swirling botanical motifs, is typical of late seventeenth-century European jewellery, but the lavish use of emeralds is distinctively Spanish. A piece so opulent and so old is unusual, as jewellery was usually broken down to realize the value of the gems and precious metal, or remade to follow new fashions.

When the museum bought the enamel ship pendant [122] in 1893, it would have done so on the grounds that it was a rare survival from the Renaissance period. But actually the pendant is a fake. It came from the collection of Frédéric Spitzer, a Viennese dealer who had a shop in Aachen and a house stuffed with antiques in Paris. Spitzer was highly regarded at the time: when his collection was put up for auction three years after his death it was described as the 'sale of the century' and museums and collectors fought over the lots. Nobody – not even the discriminating Australian collector George Salting, whose later bequest so enriched the V&A – realized the extent to which Spitzer had 'improved' and even faked objects. The true identity of the ship pendant only came to light in recent decades when scholars began to examine the thousand or so working drawings by Reinhold Vasters, a nineteenth-century German goldsmith. These drawings are in the V&A's Print Room, and among them lies the design for the pendant.

Vasters worked in Aachen and was closely involved in Spitzer's nefarious activities. Back in 1912 a V&A curator had been aware of this; some years before the museum acquired the drawings, he described them as 'designs for goldsmith's work, many pieces of which, I understand, have been placed on the market as old work'. Although later generations have had to rediscover what their predecessor already knew, the ship pendant is still an object of great interest – an 'authentic' example of a Vasters fake.

121 EMERALD AND DIAMOND NECKLACE AND EARRINGS **probably by Nitot & Fils, about 1806, altered 1820s. Napoleon gave these magnificent jewels to his adopted daughter Stéphanie, on her marriage to the hereditary prince of Baden at the age of 16.**

V&A: M.3A&B–1979. Given by Countess Margharita Tagliavia

122 ENAMEL SHIP PENDANT **designed by Reinhold Vasters, about 1860. The vogue for Renaissance jewellery in the 19th century led to the production of many fakes.**

V&A: 696–1893

123 DIAMOND BODICE ORNAMENT **probably England, about 1850. Some of the diamond flowers are set on springs so that they would glitter and tremble as the wearer moved.**

V&A: M.115–1951. Cory Bequest

124 EMERALD AND GOLD PENDANT **Spain, about 1680–1700. Through their colonies in South America the Spanish had access to immense quantities of gold and emeralds.**

V&A: M.138–1975. Given by Dame Joan Evans

# Man of Fashion

In the modern world, despite the efforts of the media and the fashion industry, men's fashion is generally more restrained than women's. In the past this was not the case. Until the late eighteenth century, when men all over Europe adopted the sober, practical dress of an English squire, the male of the species often outdid the female in the lavishness and expense of his dress.

Richard Sackville, the 3rd Earl of Dorset, was the epitome of fashion at the court of James I. A notorious gambler, womanizer and spendthrift, he died in 1624 at the age of 35, with mortgages on many of his family properties, including Knole in Kent. Dress and armour contributed to his downfall, for they were unimaginably expensive, far more costly than the paintings and furniture that we value today.

Isaac Oliver's portrait [125] is typical of its time in characterizing its sitter as much through dress and possessions as through face and posture. The earl, framed by glossy satin curtains, stands with his hand on a helmet trimmed with a great cloud of ostrich plumes. His outfit, much of which can be identified in a 1617 inventory, includes 'Bullen hose of Scarlett and blew velvet … the puffs of blew velvet embroadered all over with sonnes Moones and starres of gold'. His shoes are ornamented with 'a paire of Roeses edged with gold and silver lace', his knitted stockings with silk or gold embroidery.

Knitting, which gives the smooth, clinging fit to his stockings, was a recent introduction, as was the starch that maintains the sharp angle of the earl's lace collar and cuffs. The bulbous profile of his hose comes from the use of bombast, or stuffing, made from rags, horsehair, cotton or perhaps bran (which could lead to some embarrassment if the fabric got torn).

The armour, carefully arranged on the rush matting, and the long-fingered gauntlets on the table show the earl to be a man of action as well

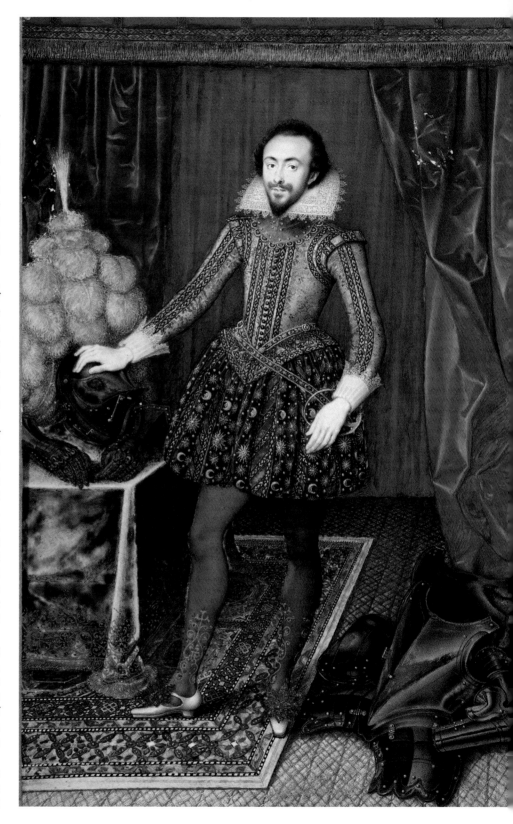

125 RICHARD SACKVILLE, 3RD EARL OF DORSET by Isaac Oliver, 1616. The Earl of Dorset is a gorgeous creature, dressed in the height of fashion with the armour that he wore for tournaments laid out on the table and floor.

V&A: 721–1882. John Jones Bequest

126 SNUFFBOX belonging to Frederick the Great, Berlin, 1765. This particularly flamboyant snuffbox is made of mother-of-pearl encrusted with diamonds, rubies, sapphires, emeralds and turquoise. It once belonged to Sir Arthur Gilbert, a passionate collector, who would pass it round at the end of a special dinner party.

V&A: LOAN:GILBERT 413:1-2008. The Rosalinde and Arthur Gilbert collection on loan to the Victoria and Albert Museum, London

127 SWORD (detail) by Joannes Kalkoen, about 1670. Made of gold and studded with precious stones, swords were as much for display as combat.

V&A: M.60:1&:2–1947. Bequeathed by Francis Mallett

as fashion, a star performer in a joust as well as a splendid creature at court. However, he might not be quite as super cool as he would like to appear. Armour was usually just as much of a fashion statement as dress – emulating its cut and decorative details, and styled to accommodate the clothing that was worn underneath – but here the earl's breastplate is behind the times, its peascod belly deeper and more pointed than that of his doublet.

As the century wore on it became less common for a man of fashion to be portrayed with, or in, his armour. Instead, a sword would suffice as a mark of status and a means

of defence. This elegant example [127] is an early example of a 'small sword', a light civilian weapon with a flexible, pointed blade that appeared in the 1640s in response to new fencing techniques.

Snuffboxes [126] were another essential accessory for a man of fashion. Both smoking and snuff-taking were thought to enhance creative and intellectual work, but snuff had greater status since the nose was seen as a direct passage to the brain, the seat of reason. While the common man smoked a cheap clay pipe, the gentleman inhaled an aromatic tobacco powder and stored it in an exquisite little

box. These boxes became virtuoso displays of craftsmanship. There were boxes for all sorts of occasions, even for every day of the year; and they were also given as high-status gifts, often with a portrait of the donor inside the lid.

Frederick the Great of Prussia carried a snuffbox at all times. Indeed, one saved his life by deflecting a Russian bullet during the battle of Kunersdorf in 1759. Each year, when he moved to Berlin for the carnival, he had a selection of his boxes carefully transported on the back of a camel. In his final illness he had jewels, boxes and specimens of hardstone laid out for solace in front of him.

128 **HAT** designed by Jacques Fath, made by Svend, about 1950. In 1974 the V&A received over four hundred garments and accessories by some of the leading haute couture designers. The collection had been assembled by Cecil Beaton, who believed that fashion should be valued as a work of art.

V&A: T.191&A-1974. Given by Lady Alexandra Trevor-Roper (later Lady Dacre of Glanton)

129 **SILK SATIN EVENING SHOES** by Christian Dior, about 1960. Mrs Loel Guinness, who gave these shoes, was the glamorous Mexican wife of a wealthy banker. She would order entire wardrobes from Dior.

V&A: T.153&A-1974. Given by Mrs Loel Guinness

# High Society

At a dinner party in New York in 1969, the director of the V&A, John Pope-Hennessy, remarked to the photographer Cecil Beaton that couture dresses should be collected as works of art. He added that all great collections were informed by individual taste. Beaton had spent much of his life contemplating the subtleties of good taste; he was also a snob and believed passionately that fashion was a true art form – 'the subtle and shifting expression of every age'. So with Pope-Hennessy's blessing, he set out to form a collection for the museum.

Writing coercive letters to his grand acquaintances ('I wonder if you would feel inclined to help me in my effort to make a collection of fashions of our day?'), Beaton amassed over four hundred items for the museum and exhibited the highlights in the 1971 exhibition *Fashion: An Anthology*. One particularly generous donor, Lee Radziwill, the sister of Jacqueline Onassis, complained that after Beaton's visit she had nothing left to wear; another, Lord Mountbatten, was annoyed when the offer of his wife's dresses was rebuffed, as they did not meet Beaton's exacting standards.

The collection went back to the turn of the century, to a dress worn at the 1897 Devonshire House Ball and an early Chanel dress made for the 1919 Paris Peace Conference. For Beaton, the event and the donor were as important as the designer. These pink crêpe gloves [130] were a gift from the film actress Ruth Ford, whom Beaton believed to be one of the ten most beautiful women in the world. She had been given them by a suitor, the Surrealist collector Edward James, and had

**130 CRÊPE EVENING GLOVES** from 'The Circus'
collection, by Elsa Schiaparelli, 1938. All the
items in the Cecil Beaton collection were gifts
from the photographer's wealthy friends and
acquaintances. The gloves belonged to the
American actress Ruth Ford.

V&A: T.393B, C-1974. Given by Miss Ruth Ford

---

**131 SILK EVENING DRESS** by Pierre Balmain,
1957. Lady Diana Cooper, wife of the former
British ambassador in Paris, wore the same dress
for the Queen's state visit in April 1957. She later
gave it to the V&A.

Photo: *L'Officiel*

Dress: V&A: T.50-1974. Given by Lady Diana Cooper

---

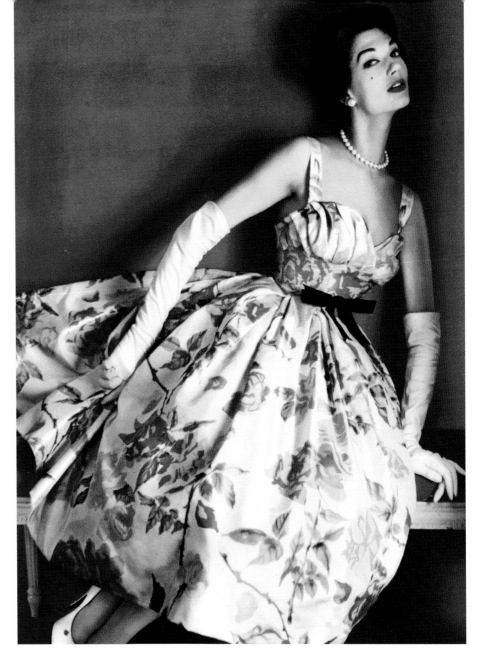

worn them with Schiaparelli's 'Tears' dress.
Schiaparelli's designs – a hat trimmed with
gloves, a sweater with a knitted bow – were
known for their wit, provocation and origin-
ality, but the 'Tears' dress had a political edge,
its imagery of rent fabric evoking the horrors of
the Spanish Civil War.

Schiaparelli was not perhaps Beaton's
favourite designer. Dior, who regarded couture
as 'a sort of fight against the demoralizing and
mediocre influences of our time', was more to
his liking. In launching the New Look in 1947,
Dior had re-created femininity with clothes
that were elegant, curvaceous and extravagant,
all qualities that had been banished during the
war. These shoes [129] were specially dyed to
match the dress they were worn with: red, said
Dior, 'is the colour of life. I love red and I think
it suits almost every complexion. Bright reds
– scarlet, pillar-box red, crimson, cherry are
very gay and youthful.'

The hat [128] comes from the house of
Jacques Fath, a designer who rivalled Dior in
the elegance and femininity of his work but
had a more youthful appeal. Fath, memorably
photographed in his salon with a white shirt
open to the navel, was a master of publicity

and inspired devotion in his clients. Lady
Alexandra Howard-Johnston, wife of the
British naval attaché in Paris, ordered her
entire wardrobe from him, and was even given
two complimentary day dresses and evening
dresses each season. In a letter to Cecil Beaton
she wrote, 'I was not allowed to go to any other
couturier, but I did not want to – Fath was
perfection.'

Four of the dresses that Beaton assembled
were linked to the Queen's state visit to Paris
in April 1957. At the state banquet the Queen

wore a gown by her favourite British couturier,
Norman Hartnell. Beaton disliked the dress,
remarking that the Queen 'triumphed over
Hartnell's bad taste', but nevertheless he was
pleased to accept it for the V&A. Other British
guests wore French couture [131], perhaps
in tribute to the host nation, or perhaps to
ensure that they would shine at one of the most
important diplomatic events of the decade.

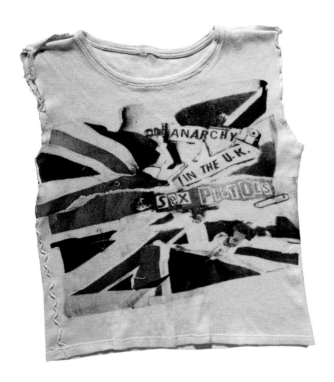

# Street Style

It has been said that fashion is either 'trickle down' or 'bubble up'. Haute couture was the former. Expensive and exclusive, it was a prerogative of a narrow elite but was copied all over the world, by fashion houses and department stores, by dressmakers and housewives. Street fashion bubbles up from below, bringing with it all the tension and vitality of the street. Yet, in turn it is adopted by fashion houses and department stores, and even by haute couture. Both are about identity, about the precise gradations that divide the privileged from the ordinary, the cool from the uncool.

The fashion revolution that created street style took place in Britain in the 1960s, from that heady mix of youth, money and music that was Swinging London. By the 1970s the hippies and pop stars were showing their age and it was the turn of a new generation to revolutionize fashion. Punk fashion was born in 1976 in a shop in the King's Road

owned by Vivienne Westwood and Malcolm McLaren. The shop had been through various metamorphoses, from 'Let it Rock' to 'Too Fast to Live, Too Young to Die' to simply 'Sex'. It then gave its name to the Sex Pistols, a new band managed by McLaren. Graphic designer Jamie Reid, a friend of McLaren's from art college, gave the band a suitably confrontational visual identity with ransom-note lettering and a tattered Union Jack [132].

The Sex Pistols played their first gig in the shop, and youth from all over London congregated in the King's Road wearing leather, zips, rips and safety pins, fetish gear and slogan T-shirts. A year later Zandra Rhodes, who had designed the dress for Princess Anne's engagement photo, was using safety pins in her 'Conceptual Chic' collection.

This rapid migration from street cool to high fashion means that street styles have to constantly reinvent themselves, to narrow and redefine the tribal or gang identity. The

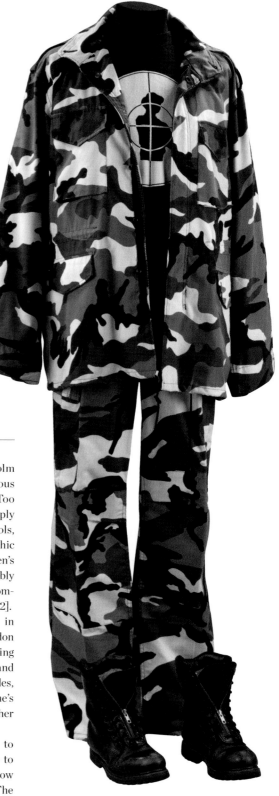

**132 'ANARCHY IN THE UK' SHIRT** by Vivienne Westwood and Malcolm McLaren, 1976. The shirt is printed with Jamie Reid's artwork for the Sex Pistols first single, 'Anarchy in the UK'. Johnny Rotten customised it by cutting off the sleeves, then wore it in performance.
V&A: S.794-1990. Given by Jamie Reid

**133 CAMOUFLAGE SUIT** Britain, 1988. In the 1980s fashion trends born out of a black subculture soon entered the mainstream.
V&A: T.1023-1994

**134 THE THIRD SUMMER OF LOVE** by Corinne Day, July 1990. This photograph shows Kate Moss on the brink of her career as an international supermodel. It epitomizes the grungy, waif look in British fashion.
V&A: E.75-1997. Copyright Corinne Day, courtesy Gimpel Fils

camouflage suit has its origins in American rap, hip-hop and break dancing. Coined by Jamaican DJs, these interlinked phenomena emerged in 1976 out of a black subculture, but within a few years kids around the world were wearing expensive trainers and label-covered tracksuits. In 1988 bands such as Public Enemy redefined the look as 'urban commando chic', the uniform of black consciousness. This camouflage jacket and trousers [133] were part of a B-Boy outfit devised by photographer and DJ Normski for the V&A's *Streetstyle* exhibition; accessories included a baseball hat, a Public Enemy T-shirt and a leather holster.

Street style, though soon absorbed by the fashion industry, tries to maintain an independent, sceptical stance. The photograph by Corinne Day [134] shows Kate Moss on the brink of her career as an international supermodel. Aged 15 and straight out of Croydon, she is posed topless on Camber Sands wearing a feather headdress, a bead necklace and a skimpy skirt. The image, with its tender, unforced beauty, created the 'waif' look that transformed British fashion and launched Day as one of the most influential photographers

of the 1990s. Her dirty realism soon had an impact in mainstream advertising but Day herself tired of the superficiality of the fashion industry and turned to reportage.

Westwood, meanwhile, has become a *grand dame* of the fashion world. In 1981 she became the first British fashion designer to show in Paris since Mary Quant, and in 2004 the V&A gave her a retrospective exhibition. Her string of accolades includes the OBE, the Queen's Award for Export and most recently the DBE, Dame of the British Empire.

# A Designer's Treasure Trove

135 LINEN AND COTTON TWILL, EMBROIDERED WITH CREWEL WOOL curtain, England, about 1650.

V&A: Circ.401-1930

136 LINEN, SCREEN-PRINTED 'Calyx' furnishing fabric, designed by Lucienne Day, manufactured by Heal & Son, England, 1951.

V&A: Circ.190-1954

137 COTTON, ROLLER-PRINTED USING ILETT'S SINGLE GREEN furnishing fabric, made by Hodge, England, about 1818.

V&A: Circ.248-1956. Given by the Calico Printers' Association

138 MOHAIR, WOOL AND NYLON, WOVEN sample, made for Ascher Ltd, Great Britain, 1957.

V&A: T.196-1988. Given by Zika Ascher

139 SPUN RAYON, SCREEN-PRINTED 'Jungle' dress fabric, designed by Felix Topolski, made for Ascher Ltd, London, about 1946.

V&A: Circ.418-1948

140 SILK VELVET AND GOLD-WRAPPED THREAD fragment, probably Bursa, Turkey, 1450–1550.

V&A: 356-1897

The V&A was founded to improve design, and this mission is central to its activities today. Many of its collections have been assembled as a lexicon or visual dictionary of materials, techniques, designs and patterns across cultures and centuries. The textile collection is particularly rich, a treasure trove for any designer or student seeking to understand the endless possibilities of pattern making.

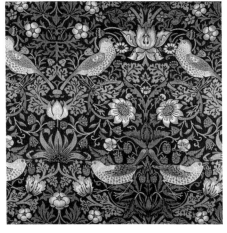
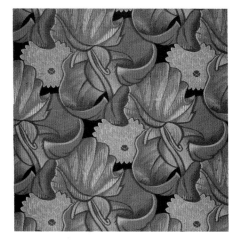

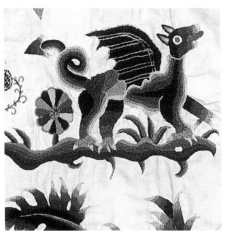

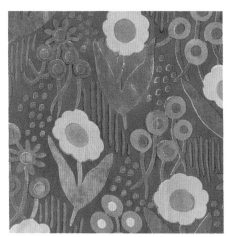

141 LINEN, EMBROIDERED WITH SILK IN REGULAR SURFACE DARNING part of a hanging, Turkey, 1600–1700.

V&A: Circ.92-1953. Given by Miss Ethel C. Newill

142 COTTON, INDIGO-DISCHARGED AND BLOCK-PRINTED 'Strawberry Thief' furnishing fabric, designed by William Morris, made by Morris & Co., London, 1883.

V&A: T.586-1919. Given by Morris & Co.

143 SILK, WOVEN 'L'Afrique' furnishing fabric, designed by Robert Bonfils, made by Bianchini-Férier, Lyons, 1925–8.

V&A: Circ.170-1932

144 LINEN AND COTTON, EMBROIDERED IN CREWEL WOOL bed hangings, made by Abigail Pett, England, 1680–1700.

V&A: T.13B&C-1929. Given by Mr and Mrs W. J. H. Whittall

145 COTTON AND SILK, IKAT WOVEN Thanjavur, India, about 1850.

V&A: 0298(IS)

146 SATIN, BLOCK-PRINTED dress fabric, designed by Atelier Martine, Paris, 1919.

V&A: T.541-1919. Given by Dr W. A. Propert

# European Masterpieces

The Raphael cartoons are among the great masterpieces of Renaissance art. Although they belong to the Queen, they have been on display in the museum since 1865 and have become its most prized exhibit. The original loan was proposed by Prince Albert, though he died before it came to fruition, and it represented a major coup for the new South Kensington Museum. Raphael was universally revered in the nineteenth century, but here he had a special role as an artist who united the fine and decorative arts. The cartoons embody this role as they are designs for tapestries (traditionally called 'cartoons' because they were drawn on large sheets of paper, *cartoni* in Italian).

Raphael designed the tapestries for one of the most prestigious locations in Rome: the Sistine Chapel in the Vatican. Michelangelo's ceiling had been completed in 1512, and three years later Pope Leo X commissioned Raphael to design ten tapestries to hang around the walls on major feast days. The tapestries

**147 THE MIRACULOUS DRAUGHT OF FISHES**
by Raphael, about 1515. This is one of the
cartoons for tapestries in the Sistine Chapel.
In the mid-19th century, when the V&A was
founded and the cartoons first came to the
museum, Raphael was regarded as the greatest
painter of all time.
V&A: ROYAL LOANS.2. On loan from the collection of
Her Majesty the Queen

**148 THE BALLET SCENE FROM MEYERBEER'S
OPERA ROBERT LE DIABLE** by Hilaire-Germain
Edgar Degas, 1876. The gift of an Anglo-Greek
stockbroker, this was the first painting by
Degas to enter a public collection in Britain.
V&A: CAI.19. Bequeathed by Constantine Alexander Ionides

are still in the Vatican – they were woven in
Brussels at a cost of 16,000 ducats, over five
times the cost of Michelangelo's ceiling – but
the seven surviving cartoons came to England.
They were purchased in 1623 by Charles I,
when Prince of Wales, for use in the tapestry
factory he had founded in Mortlake.

The theme that unites the whole sequence
is the Acts of the Apostles, specifically those of
St Peter, the first pope, and St Paul, preacher
and moral authority of the early Church. *The
Miraculous Draught of Fishes* [147] illustrates
the passage in the gospel of St Luke (5:1–11)
when Christ summons Peter, who was then a
fisherman, to join his cause, saying 'henceforth
thou shalt catch men'.

For reasons connected with the weaving
process, all the cartoons are in reverse, so
the image has to be read from right to left,
culminating in the figure of Christ with his
left hand raised in blessing. A reflection in the
water shows that his robe was originally red,

the colour of sacrifice and majesty, but has now
faded to white. Behind the fishermen – four
heavily muscled, lightly draped figures – is the
oarsman, whose raised forearm echoes that of
Christ; his pose is taken from a classical statue
of a river god. Fish tumble around the open
boats, cranes stand guard in the foreground,
and ravens circle in the sky above. These birds
may have a symbolic function, with the cranes
representing vigilance and safe keeping, and
the ravens heresy.

The ballet scene [148] came to the V&A in
1900 as part of the Ionides Bequest. It has the
distinction of being the first painting by Degas
to enter a British public museum – five years
later the National Gallery rejected an offer of a
Degas. Constantine Ionides was an enlightened
collector of contemporary art, both British and
European, and he bought this painting in 1881,
just five years after its completion.

It must then have seemed strikingly mod-
ern, in both its composition and its subject

matter. The picture plane is divided into two
bands, with the ballet scene of phantom nuns
a ghostly blur in the upper register, and orches-
tra and first three rows of the stalls crammed
into the lower. By implication the viewer is also
here, observing the performance from a low
angle as if part of the audience. The figures are
cropped in the abrupt manner of a Japanese
print, but among them are friends of Degas:
the collector Albert Hecht on the extreme left,
looking out of the picture with opera glasses;
the bassoonist Désiré Dihau in profile with
his back to Hecht; and the amateur painter
Vicomte Pepic in the foreground, with a beard.

This apparently casual scene is, like all
Degas' paintings, the result of stringent
observation. In a notebook of 1869 he wrote,
'Work hard on the effects of evening, lamps,
candles, etc. The intriguing thing is not to
show the source, but the effect of light'.

# A National Gallery of British Art

The V&A has over two thousand oil paintings, including the world's largest collection of works by John Constable. These paintings may seem an anomaly in an institution that is historically devoted to design, but actually they were central to the educational purpose of the museum: in forming taste, whether that of designers, manufacturers or the public, examples of fine art were essential.

The origins of the collection lie in the generosity of a private collector, John Sheepshanks. The son of a wealthy cloth manufacturer, Sheepshanks collected modern British paintings and was friendly with many leading artists. In 1857, the year that the museum moved to South Kensington, he donated 233 oil paintings, along with many watercolours and drawings, as the foundation of a 'National Gallery of British Art'. The

idea that the V&A should be responsible for collecting modern British art remained until 1908, when the Tate took over that role.

Like many in the Victorian period, Sheepshanks harked back to the past, to the peaceable certainties of rural England that seemed threatened by the pressure of urbanization. John Constable made these fears the subject of his great landscape paintings. *Salisbury Cathedral* [149] shows one of England's most famous medieval buildings – emblem of the Anglican Church that Constable revered – rising serenely out of the water meadows and framed by ancient trees; but the trees seem ready to topple and the sky is dark with clouds.

To John Fisher, the elderly Bishop of Salisbury, who commissioned the painting and appears on the left with his wife, these clouds

were unsettling. Constable was very fond of the Fisher family, so in other versions of the scene he obliged them by painting a 'more serene sky'. The sky was his obsession, the key to his discovery that the meticulous depiction of nature could be married to an emotional and deeply personal interpretation of a subject. 'It will be difficult', he wrote, 'to name a class of landscape in which the sky is not the keynote, the standard of scale, and the chief organ of sentiment…. The sky is the source of light in nature, and governs everything.'

*Salisbury Cathedral* is a highly finished picture intended for the Royal Academy summer exhibition, but the V&A also has many of Constable's sketches, his rapid, on-the-spot investigations of clouds, light and meteorological phenomena. These were the gift of his daughter Isabel, who in 1888 gave the remaining contents of his studio – nearly four hundred works – to the museum.

Another gift that shaped the V&A collection of paintings was that of Constantine Ionides, an Anglo-Greek stockbroker. He came from a highly cultivated family, part of the Holland Park circle that included writers, poets, photographers and artists. *The Day Dream*

149 SALISBURY CATHEDRAL FROM THE
BISHOP'S GROUND by John Constable, 1823.
This was one of the 233 oil paintings given
by John Sheepshanks. His gift formed the
foundation of the V&A's picture collection.
V&A: FA.33. Given by John Sheepshanks, 1857

[150] was commissioned from his friend Dante Gabriel Rossetti, a mercurial poet and painter of Italian extraction. Rossetti had been a founder of the Pre-Raphaelite movement but later he became more narrowly focused on the idealization of female beauty, particularly that of William Morris's wife, Jane.

Rossetti was entranced by Jane Morris and drew her over and over again. This portrait, painted in the last year of his life, shows her in a sycamore tree holding a wilted sprig of honeysuckle. Laden with symbolism – of Dante and courtly love, of Eve and the Tree of Knowledge – it was originally set in springtime but evolved into a more melancholic depiction of autumn.

In letters to Ionides, Rossetti was confident that *The Day Dream* was 'beyond question as good a thing as I ever did'. He also set out the conditions in which it should be displayed: 'It ought to stand with the light from the left of the spectator, as here, otherwise it will lose in effect.'

When Ionides himself died in 1900 he left his collection to the V&A. The prints and drawings, including outstanding works by Rembrandt and Whistler, can be viewed in the Prints and Drawings Study Room; the paintings are hung in one of the original picture galleries, with the light falling from the left on to Jane Morris's handsome face and long, bony hands.

150 THE DAY DREAM by Dante Gabriel Rossetti, 1880. The sitter is Jane Morris, wife of William Morris, and the title comes from a poem by Rossetti. Constantine Ionides, who bequeathed the painting to the museum, collected modern British painting as well as unusual work from earlier periods.

V&A: CAI 3. Bequeathed by Constantine Alexander Ionides, 1900

151 THE NATIVITY by Jean Bourdichon, about 1498. Miniature painting was linked to the art of book illustration. This is a page from a prayer book probably made for Louis XII of France.

V&A: E.949–2003. Purchased with the assistance of the National Heritage Memorial Fund and The Art Fund and the Friends of the V&A

# The Art of Limning

In 1598 the great English miniature painter Nicholas Hilliard wrote a treatise called *The Art of Limning*. In it, he described his craft as 'a thing apart … which excelleth all other painting'. This ambitious statement reflects the status of miniature painting in England, where it was practised separately from oil painting and gave rise to an independent tradition of portraiture that lasted for nearly three hundred years.

The word limning derives from 'illumination', the use of watercolour to illustrate books and manuscripts. The better-known term 'miniature' also originates in book production; it has nothing to do with smallness, but instead comes from the Latin word *miniare*, meaning to colour with red lead.

The *Nativity* by Jean Bourdichon [151] shows illumination vying with oil or panel painting in making a single dramatic image without any accompanying text. It comes from a richly decorated prayer book probably made for Louis XII of France to mark his coronation in 1498. The king's third wife, Mary, was a daughter of Henry VII, and she may have brought the book to England when she returned as a widow in 1515.

Bourdichon was official painter to four French kings. As such, he worked in many different media and even decorated the tents for the Field of the Cloth of Gold, that historic encounter between Henry VIII of England and Francis I of France. His tender portrayal of the Nativity recalls the fact that the word 'illumination' derives from another Latin word, *luminare*, meaning to give light. In it Bourdichon distinguishes three sources of light: the earthly light of Joseph's lantern, the heavenly light that pours through the roof, and the divine light than emanates from the Christ Child.

The art of the portrait miniature flourished at the French and English courts in the 1520s. Hans Holbein, the King's Painter, appears to have learned it from Lucas Hornebout, a Flemish artist who also worked for Henry VIII.

152 ANNE OF CLEVES by Hans Holbein the
Younger, 1539, with ivory case. Anne was to
become the fourth wife of Henry VIII. Holbein
was sent to Germany to record her features,
but when she arrived in England the king was
disappointed.

V&A: P.153:1, 2–1910. Salting Bequest

153 PORTRAIT OF AN UNKNOWN GENTLEMAN
by John Smart, 1789. John Smart is said to
have worked with 'exactness' and 'without any
flattery'. This arresting portrait may show an
Armenian or Jewish merchant.

V&A: P.16–1984. Bequeathed by Mrs K. Gifford Scott, from
the Hugh John Burton collection

The portrait of Anne of Cleves [152], which the connoisseur Horace Walpole described as 'the most exquisitely perfect of all Holbein's works', was commissioned as part of Henry's search for a fourth wife. Anne, from a small Protestant German court, was said to have an amenable personality but observers were equivocal about her appearance. Holbein was dispatched to Germany to obtain a likeness for the king's approval, probably making a careful life drawing as a basis for this miniature; perhaps unwisely, he showed the princess full face so as to minimize the length of her nose.

Unfortunately, when the marriage took place the following year, the king found that Anne was 'nothing fair and have very evil smells about her'. Unable to consummate their union, he claimed that the marriage was invalid and pensioned her off as the 'King's sister' so as to pursue his fifth wife, Katherine Howard.

The portrait of Anne of Cleves has a case of turned ivory, probably original. Finely worked cases are often found with miniatures, as the portraits were intensely private and intimate, for private perusal not public display. A poem by John Donne suggests that a lover would wear a miniature close to his heart:

*Here, take my Picture; though I bid
farewell, Thine,
in my heart, where my soule dwells,
shall dwell*

The miniature by John Smart [153] was made in a very different sphere from that of Anne of Cleves. In the late eighteenth century, with so many miniaturists competing for work in London, some enterprising artists set off for India, then 'an El Dorado for young men in search of a fortune'. John Smart spent ten years in India, between 1785 and 1795, mainly in Madras. His clients were East India Company officials anxious to keep in touch with their loved ones in England, as well as European merchants and wealthy Indians.

This miniature by John Smart is a fairly recent acquisition, dating from 1984, in contrast to *Anne of Cleves*, which formed part of the Salting bequest in 1910. Salting's gift laid the foundation for the V&A's national collection of British and European miniatures. It included 129 miniatures, one of them being the *Young Man among Roses* (see page 52).

**154 BOOK OF HOURS OF MARGUERITE DE FOIX**
France, possibly Rennes, 1470s. Marguerite
was the second wife of Francis II, Duke of
Brittany. Her book of hours contains 12 full-page
miniatures and a special prayer that she might
conceive a child. After five years of marriage
Margaret eventually had a child in 1476.

NAL: MSL/1910/2385. Salting Bequest

# The National Art Library

The library at the V&A dates back to the very foundation of the museum, to when the Schools of Design had a small collection of books on practical subjects. Since then it has become central to the museum's activities, with over one million books and a similar volume of archival material. It has a threefold purpose: to act as the National Art Library, to support the work of the curators, and to document the arts of the book – illumination, illustration, typography and binding.

In the Islamic world, where a book – the Qur'an – was central to religious belief and practice, the arts of calligraphy and binding had a unique status. This binding from Mamluk Egypt [155] is richly embellished by 'tooling in gilt', in which a heated brass tool is pressed against gold leaf. The technique, which became a standard form of book decoration throughout the western world,

is actually an Islamic invention; it reached Europe through Italy in the early fifteenth century. Another Islamic innovation, but one that never took hold in the West, is the fore-edge flap which tucked around the pages and protected them in the manner of a portfolio.

The illuminated book made for Marguerite de Foix [154], dating from the same period as the Mamluk binding, is an example of a volume that would have been found in most literate, Christian households. Known as a book of hours, it is a private prayer book

with sequences of psalms for each hour of the liturgical day – Matins through to Compline. As well as these religious texts, a book of hours would include illustrations from the life of Christ and the Virgin, and a calendar with signs of the zodiac and agricultural activities for each month.

In the late Middle Ages, ten of thousands of these books of hours were produced. Most were small volumes with simple, uncoloured woodcuts, but some were lavishly decorated for wealthy patrons. Wherever they lay in the

**155 BINDING** Egypt, probably Cairo, 1470–1520.
In the Islamic world, with the reverence given
to the Qur'an, the arts of the book had a special
status. This fine binding may have been made
for the Mamluk sultan Qa'itbay or one of his
successors.

NAL: L.531–1983

price range, books of hours were the result of mass production, in which a bookseller would orchestrate all the different specialists: the scribes (or towards the end of the period, the printers), the block-cutters, the illuminators, the gilders, the binders. The text was fairly standard, but individual patrons would ask for particular illustrations, special prayers and perhaps pages with their coats of arms.

Books of hours were largely anonymous, and we know the names of very few of the many thousands of craftsmen, and women, involved in their production. By contrast, Matisse's *Jazz* [156] is emphatically the work of one individual. It is a *livre d'artiste*, an example of a genre invented in Paris around 1900 by the art dealer and publisher Ambroise Vollard.

A definition of a *livre d'artiste* is that each illustration is an original work executed by the artist directly onto the support on which it is printed. In fact, by the time Matisse conceived these illustrations he was confined to bed and so ill that he could only do paper collages. His compositions were then printed using a stencilling technique known as 'pochoir'. Stencils were cut by hand, and printing was done using the same gouache paint as had been used to colour the paper cut-outs. Matisse provided a hand-written text which was reproduced by lithography. He prefaced his text with a plea that his words be treated with 'the indulgence usually given to the writings of painters'.

The use of cut-outs was, for Matisse, a form of direct carving, a technique that brought together his gifts for drawing, painting and sculpture. When reproduced in the stencil technique, they made a subtle patchwork of interlocking, vibrantly coloured forms that had no precedent in book art. The imagery of the 20 prints is rich and varied, some relating to his personal experiences, some to the world of music hall and circus, some to the recent horrors of war; with no set text to follow, Matisse was free to invent his own structure and also the title *Jazz*, which for him implied 'chromatic and rhythmic improvisation'.

Despite his infirmity, Matisse found the work exhilarating. He wrote to Tériade, his publisher, 'this old project keeps me from sleeping: the modern "illustrated manuscript"'.

156 'THE SWORD SWALLOWER' from *Jazz*, by Henri Matisse, published by Tériade, 1947. The illustrations originated as paper collages but were printed in a stencilling technique known as 'pochoir'.
NAL: L.338–1948 © Succession H. Matisse/ DACS 2010

**157 FISHING AT THE FALLS OF ROSSIE** Horatio Ross, 1847. This is a very early daguerreotype, the work of an amateur photographer and given to the V&A by his descendant in 1946.

V&A: 244–1946. Given by Major Ross

**158 AGRA: THE FORT, THE PALACE OF AKBAR, WITH TAJ IN THE DISTANCE** by Samuel Bourne, about 1865. The museum has been collecting photographs since its foundation. Some were acquired for their artistic value, others – like this view of India – as records of places and buildings.

V&A: 53:243

# Home and Abroad

The photograph of a boy fishing in Scotland [157] dates from the dawn of photography. It is a daguerreotype, taken in 1847, only eight years after the technique had been invented in France by Louis-Jacques-Mandé Daguerre. Like many of the pioneers of this new art form, the photographer, Horatio Ross, was a wealthy landowner – more famous during his lifetime for his sporting exploits than for his photographic achievements.

Although the photograph appears to be a snapshot, it was in fact painstakingly staged and captured on the silvered copper plate. The blue sky was a happy accident. Daguerreotypes are normally monochrome, but here the relative brightness of the sky has caused 'solarization', a reversal of white into blue.

Although the V&A only acquired this remarkable image in 1946, the museum was not slow to recognize the value and potential of photography. The first director, Henry Cole, was an amateur photographer and a friend of another great pioneer, Julia Margaret Cameron. He began to acquire photographs in 1856 and two years later held the first exhibition of photography to be staged in any museum. As with so much of Cole's activity, his aim was largely educational. Photographs

were useful in recording, analysing, disseminating and teaching art and design, though Cole did also value them as works of artistic expression. He set up the first museum photographic service, under the leadership of his brother-in-law Charles Thurston Thompson, and laid the foundations of the museum's vast photographic archive. When Bourne & Shepherd sent their first catalogue to the museum in 1866, Cole bought the lot: 668 photographs for £205 16s 9d.

Bourne & Shepherd had been founded by in 1862 by Samuel Bourne, a banker who threw up his career to set up a photographic business in India. At the time his work would have been seen as an accurate record of the landscape, architecture and culture of India, but now we view it as a skilful construction of a picturesque and exotic East. In his view

of the Taj Mahal [158] our eye is led from the two posed figures in the foreground, to the fort where Shah Jahan was imprisoned by his son, to the distant marble tomb where his beloved wife lay buried.

The photograph by Clementina, Lady Hawarden [159], is in many ways the polar opposite of Samuel Bourne's. He was a commercial photographer, lugging his equipment around India to document its landscape and architecture; she was an aristocratic amateur, the mother of ten children working on the top floor of 5 Prince's Gardens, just a few minutes walk from the South Kensington Museum.

Although Lady Hawarden did exhibit her work, her subject matter was largely domestic and feminine. Nearly everything about it is ambiguous. The models were her daughters, but they were not named and the photographs were simply described as a 'Photographic Study' or 'Study from Life'. The settings are her home, but mirrors, curtains, shadows and shafts of light undermine any real sense of location. The mood is dreamy, full of romance and yearning but with no obvious narrative.

This dream was shattered when Lady Hawarden died at the early age of 42. Her work lay forgotten in albums until 1939, when the V&A held an exhibition to celebrate a hundred years of photography. Lady Hawarden's granddaughter visited the exhibition and when she found it had no examples of her grandmother's work, she immediately donated 775 photographs to the museum. Many had been torn from the original albums, hence the ragged corners that add to their air of fragility and improvisation.

159 PHOTOGRAPHIC STUDY by Clementina, Lady Hawarden, about 1863–4. Lady Hawarden's work was forgotten until the 1940s.

V&A: Ph.335–1947. Given by Lady Clementina Tottenham

# Camera and Camera-less

In the early years of the twentieth century the V&A was ambivalent in its attitude to photography. It collected photographs as a visual encyclopaedia, particularly if they recorded buildings and qualities that were prized as typically English, but it showed little interest in photographs as works of art. The decisive moment came in 1969, when the museum held a retrospective of work by Henri Cartier-Bresson. The Circulation Department had begun collecting contemporary photographs for touring shows, but this was the V&A's first major display of photography as an art form since the Julia Margaret Cameron exhibition of 1865.

Along with Bill Brandt (who was also the subject of an early V&A exhibition), Cartier-Bresson was one of the giants of twentieth-century photography. Combining an acute social conscience with an impeccable grasp of formal organization, he turned photographic reportage into an art. He rarely cropped his photographs, and the only camera he ever used was a Leica with a 50mm lens. The Leica had been introduced in the 1920s; in contrast to earlier cameras, it was small, light and unobtrusive but had an excellent lens. This enabled photographers to take images of the highest quality without disturbing, or alerting, their subjects.

*Mississippi* [160] shows Cartier-Bresson's uncanny ability to seize the moment when form converges with the subject matter. It shows two black men squeezed on a narrow seat, and visually compressed by the framing elements of the composition, while a single white man lounges on a generous bench. Cartier-Bresson took the image for a book that was to combat racism in the American South. So tense was the atmosphere that his companion made him shoot the photograph through the car window before speeding away.

For Cartier-Bresson the camera was essential – 'an extension of the eye' – but an

odd thing about photography is that you can have a camera without a photograph, and a photograph without a camera. The use of a camera goes back hundreds, even thousands of years. Before photography was invented, artists used the *camera obscura*, a light-tight room or box with a pinhole. As light passes through the pinhole, it projects the exterior scene onto the interior wall. Tracing over the image, artists could capture a lifelike scene. In the late eighteenth and early nineteenth centuries many people also tried to capture these ghostly forms through some chemical means. However, the basics of photography as we now know it can be traced back to the summer of 1835, when William Henry Fox Talbot discovered a way of fixing the image in a *camera obscura* onto light-sensitive paper, and then of turning this single 'negative' into multiple 'positives'.

But you don't need a camera to create a photographic image. Ever since the early years of photography people have been captivated by the magical effects of light and shadows fixed directly on sensitized paper. At the same time as producing his camera-made negatives, and from them positive prints, Talbot and his contemporaries also created delicate one-off photographic silhouettes by placing objects such as leaves or lace on the sensitized paper and then exposing them to light. In the early twentieth century artists such as Moholy-Nagy and Man Ray used similar techniques to make abstract compositions and suggest surreal worlds.

One of the most interesting recent practitioners of cameraless photography is the English artist Garry Fabian Miller, who has been experimenting with this art form since the 1980s. He works in the darkroom, shining light through coloured glass vessels and over cut paper to create richly coloured series of geometrical images on photographic paper. Despite their recognizable forms, these images remain elusive and open to various interpretations: the *Becoming Magma* title of this image [161] refers to molten rock beneath the earth's surface, the circle perhaps to a planetary or cosmic form. These references to deep time are augmented by the use of the colour red: across languages and cultures, the earliest colour terms are light and dark, followed almost universally by red. 'The pictures I make', says Fabian Miller, 'are of nothing which exists in the world … What I am trying to suggest is a state of mind which lifts the spirits'.

160 MISSISSIPPI **by Henri Cartier-Bresson, 1961. Cartier-Bresson used a 50mm Leica and almost never cropped a photograph, even ones like this, taken at speed in difficult circumstances.**

V&A: Ph. 682–1978.

161 BECOMING MAGMA 2 **by Garry Fabian Miller, 2004. Fabian Miller's unique images are created without a camera, by shining light through coloured glass vessels to create an image on photographic paper.**

V&A: E.367–2005. Purchased through the Cecil Beaton Fund.

Copyright Garry Fabian Miller

162 SAMPLE BOOK compiled by John Kelly, 1763. The V&A collects material that relates to the whole cycle of design, production and marketing. This sample book is inscribed 'A Counter-Part of Patterns sent to Spain and Lisbon by Mr I K February 1763'.

V&A: 67-1885. Given by Mrs Bland

163 PORTRAIT OF VIRGIL SOLIS by Balthasar Jenichen, 1562. Virgil Solis is shown holding his engraving tools and a copperplate with a heraldic ornament. It was printmakers like Solis who disseminated Renaissance ornament throughout Europe.

V&A: E.1234-1926

# Marketing Design

The rapid advances in the technologies of printing and papermaking that took place around 1400 transformed society, just as the invention of the worldwide web has done in our times. As with the web, the impact was not immediate. Gradually, however, the new medium allowed for a Europe-wide exchange of ideas – in both word and image – that had not been possible before.

Virgil Solis was in his own way a tycoon in the age of print. He set up his workshop in Nuremberg around 1540 and died of plague in 1562. His wife then married his assistant Balthasar Jenichen, who engraved this portrait [163]. In this short career of just over twenty years, Solis and his workshop produced over two thousand prints and drawings. His success lay not in his originality or artistic genius, but in his versatility. Working in both

of the principal mediums – woodcut and copperplate engraving – and cribbing designs from the German and Italian masters, Solis produced a whole range of images: playing cards, illustrations for a bible, fashionable subjects such as the Nine Worthies or the Seven Planets, patterns for ornament, designs for goblets, bowls, scabbards and jewellery.

Solis, and others like him, played a vital role in the dissemination of new artistic ideas; arabesque, for example, a type of ornament that originated in the Islamic world and entered Europe via Venice, was popularized by his engravings. The V&A has at least three objects that were made in England but bear decoration based on Solis's prints: a powder flask with the Triumph of Fame, a fragment of painted plaster from a house in Kent with the Seven Planets, and a claviorgan (a cross

between a harpsichord and an organ) with monkeys taken from his playing cards.

With its focus on design, the museum has an enormous collection of prints and drawings that relate to the design process. It also collects material that records the marketing of goods and products. This sample book [162] belonged to John Kelly, a Norwich textile manufacturer who traded with the Spanish and Portuguese market. The fabric is worsted, a hard-wearing wool with a glazed finish that was a speciality of Norwich. A contemporary writer claimed that these worsteds 'were composed of the richest and most brilliant dyes and variegated by an endless diversity of colours [surpassing] any others dyed in Europe'.

To underline the novelty and fashionability of his designs, John Kelly has given them names like 'martinique', 'harlequin', 'floretta' and 'diamantine'. Then, to ensure that there

was no confusion in the ordering, he numbered the designs and kept a matching copy of the sample book.

The museum also has an outstanding collection of advertising posters, tracing the medium from the refined Art Nouveau images to the shock tactics of modern billboards. More than any other medium, advertising posters capture the spirit of the age – the look, the dream, the fears.

The Diesel advertisement [164] is aimed at a youth audience that is sexually open and media-savvy. Its photographer, David LaChapelle, began his career working for Andy Warhol's *Interview* magazine and later became known for his apocalyptic vision and ground-breaking use of computer. In creating this image he has used a faux vintage photograph, showing the crew of a diesel-powered American submarine returning home at the end of the war, and

overlaid it with two sailors kissing. With its cryptic slogan, 'Guides to Successful Living for PEOPLE interested in general HEALTH and mental POWER/ for more information: call U.S. Diesel Team/ (212)575-8222', it invites Diesel wearers into a world of sweaty camp that many high-street customers might fear to enter.

164 POSTER FOR DIESEL **by David LaChapelle and Joakim Jonasson, about 1995. The museum has a huge collection of advertising posters. Many are linked to the fashion world, others to political activism. This, cleverly, is both.**
V&A: E.37-2002

# Design for Performance

**165 ARTWORK FOR THE ROLLING STONES LOGO**
by John Pasche, 1970. Pasche designed this while a student at the Royal College of Art.

V&A: S.6120-2009. Purchased with the assistance of The Art Fund , the Mavis Alexander bequest and the American Friends of the V&A through the generosity of Chris and Nicky Thom

The V&A's theatre collections are among the most comprehensive in the world. They include sketches and stage models, props, accessories and costumes, advertising posters, promotional material and photographs. They range from classical ballet and Shakespearian theatre to pantomime and rock and roll.

The artwork for the Rolling Stones logo [165] is a recent purchase, acquired in 2008 for £50,000. Described as one of the most visually dynamic and innovative logos ever created, it was the work of John Pasche, a 24-year-old student at the Royal College of Art. Pasche said, 'I wanted something anti-authority, but I suppose the mouth idea came from when I met Jagger for the first time…. Face to face with him, the first thing you were aware of was the size of his lips and his mouth.' The logo was first used for the 1971 *Sticky Fingers* album, and since then has become an integral part of the band's identity.

The design for Widow Twankey's costume [166] represents another aspect of British culture. Although pantomime does not enjoy the international success of rock music, it is still enduringly popular in Britain. Wilhelm was one of the most prolific stage designers of his day. He worked on nearly two hundred productions and did much to raise the standards of theatre design in the West End. The sketch comes from a cache of material belonging to Mae Rogers, a wardrobe supervisor for the impresario Prince Littler. It shows how Wilhelm integrated costume and character, and also the attention he paid to colour and texture. His aim, he said, was 'a completeness of ensemble and pictorial effect'. Everything 'had to be perfect at close quarters, down to the finest embroidery and the last button'.

In writing the scenarios and coordinating the choreography, music and design into a coherent whole, Wilhelm anticipated the achievements of Diaghilev in the Ballets Russes. The Ballets Russes burst on the scene

in 1909 and survived for 20 years before disbanding on Diaghilev's death. Initially their identity was strongly Russian – an exhilarating fusion of folk art and modern music – but after 1917 they became more associated with the French avant-garde. When *Le Train Bleu* premièred in Paris in June 1924, *Vogue* declared: 'the Russian ballet is no longer Russian: the cool, quiet, utterly distinguished colours of this ballet are as French as it is possible to be.'

Like all Diaghilev's productions *Le Train Bleu* was a collaboration between many extraordinarily talented individuals. Bronislava Nijinska (Nijinsky's sister) contributed the choreography; Jean Cocteau the libretto; Darius Milhaud the score; Gabrielle 'Coco' Chanel the costumes; Henri Laurens (Romanian sculptor) the sets; and Pablo Picasso the front curtain [167]. The ballet had

**166 COSTUME DESIGN FOR WIDOW TWANKEY**
in the pantomime *Aladdin*, by Wilhelm (William Charles Pitcher), 1885. The V&A's Performance galleries cover the whole gamut of performance, from the quintessentially British pantomime through to classical ballet.

V&A: E.1327-1932

no storyline, other than the idea that a group of fashionable Parisians had just travelled down to the Riviera in the brand-new first-class express, the Train Bleu. Instead, it was a celebration of modernity – of fun, sport and frivolity.

Picasso did not actually paint the front curtain, but he allowed Diaghilev's scene painter, Prince Alexander Schervachidze, to copy it from a small gouache he had made two years earlier. Despite the huge enlargement of scale, from 30 by 40cm to 10 by 11m, the result was a success – so much so that Picasso signed

it and wrote in the corner 'Dédié à Diaghilev'.

This was not Picasso's only involvement the Ballets Russes. He designed four complete productions and married one of the dancers, Olga Koklova. Theatre design allowed him to work on a large scale (though it also brought unwelcome constraints) and introduced him to new concepts of expression and gesture. The giant maenads of *Le Train Bleu* owe their burly physique to the classical statuary that Picasso saw in Naples and their dynamic, abandoned movement to the Ballets Russes.

167 FRONT CLOTH FOR LE TRAIN BLEU from a 1922 gouache by Pablo Picasso, painted in 1924 by Prince Alexander Schervachidze. Picasso's design for *Le Train Bleu* expresses all the energy and modernity of the Ballets Russes.

V&A: S.316–1978. Succession Picasso/DACS, London 2010

168 THE THREE GRACES by Antonio Canova, 1814–17. Contemporary critics believed that only Canova could equal the sculpture of ancient Greek and Rome. This sensuous group is a variant of one made for the Empress Joséphine.

V&A: A.4-1994. Purchased jointly with the National Galleries of Scotland, with the assistance of the National Heritage Memorial Fund, John Paul Getty II, Baron Heinrich Thyssen-Bornemisza, The Art Fund, and numerous donations from members of the public

169 THE SHOUTING HORSEMAN by Andrea Briosco, also called Il Riccio, about 1510–15. For collectors it has always been important to handle sculpture, to explore its form and finish through touch as well as sight.

V&A: A.88:1, 2-1910. Salting Bequest

# To Have and to Hold

In its commitment to bring together art and design, the museum has been collecting sculpture since its foundation. Initially it focused on work that showed fine craftsmanship, but when John Charles Robinson became curator in 1853 he determined to build a first-rate sculpture collection – not classical, which was the domain of the British Museum, but post-classical and European. The V&A is now the 'national gallery' of such sculpture, with a collection that ranges from masterpieces of medieval ivory carving to an important donation by Rodin.

There is, however, a fundamental problem with sculpture in museums: it cannot be handled. You can admire a piece in the round, and study the way the composition develops and harmonizes, but you can never run your hand over a cool marble breast, or explore the finish of a bronze.

This experience of handling sculpture was something that was greatly valued in the Renaissance. Riccio's masterpiece, *The Shouting Horseman* [169], would have been kept in a study or *studiolo* for private perusal by its owner and his cultivated friends. How they must have admired the taut, nervous energy

of the composition, the lively chiselling of the mane and armour, the sense that the horse's paper-thin skin is stretched tight over its bulging veins. But they would also have known that the equestrian statue was a classical form, while the rider himself was one of the *stradiotti*, the Venetian light cavalry who were stationed in Padua, where Riccio mainly worked.

Padua had a famous university and was home to a close circle of humanist scholars. Humanists sought not only to understand the classical past, but to revitalize it – an ambition that is triumphantly realized in this bronze. Like the ancient Romans, on whom they modelled their behaviour and culture, they set great store by these small, classicizing bronzes and spent large sums on a few choice pieces. As a carping critic wrote in 1549, a collector would pay 500 ducats for 'a little antique horse in bronze, which not only cannot carry him but has itself to be borne around', while travelling on foot to save 10 ducats on a real horse.

Canova's *Three Graces* [168] is a more public statement of wealth and connoisseurship. Commissioned by the 6th Duke of Bedford from Europe's most famous sculptor, for the hefty sum of £3,000, it is a close variant of

a version made for the Empress Joséphine shortly before she died. The duke saw the original group in Canova's studio and hoped to buy it, but was pre-empted by Joséphine's son. Canova offered him a 'replica, with alterations' and in 1815 supervised its installation in the duke's new sculpture gallery at Woburn Abbey. It stood in a Temple of the Graces at the west end of the gallery, with top lighting and a revolving pedestal to reveal the sinuous charms of the three nudes to best advantage.

The gallery housed both classical and modern sculpture, but Canova's piece was pivotal as he was thought to be the only contemporary sculptor who could equal the work of the ancients. This group shows the three daughters of Zeus: Thalia representing youth and beauty, Euphrosyne mirth and Aglaia elegance. Celebrated by the poets as companions of Aphrodite, they lived on Mount Parnassus with the Muses.

*The Three Graces* came on the market in the late 1980s. After a strenuous and highly publicized fund-raising campaign, the group was bought jointly by the V&A and the National Galleries of Scotland, and is now displayed alternately in the two museums.

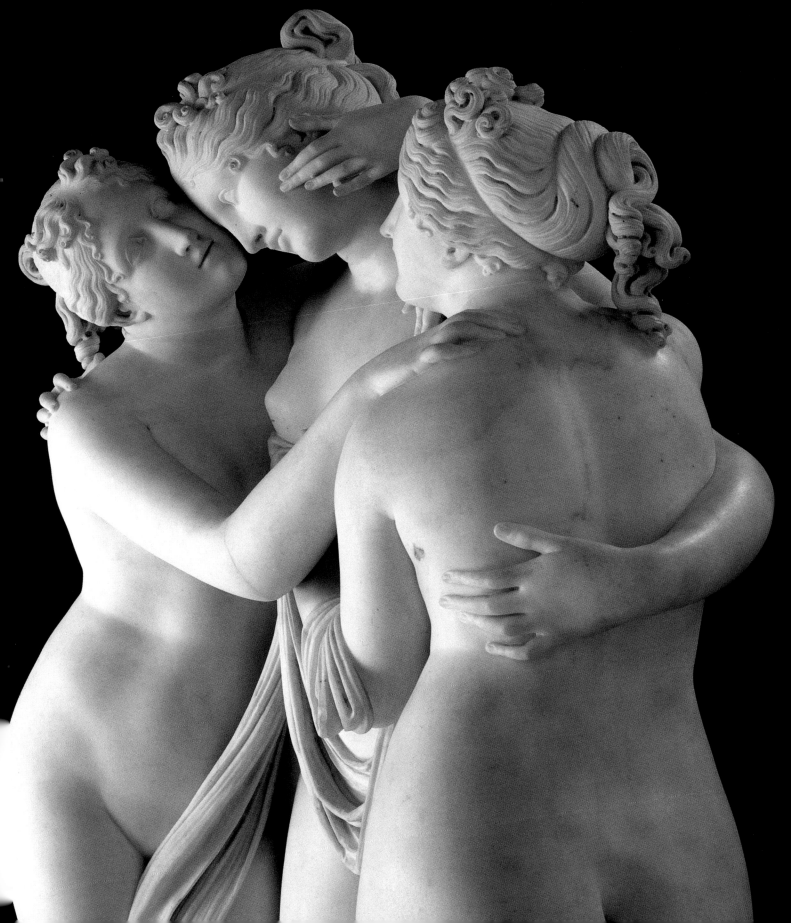

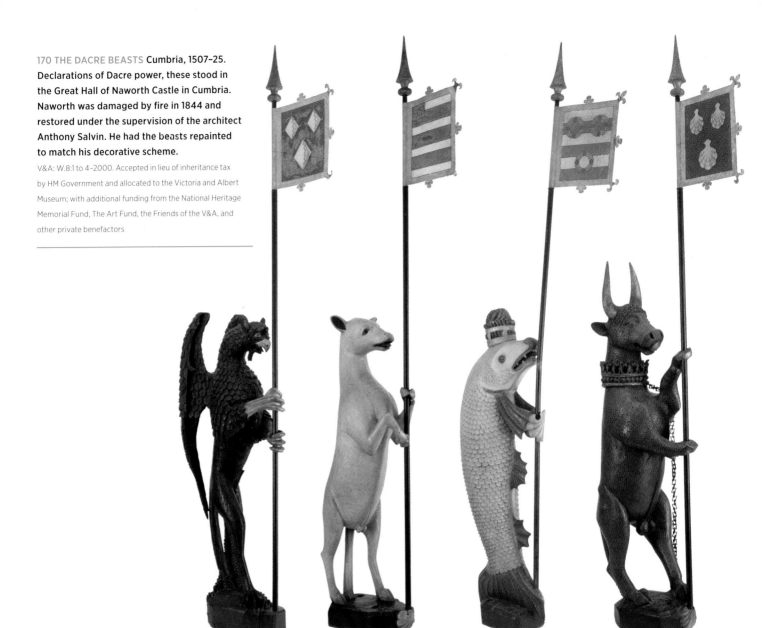

170 THE DACRE BEASTS Cumbria, 1507–25.
Declarations of Dacre power, these stood in
the Great Hall of Naworth Castle in Cumbria.
Naworth was damaged by fire in 1844 and
restored under the supervision of the architect
Anthony Salvin. He had the beasts repainted
to match his decorative scheme.

V&A: W.8:1 to 4–2000. Accepted in lieu of inheritance tax
by HM Government and allocated to the Victoria and Albert
Museum; with additional funding from the National Heritage
Memorial Fund, The Art Fund, the Friends of the V&A, and
other private benefactors

# Beasts, Saints and Heroes

The V&A's collection of British sculpture starts in the Middle Ages and continues up to the early twentieth century, when the Tate takes over. The head of John the Baptist [171] represents a flourishing medieval industry. It was found in Spain – where the slightly macabre bluish lips and trickles of blood might have been added – but made in England, probably in Nottingham. At the time when it was made, Nottingham and the surrounding Midlands had abundant sources of 'true' alabaster, a form of gypsum that has the transparency and smoothness of marble but is easier, and therefore cheaper, to work.

English sculptors turned out alabasters for the home market and for export, but it is mainly the latter that survive, as so much of our religious sculpture was destroyed during the Reformation and later Commonwealth. There are over two thousand alabasters in

171 HEAD OF ST JOHN THE BAPTIST probably
Nottingham, 1470–90. In the late Middle Ages
English sculptors working in alabaster exported
their products to countries throughout Europe.

V&A: A.79–1946. Given by Dr W.L. Hildburgh FSA

172 WILLIAM SHAKESPEARE by John Michael
Rysbrack, about 1730. The heroes of modern
Britain and ancient Rome were a popular subject
for sculpture at this period.

V&A: A.6–1924. Presented by Mrs M.A. Miller, in memory of her
father, Augustus William Roxon

mainland Europe – small devotional panels, larger altarpieces, and heads of John the Baptist. This head, with its crisp carving and gilded hair, was probably a special order for a rich client, either a private individual or a guild. Inventories suggest that these heads could be seen in many English homes; they were kept on a platter, made of wood, alabaster or even silver, and covered by a cloth when not on display. The alabaster head was a gift to the museum from one of the V&A's most genial benefactors, Dr W.L. Hildburgh, who had the delightful habit of giving a present to the museum on his birthday. In 1946, when he reached 70, he gave his whole collection of alabasters, over 260 in total.

The Dacre Beasts [170] are unique survivals of another sculptural tradition, that of heraldic woodwork. Declarations of power, dynasty and sexual prowess, they were commissioned by Thomas, Lord Dacre, probably for the Great Hall in Naworth Castle in Cumbria. Dacre was an impoverished border baron who eloped with an heiress and then expanded his power base to become England's eighth most wealthy

peer and a member of the Order of the Garter. The beasts comprise a red bull with the crest of Lord Dacre, a white dolphin representing his wife Elizabeth de Greystoke, a black gryphon standing for his Dacre ancestors, and a white ram that was the supporter of the de Multon family, another illustrious name in the Dacre ancestry.

Though vigorous and impressive, the beasts are somewhat primitive compared to Italian sculpture of the same date. English sculpture continued to have this slightly provincial air until the early eighteenth century, when an influx of foreign sculptors brought about a transformation.

John Michael Rysbrack, who arrived from Antwerp in 1720 and spent the rest of his life in London, was one of those foreigners. He became the most important sculptor in England, admired for his lively and eclectic style and for his ability to model in terracotta. The diarist John Vertue recognized his talent immediately, noting that his 'modells in Clay are very excellent & shows him to be a great

Master *tho' young*'. He was particularly known for his portrait busts, a genre that was then very fashionable.

The bust of Shakespeare [172] is a model for the stone version in the Temple of British Worthies in the Elysian Fields at Stowe. There the stone bust formed part of a pantheon of great Englishmen – plus one woman, Elizabeth I – representing the dynamism and intellectual abilities of the nation. Each had an inscription, taken from the classics or penned by a member of the Whig coterie that surrounded the patron, Lord Cobham. Drake, for instance, was described as 'the first of Britons who ventured to sail round the globe; and carried into unknown seas and nations the knowledge and glory of the English name'.

Such busts of illustrious Englishmen were fashionable in an age that defined itself through its historic freedoms and its Protestant individualism; and Rysbrack, though a foreigner and a Catholic, did more than any other artist to express this incipient British identity.

# At the Court of the 'Great Mogul'

*On his head he wore a rich turbant
with a plume of herne tops, not many
but long; on one side hung a ruby
unsett, as big as a walnut; on the other
side a diamond as greate; in the middle
an emerald like a harte, [but] much
bigger ... Around his neck he carried
a chaine of the most excellent pearles,
three double (so great I never saw).*

The wide-eyed author of this description is Sir Thomas Roe, the first English ambassador to India, in the years 1615–19. Another European visitor, François Bernier, wrote around 1660: 'the consumption of fine cloths of gold, and brocades, silks, embroideries, pearls, musk, amber and sweet essences, is greater than can be conceived'. Both men were familiar with the splendour of a European court – Roe had served Queen Elizabeth, and Bernier was reporting to Colbert, Louis XIV's chief minister – yet both were overwhelmed by the wealth and excess of the 'Great Mogul'.

The Mughal emperors were not merely magnates, buying and commissioning works of art to enhance their status and glorify their rule. They were also deeply knowledgeable about calligraphy, painting, gardening, literature, gemstones and architecture. The dynasty had been established in 1526 by Babur, descendant of the great Central Asian ruler Timur, but the first 30 years of Mughal rule were shaky. It was not until Akbar came to the throne in 1556 (two years before Elizabeth) that the Mughals were able to consolidate their authority and devote huge resources to building and the production of art.

The *Akbarnama* is the official chronicle of the reign of Akbar. It was written by his court

**173 ROYAL MUSICIANS PERFORM AT THE MARRIAGE OF MAHAM ANAGA'S SON** by La'l and Sanwala, 1590–95. This comes from the *Akbarnama*, the official history of the reign of Akbar. Like many of the Indian objects in the V&A, it once belonged to a British official in India.

V&A: IS.2:9–1896

historian and biographer, Abu'l Fazl, between 1590 and 1596, and illustrated in this imperial copy by about 49 different artists from the royal workshops. This page [173] shows Akbar at the age of 12, seated on a throne, with his foster mother Maham Anaga to his right. Before him, royal musicians celebrate the marriage of her eldest son. The emperor wears a simple white garment but has a plume in his turban and a jewelled necklace. The festivities appear to be taking place in a courtyard but, as in the great encampments that the Mughals so loved, the decoration is provided by textiles: rich brocades and velvets, embroidered canopies and flowered carpets.

The jade wine cup [174] was a personal possession of Shah Jahan, creator of the Taj Mahal. It is engraved 1067 of the Muslim era (AD 1657) and inscribed with one of his titles: 'The Second Lord of the Conjunction'. This is a tribute to his ancestor Timur, who was thought to have been born under two favourable planets and so called himself the 'Lord of the Conjunction'. The jade is a further tribute to Timur, for it was not an Indian material but one associated with China and Central Asia.

Jade is an extremely difficult stone to work. Too hard to chisel, it has to be cut with a bow saw impregnated with corundum powder, or drilled with a diamond tip. Yet this cup appears as soft and tactile as wax. Worked to the point of translucency, it takes the form of a gourd, resting on a lotus petal foot and sweeping gracefully into the head of a wild goat. As with other Mughal objects, the cup shows a fusion of Indian and foreign influences: the gourd is Chinese in origin, the lotus Hindu, and the goat's head European.

**174 JADE WINE CUP** India, 1657. One of the finest jades in existence, the cup belonged to the Mughal emperor Shah Jahan.

V&A: IS.12–1962. Purchased with the assistance of The Art Fund, the Wolfson Foundation, Messrs Spink and Son, and an anonymous benefactor

**175 THE CAREW SPINEL** India, 1600–1700. In Mughal India, gemstones were an attribute of kingship. This enormous spinel bears the names of three successive emperors: Jahangir, Shah Jahan and Aurangzeb.

V&A: IM.243–1922. Bequeathed by the Rt Hon. Julia Mary, Lady Carew

**176 CARPET FRAGMENT** possibly Kashmir, about 1650. The carpets shown in the painting are probably Iranian, but Akbar also set up carpet workshops in India. The very fine weave and the use of goat hair, or pashmina, give this fragment the feel of silk velvet.

V&A: IM.153–1926

177 CABINET Gujarat or Sindh, 1575–1625. With
the discovery of sea routes to the East, Indian
goods became highly desirable in Europe.

V&A: IM.16&A–1931. Given by Mrs Beachcroft

# Indomania

The cabinet was a European invention that doubled as a status symbol and a place to store valuables. But this particular example [177], veneered in ebony and inlaid with ivory, has a distinctly exotic air. On the outside are Indian gentlemen, enmeshed in delicate foliage; some dance, some converse, some hunt with elephants, horses and falcons. They each wear an Indian robe (*jama*) and sash (*patka*), and sport the curly moustaches seen in Gujarati and Rajasthani painting.

A tour de force of Indian workmanship, the cabinet was made in Gujarat or Sindh and exported to Europe via Portuguese traders. It shows the astonishing ability of Indian craftsmen to copy foreign models and meet the demands of an export market. As an English visitor observed in the late seventeenth century, 'The Indians are in many things of matchless Ingenuity in their several Imployments, and admirable Mimicks of whatever they affect to copy after'.

Similar excellence could be seen in Indian cottons. In a period when European textile workers could only manage simple, block-printed patterns in fugitive colours, the Indians had perfected a method of dyeing elaborate pictorial designs in rich, deep, fast tones. They achieved this by drawing the outlines with a pen, then treating the cloth with repeated applications of mordants and resists before dyeing. These cottons became known as 'chintz', from the Indian word *chint*, meaning to sprinkle or spray. By the mid-seventeenth century, 75 per cent of Indian exports were cottons. Only some had elaborate dyed patterns – most were plain, checked or striped – but all were washable, affordable and infinitely more desirable than the woollens and linens used in Europe.

The decorative chintzes were initially used for bed curtains, bedspreads and wall hangings. As these wore out, they were given to the servants and turned into garments. Then, in a shocking departure from the laws of social precedence, the upper classes began to copy their servants in wearing the same

colourful cottons. In 1694 an agent wrote to his Indian supplier: 'the greatest ladies will wear chintz for upper garments as well as for petticoats … you can never make or send us too many of them.'

These cottons [178] were made on the Coromandel Coast in south-east India. Agents of the East India Company supplied up-to-the-minute designs from England and controlled a network of suppliers. As the Company grew and prospered throughout India, and as the Mughal Empire weakened, it was able to assume political control over great swathes of the subcontinent. A key moment was the battle of Plassey in 1757, when the Company outmanoeuvred the Mughal governor of Bengal and installed a puppet ruler in his place. Murshidabad became the administrative capital of the new Presidency and its miniature painters soon found work among the Company officials.

William Fullerton, whose portrait is executed with the 'grey precision' of the Murshidabad court style [179], was a Scottish surgeon in the employ of the East India Company. Like many Britons in India at this period, he enjoyed an Indian lifestyle and probably had an Indian wife or *bibi*, though he did not go so far as to adopt native dress.

Back in Britain, chintz was still the height of fashion despite repeated attempts by English weavers to stem the flow. In 1701 a law had been passed forbidding the import of Indian printed cottons except for re-export; another, even tougher law was passed in 1724; but neither had much effect. The East India Company found ways to circumvent the ban, and smugglers ensured that there was a steady supply of goods for wealthy buyers. In the end, it was not the law that killed off the Indian trade, but improvements in technology. With the invention of copperplate printing, roller printing and the spinning machine, English manufacturers were eventually able to make cottons that rivalled the Indian imports.

By the time of the Great Exhibition in 1851, there had been a turnaround. English goods were flooding into the subcontinent, but the controlled flat patterns of Indian textiles had come to the attention of the design reformers, who saw them as a way of reinvigorating the debased European tradition.

178 COTTON JACKET Coromandel Coast, about 1775. Until the late 18th century, Indian cottons were more colourful and colour fast than their European equivalents. This made them popular for both clothing and furnishing, so much so that the British government tried to restrict the trade.
V&A: IS.11-1950. Given by G.P. Baker

179 PORTRAIT OF AN EAST INDIA COMPANY OFFICIAL probably William Fullerton, by Dip Chand, 1760–63. At this period British officials in India often showed a keen interest in Indian culture and lifestyles. Fullerton has a *paan* set at his side and a hookah or water pipe in his hand.
V&A: IM.33-1912

180 VIEW OF THE NAVE OF AYASOFYA LOOKING
EAST by Gaspard Fossati, 1852. Ayasofya is the
great masterpiece of Byzantine architecture. It
was built as a cathedral, but became a mosque
after the Ottoman conquest. In 1934 it ceased
to be a mosque and reopened as a museum, but
with an area still used for prayer.
V&A: SP270.2

# Inside the Mosque

In contrast to a church, a mosque has no liturgy and no priesthood, other than the imam who gives the Friday sermon. Instead, it is a place of assembly where people gather for communal prayer. At other times they might listen to a teacher or study the Qur'an – or just doze, rest and enjoy the cool, calm space.

Ayasofya only became a mosque in 1453, when Sultan Mehmet II conquered the Byzantine capital of Constantinople. It had been built during the reign of Justinian, in the years AD 532–7, to accommodate the complex liturgy of the Orthodox church. The dome, the largest in Christendom until the completion of St Peter's in Rome, was a symbol of the emperor's universal sovereignty. This claim, alongside the size and splendour of the church, made it the greatest trophy of the Ottoman conquest. The Ottomans preserved its Greek name, Hagia Sophia or 'Holy Wisdom', but converted the church into a mosque by plastering over the mosaics and wall paintings, and stripping out the altar, the relics and other instruments of Christian worship. In their place they installed a marble minbar or pulpit and a mihrab to indicate the direction of Mecca.

In the 1840s Ayasofya was damaged by an earthquake and the sultan commissioned the Fossati brothers, two Italian architects working in Istanbul, to undertake repairs. They exposed the surviving mosaics and frescoes, and also published a splendid set of lithographs showing both external and internal views of the church. Fossati's view [180], looking to the east, shows the thickly carpeted floor, the raised platform where the sultan prayed behind screens, the hanging lamps and the large calligraphic plaques suspended from the piers at gallery level. Written in gold on a green ground, these plaques bear the names of God, Muhammad, the first four caliphs, and Hasan and Husayn, grandsons of the Prophet. They were the work of the same calligrapher who renewed the Qur'anic inscription in the dome.

181 QUR'AN MANUSCRIPT by Mustafa ibn Muhammad, about 1680–1703. The scribe who signed this Qur'an is probably the Ottoman sultan Mustafa II.
V&A: 23.ix.1890

182 MOSQUE LAMP Turkey, probably Iznik, about 1557. Although called a lamp, this vessel is symbolic rather than functional. It was made for the Süleymaniye mosque in Istanbul.
V&A: 131–1885

This use of calligraphy is a standard practice in Islam. The word of God, as revealed to the Prophet Muhammad and set out in the Qur'an, is the foundation of Islamic belief and moral conduct. At the same time, images of living beings are discouraged in any religious context (though not always in a secular one) for fear of idolatry.

The great reverence given to the holy text meant that calligraphy in the Arabic script enjoyed an exalted status. Scribes used the finest materials – including gold and ultramarine – and underwent years of training. This Qur'an [181], with a richly ornamented frame around its opening pages, is the work of a scribe who called himself Mustafa ibn Muhammad; it seems likely that he was the Ottoman sultan Mustafa II, who ruled from 1695 to 1703. The text is written in the *naskh* style, one of a group of styles known as the Six Pens that were often used for religious manuscripts.

The ceramic mosque lamp [182] also includes a Qur'anic verse, 'Allah is the Light of the heavens and the earth. His Light is as a niche wherein is a lamp'. Though called a lamp,

and fitted with suspension chains, it cannot have been functional as there is no means for the light to escape. Instead, it probably hung among smaller glass lamps to add visual interest, as did the metal lamps on which it was modelled.

The lamp was also an example of the latest ceramic technology. It comes from the Süleymaniye mosque in Istanbul, commissioned by Süleyman the Magnificent and completed in 1557. The mosque, inspired by Ayasofya in plan, was decorated with tiled revetments made in Iznik fritware. Both the lamp and the revetments included the colour red, which was new in Iznik ceramics. This vibrant red was made by diluting a special clay and applying it as a slip before glazing and firing. When perfected, the red formed a slight relief on the surface of the vessel; in the more experimental stage here, the slip was too thin to create a solid colour. Despite this, the lamp is important as the earliest datable use of the colour red in Iznik vessels and as the sole survivor of those made for the Süleymaniye.

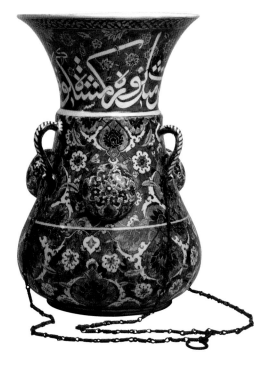

# Imperial China

Most of the Chinese objects in the V&A are ceramics, acquired as examples of ceramic technology and design; but there is also a broader collection of textiles, furniture, jades, metalwork, paintings and prints. Many of the finest items evoke the splendour of imperial China, a subject that had a great hold on the public imagination in the late nineteenth and early twentieth centuries.

The emperor in particular had an extraordinary mystique as the sole link between heaven and earth – the 'Son of Heaven' who wielded huge power over a vast territory. This dragon robe [185] was not necessarily worn by an emperor but it bears unmistakably imperial imagery, in particular the special yellow colour and the 12 symbols within the dragon-and-cloud layout.

The jade horse [183] is a unique survival from the Han dynasty, the second imperial dynasty in China. Many jades exist, and countless pottery horses, but this is the only jade horse. Although fragmentary, and under 20cm high, it has a power and presence that belie its size. It presumably comes from the tomb of a noble or high-ranking official, but we know nothing about its origin, other than the fact that it belonged to an important collector called George Eumorfopoulos.

In ancient China it was thought that when a person died, his inner spirit, or *hun*, became detached from the body. The *hun* ascended to paradise, to the same level in the social hierarchy as the deceased had enjoyed when on earth, while the material soul, the *po*, took up residence in the tomb – for which it required the utensils, accoutrements and retinue of its earthly life. These would include horses, which were greatly prized by the Han nobility. Much of the military success of the Han dynasty

183 JADE HORSE China, Han dynasty, 206 BC – AD 220. This presumably comes from a tomb. In ancient China jade was thought to prevent decomposition, while a 'dragon mount' would transport the soul to paradise.
V&A: A.16–1935. Purchased with the assistance of The Art Fund, the Vallentin Bequest, Sir Percival David and the Universities China Committee

184 LACQUER THRONE China, Qianlong reign, probably late 1780s. The throne was made for a 'Travelling Palace' outside Beijing. As imperial power collapsed – first in China and then in Russia – it ended up in Britain.
V&A: W.399:1, 2–1922

185 DRAGON ROBE China, Qing dynasty, 1780–1850. Robes like this, woven in an intricate tapestry technique, were worn by the emperor on formal occasions. The design shows mountains rising from the swirling waves above the flowing waters of the ocean.
V&A: T.199–1948. Purchased with a grant from The Art Fund

was due to importation of 'blood sweating' horses from Central Asia – light, swift horses in contrast to the stocky local breeds. In the tomb these horses had an additional role: as 'dragon mounts' they transported the soul of the emperor to paradise.

Jade was often put in tombs as it was a highly prestigious material with the power – so it was believed – to preserve the dead body from corruption. The tomb of Prince Liu Sheng of the Western Han dynasty (206 BC – AD 9) contained over two hundred jade objects, including discs, rings, pillows, dancers, cicadas and leopards. The dead prince wore a garment made of 4,000 thin jade plaques, sewn with

gold thread and decorated with gold flowers and buttons.

The lacquer throne [184] has a definite link with the Qianlong emperor, who reigned from 1736 to 1795. It was probably commissioned in the 1780s for one of his 'Travelling Palaces' in the Southern Park just south of Beijing, an area that was used for troop reviews and sometimes for hunting. The lacquer decoration, in five different colours, includes five-clawed dragons exclusive to the emperor (also seen on the dragon robe) and exotic figures representing bearers of tribute from foreign lands. Other symbols invoke longevity, happiness, wealth, good fortune and peace.

In 1900–1901, as imperial China crumbled and foreign powers jostled for control of Beijing, the park was looted by Russian troops. The Russian ambassador got hold of the throne and brought it to Britain in 1917, in flight from the chaos in Russia. The throne went on display at Spink, a leading London dealer, and was bought as a gift for the museum by George Swift, a potato magnate and friend of a V&A furniture curator. It has since been regarded as one of the most important objects in the V&A's Chinese collection, valued for its history as much as its superb craftsmanship.

186 PORCELAIN EWER with the Peixoto coat of arms, Jingdezhen, 1522–66. Very little Chinese porcelain was seen in Europe before 1600. This rare example was commissioned by a Portuguese merchant and navigator who reached China in 1542.

V&A: C.222–1931. Gulland Bequest

# Workshop of the World

Jingdezhen, in south-west China, is the largest kiln site in the world. It has been producing ceramics for one and a half thousand years: by 1600 it was employing 10,000 workers simply to fulfil court and official orders; today it manufactures over 300 million pieces of household porcelain annually. The astonishing success of Jingdezhen is due to its location, with plentiful supplies of china stone, kaolin and other clays – plus wood to fuel the kilns – but also to its early skill in developing assembly-line production, with specialized crafts and a subdivision of labour.

Its most famous export, one that epitomized the 'exotic' East in the eyes of Europeans, is blue-and-white porcelain. Initially, however, this porcelain was not made for the European market but for export to the Middle East, via the overland trade routes known fancifully as the Silk Road. A few pieces trickled through to Europe, where they were regarded as precious rarities, but there was no direct trade until around 1600, when European traders began to capitalize on the newly found sea routes to the Far East.

This ewer [186] is one of the first porcelains to be made for a European customer, but it is a one-off, not part of sustained trade with the West. It bears the arms of the Peixoto family of Portugal and was probably commissioned by Antonio Peixoto, a navigator and merchant who reached Canton (Guangzhou) in 1542. The mounts were added in Iran, presumably on Peixoto's return journey.

In these early years the Portuguese dominated the porcelain trade, both to Europe and the Middle East, but they were soon outstripped by the Dutch and the English, greedy for porcelain, spices, silk and, most of all, tea. All the trade took place through the port of Canton, on the mouth of the Pearl River, where the East India Company gained a monopoly and set up business in 1685. The merchants lived in special quarters reserved for foreigners and operated under the close supervision of a Chinese official responsible to the Imperial Household Department, meaning that the ultimate beneficiary of the Chinese export trade was the emperor himself.

Tea was always the most important commodity, followed by porcelain, with painted wallpapers lagging far behind. But these papers, though not significant in the trade figures, did much to create the *chinoiserie* style that was so fashionable in eighteenth-century England and France. Even in the twentieth century they were copied and adapted in countless papers and furnishing fabrics to create the fresh, 'country house' look that remained enduringly popular.

This ability to turn out goods that appealed to consumers with unimaginably different lifestyles was one of China's great strengths. There was no tradition of wallpaper in China itself. Instead, this production brought together two well-established practices, that of lining rooms with plain white paper, and that of painting screens and scrolls to act as freestanding decoration. The wallpapers were probably made in the same workshops as the screens and scrolls but both the dimensions and the designs were adapted to the European market. They were produced in sets of 25 to 40 numbered rolls, often with spare sheets

187 WALLPAPER China, about 1810–30. Chinese wallpapers and silks, painted with exotic flowers and birds, were very popular in the early and mid-18th century. This paper represents a revival in the Regency period.
V&A: E.2853-1913

188 'BUZZ LIGHTYEAR' TOY China, 1997. Most toys are now made in China or East Asia. This one is in the V&A Museum of Childhood, a gift from a curator who tracked it down as the 'Most Elusive Toy of the Year' for 1996.
V&A: B.35: 1, 2-2004

of decorative motifs that could be patched in to conceal damage or create a more ornate effect. The designs include hunting scenes, activities such as porcelain manufacture or silk production, and these 'bird and flower' panels [187] suitable for a lady's boudoir or bedroom.

Despite being so carefully tailored to the European market, this wallpaper is immediately and distinctively Chinese; indeed, it is this exoticism that made it so attractive. The 'Buzz Lightyear' toy [188], by contrast, is entirely American, but with a carefully calculated global appeal. A spin-off from *Toy Story*, the world's first full-length computer animation, Buzz was so popular in 1996 that supplies ran out just before Christmas and it was voted the 'Most Elusive Toy of the Year'. Its inspiration, instantly recognizable around the world, is Buzz Aldrin, the *Apollo* astronaut. Created in America and marketed by a Canadian company, it was made – of course – in China.

# The Mazarin Chest

The V&A has one of the most important collections of Japanese lacquer outside Japan, much of it given to the museum as gifts or bequests by generous individuals. The collection ranges from the intricate and diminutive *inro* that were so characteristic of Edo culture to a few rare and lavish pieces of export lacquer. The Mazarin Chest [189], named after the family that once owned it, is a hybrid. Its solid and capacious form is European, but the technique and much of the subject matter are Japanese and exceptionally sophisticated.

True East Asian lacquer (as opposed to japanning, its European imitation) is a demanding technique. It uses the allergenic resin of the lacquer tree, *Rhus vernicifera*, applied in successive very thin layers to a substrate such as wood or paper and cured in a special high-humidity cabinet. The resin is coloured by the addition of pigments and worked in a myriad of specialized techniques to create particular effects. One whole class of techniques, called *maki-e* or 'sprinkled picture', uses gold, silver or coloured powders sprinkled onto the wet lacquer before it hardens.

The Mazarin Chest employs a whole range of *maki-e* techniques, plus beads, mother-of-pearl, silver foil and copper sheet for certain details. The imagery itself is complex: on the front panel and one of the side panels are scenes from *The Tale of Genji*, the supreme masterpiece of Japanese prose, written in the eleventh century by a court lady; on the other side panel is a scene from *The Tale of the Soga Brothers*, a lurid story of filial piety and revenge; on the lid are palaces and landscapes, which perhaps allude to the setting in which *The Tale of the Genji* was written. Japan and Europe were then so ignorant of each other's culture that no European client could possibly have understood this decorative programme, though the Japanese designer probably assumed that it was common knowledge.

The chest may have been created in the workshop of Koami Nagashige, the tenth-generation head of a family of lacquerers. It

is not known how it reached Europe, whether it was shipped directly or via an agent in the Dutch East Indies. A coat of arms on the French key suggests that the chest belonged to the Mazarin-La Meilleraye family, who might have inherited it from Cardinal Mazarin, first minister to the infant Louis XIV and a lavish patron. Later it passed into the possession of William Beckford, one of England's most discerning and eccentric collectors, and eventually reached the museum in the 1880s.

Japanese export lacquer of any kind is scarce because the trade was severely restricted. Europeans first reached Japan in the 1540s. They established a trading foothold and introduced Jesuit missionaries to convert the population to Christianity. The Japanese authorities tolerated this situation for some decades, but finally, fearful of change and political instability, they enacted a whole series of decrees that would strangle any foreign contact. In 1633, shortly before the Mazarin Chest was made, they forbade Japanese citizens from living or trading overseas, on penalty of death; a few years later they expelled all Europeans with the exception of the Dutch East India Company, which was confined to an island in Nagasaki harbour.

The country remained closed to foreigners until the 1850s, a time span that roughly coincides with the Edo period, 250 years in which Japan enjoyed peace, prosperity, and a vibrant artistic and cultural life. Lacquer, a sign of wealth and status, was in great demand among those who could afford it – the wealthy samurai, feudal lords and merchants. In increasingly inventive forms, it was used for dowry articles, writing utensils, picnic sets and *inro*.

The *inro* was a multi-purpose container, with tightly fitting compartments for seals, ink, medicines and herbal remedies. It hung from a cord from a man's sash and was closed by a decorative toggle or *netsuke*. As time went by, the *inro* lost its practical function and became an expensive fashion accessory. A wealthy man would have a series of *inro* for different

occasions; this example [189], with a man and woman cleaning the house, would have been worn for New Year, the most important time of festivity in the Japanese calendar. In contrast to the Mazarin Chest it is uniquely Japanese in its form, function and decoration.

**189 INRO** by Kanshosai, about 1775–1850.
In Japan lacquer was used for all kinds of small articles. An *inro* was a fashion accessory worn by men, though originally it had a more functional purpose.

V&A: W.207:1–1922. Pfungst Gift

**190 THE MAZARIN CHEST** Kyoto, about 1640.
The chest comes from a small group of very high-quality Japanese lacquerwares that were made specifically for export. One metre wide and decorated with a range of sophisticated lacquer techniques, it could have taken as long as two and a half years to make.

V&A: 412:1, 2–1882

191 A VIEW FROM UNDER THE SHIN-OHASHI
BRIDGE from *Thirty-six Views of Mount Fuji from
Edo*, by Utagawa Kuniyoshi, about 1843. Japanese
woodblock prints had a huge impact on European
art and design. Henry Van de Velde, one of the
leaders of Art Nouveau, said, 'It took the power
of the Japanese line, the force of its rhythm and
its accents, to arouse and influence us'.
V&A: E.2266–1909

# West Meets East

The moment when European designers first discovered Japanese graphic art has been much disputed. It is said this vital encounter took place in 1856, when the French ceramicist and engraver Félix Bracquemond found a collection of Hokusai prints in a shop in Paris. Whatever the truth, there is no doubt that the opening of Japan in 1853 had a dramatic effect on European art and design. For painters it offered new ways of depicting the world around them, less bound by the conventions of European realism; for designers it offered fresh approaches to decoration, free of tired historicism.

The V&A soon began to collect Japanese art for educational purposes. It bought 12,000 woodblock prints as a single lot in 1886 and eventually built up a collection of over 25,000 images. As a 1908 handbook explained, these prints were 'filled with examples of costumes, furniture, and all sorts of utensils; and if they are inferior in absolute artistic merit, they are of inestimably greater utility for these reasons to the designer'.

192 BRONZE INCENSE BURNER (detail) by
Suzuki Chokichi, about 1877 0. The V&A
collected modern Japanese manufactures to
show how traditional skills could be applied to
contemporary design.

V&A: 188:1 to 9–1883

193 GLASS VASE by Emile Gallé, about 1904.
The design of the vase is centred on a symbolic
interpretation of bats. This use of natural
imagery comes from Japanese art, in which
'nothing exists in creation, be it only a blade of
grass, that is not worthy of a place in the loftiest
conception of art'.

V&A: C.53–1992

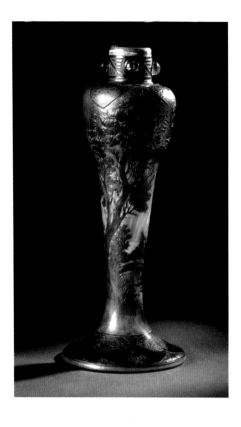

The view that Japanese woodblock prints were 'inferior' in artistic merit would have astonished painters such as Degas, Whistler, Manet and Gauguin. In different ways, they all drew on these prints [191] – with their flat colour, asymmetrical composition, violent contrasts of scale, and subordination of subject to foreground – to transform western art.

Artists were also attracted by the subject matter of the prints, by the *ukiyo-e* or 'floating world' of *kabuki* theatre, popular entertainment and erotic encounter. These images were not conceived as high art for a cultured elite. Instead, they were produced in huge print runs for the urban masses and sold individually for the price of a bowl of noodles or a haircut.

As well as prints, the museum acquired Japanese manufactures as examples of fine design and virtuoso craftsmanship. Metalwork in particular was of interest as it showed how traditional skills could be applied to contemporary objects – a move that had been forced on Japanese metalworkers when the military government collapsed in

1868 and there was a ban on the wearing of swords in public. Seeking a new clientele, the metalworkers began to make vases and decorative items, often for display in the international exhibitions that did so much to promote Japanese art abroad.

Suzuki Chokichi, maker of the incense burner [192], was professor at the Tokyo Fine Arts School. He excelled in plant and animal imagery, making castings from real tree stumps and keeping live birds in his studio so that he could observe their every movement. Exhibited at the 1878 Paris Universal Exhibition, the incense burner was bought by a Parisian dealer called Siegfried Bing, who later sold it to the museum for £1,568 7s 2d – a sum so enormous that Treasury had to give special permission for the purchase.

Siegfried Bing was a key figure in the popularization of Japanese art, though he is better remembered as the progenitor of Art Nouveau. He opened an oriental crafts shop in Paris in the late 1870s and later organized a series of exhibitions; his private collection

of ceramics and prints became a mecca for artists. In 1895 he changed gear, from dealer to entrepreneur, and opened a gallery in Paris called L'Art Nouveau – from which the movement took its name. Among the artists that he promoted was Emile Gallé, who shared Bing's interest in oriental art and particularly admired the Japanese aesthetic, for its immaculate sense of design, its uncontrived naturalism and its sensitive portrayal of flowers, birds and insects.

This vase [193] was made in the Gallé workshop in Nancy in 1904, the year he died. Towards the end of his life, troubled by melancholia and ill health, Gallé developed Symbolist themes in which natural phenomena took on a deeply personal significance. The bat, isolated in the Japanese manner against a solid background colour, evoked, in the words of this artist-scientist-philosopher, 'the darkness of a night in the forest ... the rustle, the whispering and mysterious activity of things which are unseen, but which watch, and go about their business in secret'.

194 ORNAMENT Ghana, before 1874. Asante gold, seized by British forces during a campaign in 1874, was displayed in the museum, along with the state parasol of 'King Coffee' (Kofi Karikari).
V&A: 374-1874

195 SACRAMENTAL SPOON WITH THE CRUCIFIXION Ethiopia, 1650-1710. The V&A has not traditionally collected African art, but some objects entered the collections in the 19th century, usually as the spoils of imperial incursions into Africa.
V&A: 186-1869

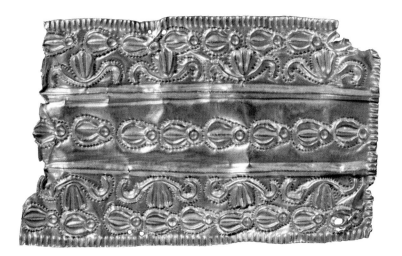

# Africa

In 1868 the South Kensington Museum put on a display entitled 'Abyssinian Objects from the Emperor Theodore, Lent by the Queen, the Admiralty and others'. It included a depiction of the dead emperor's head and, in the words of the *Gentleman's Magazine*, a 'show-case full of victorious trophies, "spolia opima" of our late enemy, his Majesty King Theodore'. This, regrettably, sums up the status of African art in the early years of the museum. Items such as the famous rock crystal jug, made in Cairo in the early eleventh century, were valued as examples of Islamic art, but otherwise African artefacts were simply trophies, physical witnesses to what was assumed to be the cultural and military superiority of the British Empire [195].

The Abyssinian campaign of 1867–8 was ostensibly to free a British hostage, though actually it was more to do with European *realpolitik*. It yielded a young Ethiopian prince, the robes and ornaments of a dead queen, objects from the imperial treasury, and liturgical material from the Church of the Saviour of the World. The prince, though kindly treated by his British guardian and educated at the expense of Queen Victoria, soon died of pleurisy, while the booty was divided between the British Museum and the South Kensington Museum.

Another incursion into Africa, in 1874, led to the defeat of the powerful Asante state that controlled key coastal towns and trade routes across the Sahara. The wealth of the Asante was founded on slaves obtained from the interior, and gold from natural deposits in the deep forests of southern Ghana. Both flowed through the capital, Kumasi, and gold became central to Asante art and culture. An early nineteenth-century visitor to Kumasi recorded how 'the royal stool, entirely cased in gold, was displayed under a splendid umbrella, with drums, *sankos* [harp-lutes], horns and

various musical instruments, cased in gold, about the thickness of cartridge paper'.

When British forces took Kumasi and ransacked the royal palace in retaliation for an attack on the trading post at El Mina, they imposed an indemnity of 50,000 ounces of gold. Sold at Garrard's, the royal jewellers in London, to provide pensions for the soldiers and next of kin, some of this rich ornament and regalia was bought by the South Kensington Museum [194].

Other objects in the V&A, acquired by accident rather than design, reveal the presence of black people in European art and society. In the Middle Ages this presence tended to be virtual rather than real. The three Magi, for instance, often include a black king as a sign that all mankind has submitted to the rule of Christ. Later, with the growth of the slave trade, black people became a visible presence in the bigger cities, usually as servants and pageboys but occasionally as people of education and rank.

Francis Williams achieved a modest fame in London as the 'Jamaican scholar'. Most unu-sually, he was the son of freed, and wealthy, slaves. Sent to England to be educated, possibly through the Duke of Montagu, he became proficient in mathematics, astronomy and Latin verse. Later he returned to Jamaica, where he lived off his family's assets – land and slaves – and kept a school for several years. His portrait [196] was given to the V&A in 1928 by Viscount Bearsted, for its depiction of furniture and fittings, but also for 'the striking story of the individual whom it represents'.

In recent years the museum has been more active in collecting work from Africa and the black diaspora. Gavin Jantjes is an artist of mixed-race descent from South Africa. He played an important role in the struggle against apartheid, specifically in breaking the 'culture of silence' in which oppressed peoples had no voice, but in 1982 was forced into exile in Britain. The title of this work [197], *Zulu*, refers to the Zulu people but also translates as 'the space above your head' or 'the heavens'. Three hybrid figures with human bodies and animal tails stand against a star-strewn sky, as if in a cultic ritual, receiving divine force from nature.

**196 FRANCIS WILLIAMS, THE NEGRO SCHOLAR OF JAMAICA** probably Britain, about 1745. Francis Williams is shown as a scholar in his study, with rows of expensively bound books and an open volume entitled *Newton's Philosophy*.
V&A: P.83-1928. Given by Viscount Bearsted MC and Spink and Son Ltd, through The Art Fund

**197 ZULU, THE SKY ABOVE YOUR HEAD** Gavin P. Jantjes, 1988. Jantjes is a South African artist. He explains: 'The heavens are the most neutral space – no nations lay claim to the heavens. They are undefined … and accessible to every human being.'
V&A: E.1232-1995

# Childhood

The V&A's interest in children goes back to the First World War, when an enterprising volunteer called Ethel Spiller developed a holiday programme that eventually earned her an OBE:

*When the Christmas holidays begin there is a good deal of bustle in the Entrance Hall of the Museum.... Boys and girls troop in with a business-like air; they greet one another as old friends and reminders pass round that clean hands and faces are desirable.... Whir-r-r, round goes the revolving door ... and finally a gang of a dozen grubby urchins emerges helter-skelter, dragging in a few babies and little girls with them.*

After the war the museum set up a Children's Corner and many years later, in 1974, it launched the Museum of Childhood. This provided a platform for the collections that linked to childhood, but it also solved the problem of what to do with the Bethnal Green Museum. An outstation of the V&A, this was housed in the 'Brompton Boilers', a cast iron and glass building that had been built on the South Kensington site and moved to Bethnal Green in the 1870s. The idea was to introduce the poor of the East End to the cultural riches of the nation, but the museum lacked a coherent focus. The solution was to turn it into a Museum of Childhood.

This has since become an enormous success, establishing links with many local schools and attracting visitors from all over the world. Among the most popular displays are the dolls' houses, which form a fascinating record of changing lifestyles and household management. The earliest of these was made

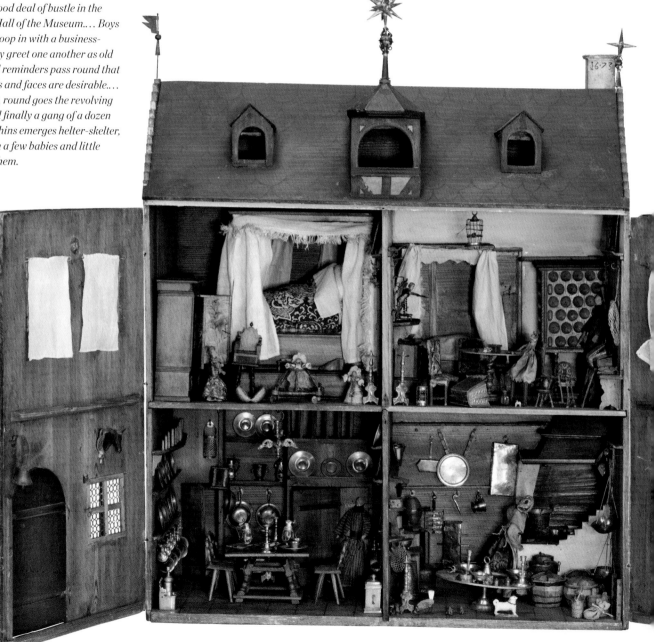

in Nuremberg in 1673 [198]. It has four well furnished rooms: two bedrooms, a best kitchen with a display of pewter and a privy leading off to the left, and a working kitchen equipped for the preparation of food. A unicorn on the front of the house indicates that the owner was an apothecary or chemist; a print of Martin Luther shows him to be a Protestant.

These early dolls' houses were more than playthings. Expensively equipped with all the comforts of a wealthy household, they were also a status symbol and an educational device. A German broadsheet of 1631, advertising a dolls' house on public display, makes both roles very clear: 'So look you then at this Baby House, ye babes, inside and out. Look at and learn well ahead how you shall live in days to come. See how all is arranged, in kitchen, parlour and chamber.… See what great number of chattels a well arrayed house does need.'

The Museum of Childhood does of course have many toys, but its main aim is to communicate the nature of childhood – both now and in earlier times. The one sober fact that divides our experience from that of the past is child mortality. Justinian William Andria Laczkovic [199] died suddenly just before his tenth birthday. He was his parents' only son, sent away to school at Christ's Hospital in Horsham. This photograph from a memorial album shows him at the age of eight, dressed in a commercial version of the 'Scotch' or Highland costume that had been popularized by Queen Victoria's many children. Other photographs in the album show him as a naked baby, as a toddler in a white dress and as a six-year old with a wheelbarrow.

The sad fate of Justinian, and the educational nature of the dolls' house, might suggest that childhood in the past was a serious matter, but written sources show that the more fortunate children had plenty of fun. They played tricks, made a racket, slid down the banisters and rode around on hobbyhorses and other contraptions just as they do now. All they lacked were the plastic toys and computers of our era – the Lego, Space Hoppers [200] and Nintendo.

198 THE NUREMBERG HOUSE **Nuremberg, 1673.** This is probably one of the more popular exhibits in the V&A Museum of Childhood. Close inspection reveals a baby-walker, a pair of gloves, a song book, a cheese grater and hens in the kitchen.
V&A: W.41-1922

199 PHOTOGRAPH **from the memorial album of** Justinian Laczkovic, England, 1883. This shows Justin in Highland dress at the age of eight. He died shortly before his tenth birthday.
V&A: B.82:27-1995

200 SPACE HOPPER **Mettoy Playcraft, 1970.** Said to have been inspired by the sight of children bobbing up and down on a floating buoy in a Norwegian harbour, the Space Hopper quickly became a cult toy of the 1970s.
V&A: B.87-2004

Providing fuel since 1857

201 MIKE DEMPSEY **for the V&A's Anniversary Album, 2007**

# Further Reading

More information on most of the objects in this book can be found on the V&A website (www.vam.ac.uk), in Search the Collections and on other web pages. The website also has reading lists that include V&A publications on aspects of the collection.

Information on the history of the museum and its collections can be found in:

*Journal of the History of Collections* (2002), vol.14 [*JHC*]

Anthony Burton, *Vision & Accident: The Story of the Victoria and Albert Museum* (London, 1999)

Brenda Richardson (ed.), *A Grand Design: The Art of the Victoria and Albert Museum* (London, 1997)

Anna Somers-Cox, *The Victoria and Albert Museum: The Making of the Collection* (London, 1980)

# Sources

p.7 'If ever there was': Anthony Burton, 'The uses of the South Kensington art collections', *JHC*, p.86.

p.7 'Moresque ornaments': Burton 1999, p.21.

p.8 'French modern': V&A, Search the Collections, http://collections.vam.ac.uk/item/O84915/vase/ (accessed 10 February 2010).

p.8 'elevate the Art-Education': Anthony Burton, 'The uses of the South Kensington art collections', *JHC*, p.29.

p.8 'chamber of horrors': *JHC*, p.32.

p.8 'General principles': *JHC*, p.30.

p.9 'gas flaming from the petal of a convolvulus!': Eric Turner, cat.20, Richardson 1997, pp.123–4.

p.9 'to act upon the principle': Burton 1999, p.30.

p.10 'Brompton Boilers': Burton 1999, p.48.

p.10 'immense bazaar': Burton 1999, p.53.

p.10 'refuge for destitute collections': Burton 1999, p.53.

p.10 'sleepy and useless': Anthony Burton, 'The uses of the South Kensington art collections', *JHC*, p.80.

p.13 'incomparably the most important monument': Christopher Titterington, cat.25, Richardson 1997, p.129.

p.14 'practical utility': Anthony Burton, 'The uses of the South Kensington art collections', *JHC*, p.80, p.79.

p.14 'Of what actual use': *JHC*, p.91.

p.14 'No artist': *JHC*, p.85.

p.14 'the Art of Drawing': ibid., p.89.

p.14 'If ever there was': *JHC*, p.85.

p.14 'make the public hunger': *JHC*, p.82.

p.34 'all so civil': Peter Trippi, 'Industrial Arts and the Exhibition Ideal', in Richardson 1997, p.81.

p.34 'the great truth': Rosemary Hill, *Pugin & the Building of Romantic Britain* (London, 2007), p.472.

p.34 'Elkington electrotypes': Peter Trippi, 'Industrial Arts and the Exhibition Ideal', in Richardson 1997, p.85.

p.35 'There are no carpets': Richardson 1997, p.86.

p.35 'the application of Science and Art': Burton 1999, p.44.

p.36 'the rare, the old': Richardson 1997, p.32.

p.36 'many things': Burton 1999, p.38.

p.36 'certain continental people': Timothy Stevens and Peter Trippi, 'An Encyclopedia of Treasures: The Idea of the Great Collection', in Richardson 1997, p.157.

p.36 'yielded up an infinity of treasures': Burton 1999, p.63.

p.37 'all classes are willing to barter': Somers-Cox 1980, p.66.

p.37 'reckless and useless expenditure': Peta Motture, cat.54, Richardson 1997, p.177.

p.38 'it was bought for me': William Morris's Socialist Diary, http://www.marxists.org/archive/morris/works/1887/diary/diary.htm (accessed 2 February 2010).

p.38 'complete degradation': Fiona MacCarthy, *William Morris: A Life for our Time* (London, 1994), p.167.

p.38 'have nothing in your houses': Peter Stansky, 'Morris, William', in *Grove Art Online*. Oxford Art Online, http://www.oxfordartonline.com/subscriber/article/grove/art/T059724 (accessed 2 February 2010).

p.39 'bright dream': Fiona MacCarthy, *William Morris: A Life for our Time* (London, 1994), p.433.

p.39 'crispness and abundance': MacCarthy 1994, p.406.

p.42 'frivolous and false': Burton 1999, p.124.

p.43 'advise him how': Somers-Cox 1980, p.83.

p.44 'pale, lean, tall, eccentric person': Stephen Coppel, 'Salting, George (1835–1909)', *Oxford Dictionary of National Biography*, online edn, October 2006, http://www.oxforddnb.com/view/article/35920 (accessed 3 February 2010).

p.44 'unto the Nation': Coppel 1996

p.46 'well attested descent': Horace Walpole, *The Works of Horatio Walpole Earl of Orford* (London, 1798), vol.II, p.396.

p.46 'Margaret of Austria': V&A, Search the Collections, http://collections.vam.ac.uk/item/O128865/medallion/ (accessed 3 February 2010).

pp.46 Their pedigrees': Bet McLeod, 'Rothschild', in *Grove Art Online*. Oxford Art Online, http://www.oxfordartonline.com/subscriber/article/grove/art/T074113 (accessed 3 February 2010).

p.49 'I record': V&A, http://www.vam.ac.uk/collections/sculpture/stories/madonna/chellini-madonna/index.html (accessed 2 February 2010).

p.50 'MUSICAL TYGER': Susan Stronge, *Tipu's Tigers* (London, 2009), p.62.

p.50 'a play-thing': Stronge 2009, p.67.

p.50 'shrieks and growls': Stronge 2009, p.68.

p.50 'big enough for the bed of Ware': quoted Catherine S. Hay, 'The Great Bed of Ware', in Christopher Wilk (ed.), *Western Furniture, 1350 to the Present Day* (London, 1996), p.48.

p.50 'twenty-six butchers': Eileen Harris, *Going to Bed* (London, 1981), p.61.

p.52 'exceedingly Richly Carv'd': Richardson 1997, p.321.

p.54 'excellently well': Richardson 1997, p.289.

p.57 'Fashion is like walking a tightrope': Claire Wilcox, *Vivienne Westwood* (London, 2004), p.27.

p.61 'made of flesh': Hugh Honour and John Fleming, *A World History of Art* (London and Basingstoke, 1982), p.226.

p.61 'I know not for sure': Eamon Duffy, *The Stripping of Altars: Traditional Religion in England, c.1400–c.1580* (New Haven and London, 1992), p.237.

p.61 'as useless as a leaking pot': John Guy, *Indian Temple Sculpture* (London, 2007), p.51.

p.63 'As the goblet ringing flies apart': Mark Jones, 'The Luck of Edenhall', in *Palace and Mosque: The Jameel Gallery of Islamic Art at the Victoria and Albert Museum*, ed. Tim Stanley (London, 2004), p.108.

p.64 'unexpressable griefe': John Evelyn, 'Excerpts from John Evelyn's Diary, 1658', in *Children and Youth in History*, Item #160, http://chnm.gmu.edu/cyh/primary-sources/160 (accessed 28 August 2009).

p.66 'If you are going underground': quoted by Ian Christie, cat.261, Christopher Wilk (ed.), *Modernism: Designing a New World, 1914–1939*, exh. cat. (London, 2006), p.407.

p.69 'Whenever perfect works': Elizabeth Jennings (trans.), *The Sonnets of Michelangelo* (London, 1961), XIV (i), p.41.

p.69 'tragedy of the tomb': Condivi, quoted in Anthony Hughes and Caroline Elam, 'Michelangelo', in *Grove Art Online*. Oxford Art Online, http://www.oxfordartonline.com/subscriber/article/grove/art/T057716pg2 (accessed 2 February 2010).

p.70 'Balenciaga uses fabric': quoted in National Gallery of Victoria, *Balenciaga: Masterpieces of Fashion Design* (Melbourne, 1992), p.37.

p.71 'I am exploring': Jennifer Hawkins Opie, *Contemporary International Glass: 60 Artists in the V&A* (London, 2004), p.122.

p.72 'scissors formed as birds': Burton 1999, p.33.

p.72 'Our objective' and 'wanted it to be': Design Museum, London, http://designmuseum.org/exhibitions/online/jonathan-ive-on-apple/imac-1998.

p.74 'resilient column of air': Christopher Wilk, 'Sitting on Air', in *Modernism: Designing a New World, 1914–1939*, exh. cat. (London, 2006), p.226.

p.74 'philosophize before every move': Design Museum, London, http://designmuseum.org/design/marcel-breuer (accessed 2 February 2010).

p.75 'Metal plays the same part': Christopher Wilk (ed.), *Modernism: Designing a New World, 1914–1939*, exh. cat. (London, 2006), p.230.

p.75 'Furniture is nothing to me': Vitra Design Museum, *100 Masterpieces from the Vitra Design Museum Collection* (Weil am Rhein, 1996), p.215.

p.75 'For me mood is also a function': 'A conversation with Verner Panton', typescript in Furniture, Textiles and Fashion department, V&A.

p.80 'God, our creator': George Savage, *Porcelain through the Ages* (Harmondsworth, 2nd edn 1963), p.125.

p.80 'A most magnificent LUSTRE': V&A, Search the Collections, http://collections.vam.ac.uk/item/O8069/group-chinese-musicians/ (accessed 3 February 2010).

p.85 'one cannot and must not': Reino Liefkes, 'Tradition and Innovation', in *Glass*, ed. Reino Liefkes (London 1997), pp.50–51.

p.85 'inner light space': Jennifer Hawkins Opie, *Contemporary International Glass: 60 Artists in the V&A* (London, 2004), p.74.

p.86 'the cunning hunter'. Genesis 25;27.

p.89 'a fine diamond parure': Diana Scarisbrick, *Chaumet: Master Jewellers since 1780* (Paris,

1995), p.40.

p.89 'sale of the century': Yvonne Hackenbroch, 'Reinhold Vasters, Goldsmith', *Metropolitan Museum Journal* (1984–5), vol.19, p.171.

p.89 'designs for goldsmith's work': Hugh Tait, cats 211–13, in *Fake? The Art of Deception*, ed. Mark Jones, exh. cat., British Museum (London, 1990), p.201.

p.90 'Bullen hose of Scarlett': Peter and Ann Mactaggart, 'The Rich Wearing Apparel of Richard, 3rd Earl of Dorset', *Costume* (London, 1980), vol.14, pp.50–53.

p.92 'the subtle and shifting expression': Cecil Beaton, *The Glass of Fashion* (London, 1954), p.337.

p.92 'I wonder if': Hugo Vickers, 'Cecil Beaton and his Anthology of Fashion', in *The Golden Age of Couture: Paris and London, 1947–1957*, ed. Claire Wilcox (London, 2007), p.161.

p.92 'a sort of fight': Cecil Beaton, *The Glass of Fashion* (London, 1954), p.254.

p.92 'is the colour of life': V&A, Search the Collections, http://collections.vam.ac.uk/item/O138238/pair-of-evening/ (accessed 3 February 2010).

p.92 'I was not allowed': V&A, Search the Collections, http://collections.vam.ac.uk/item/O120400/hat/ (accessed 3 February 2010).

p.99 'Work hard on the effects': Michael Kauffmann et al., *100 Great Paintings in the Victoria & Albert Museum* (London, 1985), p.176.

p.100 'more serene sky': V&A, Search the Collections, http://collections.vam.ac.uk/item/O56227/oil-painting-salisbury-cathedral-from-the-bishops/ (accessed 4 February 2010).

p.100 'It will be difficult': Ronald Blythe, *Field Work: Selected Essays* (Norwich, 2007), p.173.

p.101 'beyond question': V&A, Search the Collections, http://collections.vam.ac.uk/item/O14962/oil-painting-the-day-dream/ (accessed 18 February 2010).

p.102 'a thing apart': Katherine Coombs, *The Portrait Miniature in England* (London, 1998), p.7.

p.103 'the most exquisitely perfect': Michael Kauffmann et al., *100 Great Paintings in the Victoria and Albert Museum* (London, 1985), p.38.

p.103 'nothing fair': Alison Weir, *Henry VIII: King and Court* (London, 2001), p.427.

p.103 'exactness' and 'without any flattery': V&A,

Search the Collections, , http://collections.vam.ac.uk/item/O75215/miniature-miniature-self-portrait/ (accessed 18 February 2010).

p.103 'King's sister': Alison Weir, *Henry VIII: King and Court* (London, 2001), p.435.

p.103 'Here, take my Picture': Katherine Coombs, *The Portrait Miniature in England* (London, 1998), p.45.

p.103 'an El Dorado': J.H. Plumb, *England in the Eighteenth Century* (Harmondsworth, reprinted 1981), quoted in Katherine Coombs, *The Portrait Miniature in England* (London, 1998), p.102.

p.105 'the indulgence': Greg Kucera Gallery, Inc., Seattle, http://www.gregkucera.com/matisse.htm (accessed 2 February 2010).

p.105 'chromatic and rhythmic improvisation': ibid.

p.105 'this old project': ibid.

p.108 'extension of the eye': Lincoln Kirstein and Beaumont Newhall (intros), *Photography by Henri Cartier-Bresson* (London, 1964), n.p.

p.109 'The pictures I make': Spin, http://www.spinscotland.co.uk/events/view/garry_fabian_miller/ (accessed 2 February 2010).

p.111 'were composed of the richest and most brilliant dyes': V&A, Search the Collections, http://collections.vam.ac.uk/item/O77694/pattern-book/ (accessed 3 February 2010).

p.112 'I wanted something anti-authority': *The Guardian*, http://www.guardian.co.uk/music/2008/sep/02/therollingstones.design (accessed 3 February 2010).

p.112 'a completeness of ensemble and pictorial effect': V&A, http://www.vam.ac.uk/collections/theatre_performance/features/Costume/1739_Designers_Speak/1739_Wilhelm/index.html

p.112 'the Russian ballet': Mary E. Davis, *Classic Chic: Music, Fashion, and Modernism* (Berkeley, 2006), p.197.

p.115 'a little antique horse': Jeremy Warren, 'Bronzes', in Marta Ajmar-Wollheim and Flora Dennis (eds), *At Home in Renaissance Italy* (London, 2006), p.299.

p.115 'replica, with alterations': Gervase Jackson-Stops, *The Treasure Houses of Britain: Five Hundred Years of Private Patronage and Art Collecting*, exh. cat. (New Haven and London, 1985), p.541.

p.117 'modells in Clay': Katharine Eustace, 'Rysbrack, (John) Michael (1694–1770)',

*Oxford Dictionary of National Biography*, online edn, May 2009, http://www.oxforddnb.com/view/article/24427 (accessed 3 February 2010).

p.117 'the first of Britons': John Martin Robinson, *Temples of Delight: Stowe Landscape Gardens* (London, 1994), p.26.

p.118 'On his head he wore': John Keay, *India: A History* (London, 2004), p.326.

p.118 'the consumption of fine cloths': Keay 2004, p.327.

p.120 'The Indians are in many things': Amin Jaffer, *Luxury Goods from India: The Art of the Indian Cabinet Maker* (London, 2002), p.11.

p.121 'the greatest ladies': Rosemary Crill, *Chintz: Indian Textiles for the West* (London, 2008), p.18.

p.121 'grey precision': John Guy and Deborah Swallow, *Art of India, 1550–1900* (London, 1990), p.177.

p.130 'It took the power of the Japanese line': Anna Jackson, 'Orient and Occident', in *Art Nouveau, 1890–1914*, ed. Paul Greenhalgh (London, 2000), p.107.

p.130 'filled with examples of costumes': Rupert Faulkner, *Masterpieces of Japanese Prints: The European Collections: Ukiyo-e from the Victoria and Albert Museum* (London, 1991), p.24.

p.131 'nothing exists in creation': Anna Jackson, 'Orient and Occident', in *Art Nouveau, 1890–1914*, ed. Paul Greenhalgh (London, 2000), p.107, p.109.

p.131 'the darkness of a night in the forest': V&A, Search the Collections, http://collections.vam.ac.uk/item/O5194/vase/ (accessed 3 February 2010).

p.132 'King Coffee': V&A, Search the Collections, http://www.vam.ac.uk/collections/periods_styles/hiddenhistories/stories_themes_africa/asantegold/index.html (accessed 3 February 2010).

p.132 'Abyssinian Objects': V&A, Search the Collections, http://www.vam.ac.uk/collections/periods_styles/hiddenhistories/stories_themes_africa/ethiopia_treasures/index.html (accessed 3 February 2010).

p.132 'show-case full of victorious trophies': V&A, Search the Collections, http://www.vam.ac.uk/collections/periods_styles/hiddenhistories/stories_themes_africa/ethiopia_treasures/index.html (accessed 3 February 2010).

pp.132 'the royal stool': V&A, Search the Collections, http://www.vam.ac.uk/collections/periods_styles/hiddenhistories/stories_themes_africa/asantegold/index.html (accessed 3 February 2010).

p.133 'the striking story': V&A, Search the Collections, http://www.vam.ac.uk/collections/periods_styles/hiddenhistories/object_stories/francisblackwriter/index.html (accessed 3 February 2010).

p.133 'culture of silence': Tate, London, http://www.tate.org.uk/servlet/ViewWork?cgroupid=999999961&workid=74144&searchid=15832&tabview=text (accessed 3 February 2010).

p.133 'the space above your head': V&A, Search the Collections, http://collections.vam.ac.uk/item/O134449/print-untitled-zulu-the-sky-above/ (accessed 3 February 2010).

p.134 'When the Christmas holidays begin': Burton 1999, p.171.

p.135 'So look you then': Halina Pasierbska, *Dolls' Houses* (Princes Risborough, 1991), p.4.

202 GRAYSON PERRY **for the V&A's Anniversary Album, 2007**

V&A Bodoni typeface

# A B C D E F G H I J K L M N
# O P Q R S T U V W X Y Z & .

&A V&A 64 pt

ABOUD SODANO, TYPOGRAPHIC
COLLABORATION FROM JULIAN MOREY,
for the V&A's Anniversary Album, 2007

# Acknowledgements

The collections of the V&A are so vast, and its history so complex, that it would not be possible to write this book without the help of colleagues throughout the museum. I am particularly grateful to David Anderson, Julius Bryant, Mark Eastment, Rhian Harris, Beth McKillop, Christopher Wilk and Paul Williamson for their guidance.

I would also like to thank the following, who were so willing to share their expertise and answer my many queries: Glenn Adamson, Nick Barnard, Martin Barnes, Bryony Bartlett-Rawlings, Ian Blatchford, Terry Bloxham, Susanna Brown, Clare Browne, Matthew Clarke, John Clarke, Frances Collard, Katie Coombs, Rosemary Crill, Glyn Davies, Kate Dorney, Richard Edgcumbe, Mark Evans, Rupert Faulkner, Juliette Fritsch, Ruth Hibbard, Claire Hudson, Nick Humphrey, Julia Hutt, Clare Inglis, Anna Jackson, Elizabeth James, Abbie Kenyon, Reino Liefkes, Karen Livingstone, Christopher Marsden, Noreen Marshall, Amy Mechowski, Sarah Medlam, John Meriton, Liz Miller, Peta Motture, Tessa Murdoch, Eithne Nightingale, Susan Owens, Angus Patterson, Clare Phillips, Gill Saunders, Jana Scholze, Michael Snodin, Tim Stanley, Emma Stewart, Matthew Storey, Susan Stronge, Louise Taberer, Marjorie Trusted, Frances Warrell, Rowan Watson, Claire Wilcox, Ming Wilson, Lucy Wood, Anna Wu, Hilary Young.

In the Photo Studio, Richard Davis, Peter Kelleher and James Stevenson supplied many new photographs. In Publishing, Anjali Bulley, Clare Davis, Laura Potter and Julie Chan were supremely efficient.

Outside the V&A, I would like to thank Father Rupert McHardy, Charles Hind, Joe Perkins, Mary Butcher and Alice Ladenburg. Johanna Stephenson, as editor, was judicious and enthusiastic. Will Webb, the designer, created a beautiful book. It was a pleasure to work with them both.

Finally, I would like to thank Robert Collingwood for his tough questions and sound answers.

# Index

Alan Fletcher (1931–2006)
*V&A Logo* (detail)
1989

Suzuki Osamu (1981–2001)
*Cloud Image*
Stoneware with iron slip
and ash glaze
1981

*Victorian Comb*
Circa 1800–1880

*Dada magazine no.7, M*
*Dadaphone* (Title detail
Edited by Tristan Tzar
Paris: Au Sans Pareil, 1

Takeuchi Denji
*Sculpture*
Cast, polished
and glued glass
Japan, 1992

*The Pusey Horn*
Horn, probably ox, with
silver-gilt mounts
Unmarked, around 1400

*Dagger Handle*
Ivory, French (Paris)
Second quarter of
the 14th century

Gae Aulenti
*Table lamp: Pileo*
Steel, painted white with plastic base
Artemide, Milan, 1970

*Key*
Steel
England, 17th Century

Hans Schle
(1898–1976)
*Symbol*
W. Raven &

*Ring Stone*
Polished sandstone
Taxila region, Pakistan
Late Maurya period
or early Sunga period
3rd to 2nd century BC

Eric Gill (1882–1940)
*Alphabets and Numerals* (detail)
Carved Hoptonwood stone
1909

*Folding Fan*
Pierced and painted ivory
About 1700–1730